THE PARADOX OF
REMBRANDT'S 'ANATOMY OF DR. TULP'

(*Medical History*, Supplement No. 2)

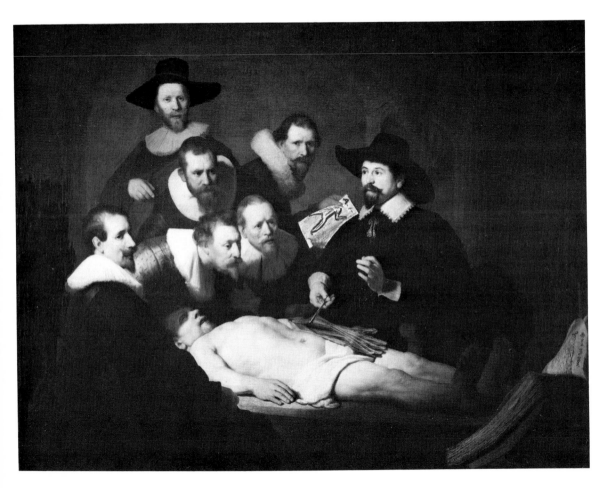

Pl. 1 *retouched photograph:* approximate reconstruction of the original state of Rembrandt's 'Anatomy of Dr. Nicolaes Tulp' (so called), 1632. London, Wellcome Institute. *See Pl. 2 for the present state of the painting.*

THE PARADOX OF REMBRANDT'S 'ANATOMY OF DR. TULP'

by

WILLIAM SCHUPBACH

(*Medical History*, Supplement No. 2)

LONDON

WELLCOME INSTITUTE FOR THE HISTORY OF MEDICINE

1982

Published 1982 by the Wellcome Institute for the History of Medicine, 183 Euston Road, London NW1 2BP.

ISBN 0 85484 039 7
ISSN 0025 7273 2

Supplements to *Medical History* may be obtained at the Wellcome Institute, or by post from Science History Publications Ltd., Halfpenny Furze, Mill Lane, Chalfont St. Giles, Bucks HP8 4NR.

Printed by the Wellcome Foundation Limited, Print and Packaging Division (Crewe).

CONTENTS

* researched in collaboration with Dr. J. G. Bearn

TO

MY PARENTS

PREFACE

The oil painting known as the 'Anatomy (or "Anatomy lesson") of Dr. Nicolaes Tulp', which is attributed on stylistic grounds to Rembrandt and dated 1632, hangs today in the Hague, as the cynosure of the Rembrandt collection in the Royal Cabinet of Paintings (Mauritshuis). The iconography of this one painting is the subject of the present essay. The argument of the essay is that this picture makes a cryptic but deliberate and precise statement about the nature of human life as revealed to the arts of anatomy, literature, metaphysics, and painting. From about 1675 to the present, according to the argument proposed here, although the picture has been much admired, studied, and reproduced, its original meaning has been completely forgotten.

If, as I claim, the picture's meaning was already lost in the seventeenth century, one might wonder how it could be recovered in 1982, the picture's 350th anniversary. I must admit at once that I have not discovered any hitherto unknown drawings, letters, or other documents which might reveal new facts about Rembrandt's painting. Although I do adduce some neglected circumstantial evidence, my argument is primarily a new hypothesis which accounts for the existence of documents already known. That this hypothesis is making its début only now, late in the picture's history, is due to the fact that, although much has been written in the past about Dutch seventeenth-century pictures, only recently has their iconography been studied for the first time. Some of this work has been done by former students of Professor William S. Heckscher, whose own iconographic study, *Rembrandt's anatomy of Dr. Nicolaas Tulp* (New York, 1958) has been especially useful for its magnificent bibliography, an indispensable adjunct to the present book. Then, the physical and chemical analysis of the painting which was made by Professor W. Froentjes and colleagues, and which was published by the Mauritshuis in 1978, was also of crucial importance: I believe the present essay is the first to exploit it. Dr. A. B. de Vries, Mr. L. A. Houthakker, and Mr. P. N. G. Pesch kindly sent me further valuable information from Renswoude, Amsterdam, and Utrecht.

In London, Dr. J. G. Bearn provided the necessary anatomical expertise, and facilities for testing the competing interpretations of the dissection shown in Rembrandt's painting. Indeed, it was his *obiter dictum* about that dissection that first stimulated the enquiries which ended in the present book. Dr. Bearn has kindly permitted me to write up our joint researches and to present them here as Appendix I (pp. 52–56 below).

My greatest debt, however, is to the Wellcome Institute, not only because this study is founded on books and pictures in its incomparable library, but also because of the help which I have received from fellow-members of the Institute's staff. The interest of Dr. C. H. Talbot encouraged me to persevere in this work when the seemingly insoluble problems of composition tempted me to abandon it less than half-written. The text was typed by Miss Stella Coomber; improved by the criticism of Dr. R. Burgess, Dr. E. Clarke, Dr. V. Nutton, and Professor A. R. Hall; much retyped by Miss Rosemarie Jenkins; provided with the means of publication by the editors of this series, Dr. W. F. Bynum and Dr. V. Nutton; and prepared for the press by Mrs. J. Runciman. I thank them all. But let me exculpate them by adding the time-honoured "preface-paradox": some of what I say is false, and I alone am responsible for every word of it.

W.S.

LIST OF ILLUSTRATIONS

Riolan, *Anthropographia et osteologia*, Paris, 1626, frontispiece. London, Wellcome Institute.

FIGURES

ACKNOWLEDGEMENT OF SOURCES OF ILLUSTRATIONS

Plate 13 is published by gracious permission of H.M. the Queen.

The following are published from photographs in the Wellcome Institute library, by courtesy of the Wellcome Trustees: Plates 1, 3, 4, 5, 6, 7, 10, 11, 12, 15, 20, 21, 22, 29, 31, 32, 33, 34, 35, 37, 38; Figures 1, 2, 3, 4, 5, 6, 7, 9, 10, 11.

Other illustrations are published by permission of the following: The Foundation Johan Maurits van Nassau, the Hague (Pls. 2, 9, 16); Jhr. Six van Hillegóm (Pl. 18); the Trustees of the British Museum (Pl. 19); the Victoria and Albert Museum (Pls. 27, 28, 39); the Scottish Development Department, Edinburgh (Pl. 30, Crown copyright); the British Library Board (Pl. 36; Figs. 12, 13); Christie's, London (Pl. 44); Mr. L. A. Houthakker, Amsterdam (Pl. 45); the Syndics of the Fitzwilliam Museum, Cambridge (Fig. 8); and the other owners listed in the list of illustrations above.

ABBREVIATIONS

Cetto

A. M. Cetto, 'Katalog der bildlichen Darstellungen der anatomischen Sektion' in her and G. Wolf-Heidegger's *Die anatomische Sektion in bildlicher Darstellung*, Basle, Karger, 1967.

Heckscher

William S. Heckscher, *Rembrandt's anatomy of Dr. Nicolaas Tulp: an iconological study*, New York University Press, 1958.

(Heckscher [followed by a number])

The item cited under that number in the bibliography of Heckscher, pp. 193–217.

Mauritshuis

Rembrandt in the Mauritshuis: an interdisciplinary study, by A. B. de Vries, M. Tóth-Ubbens, and W. Froentjes, Alphen aan de Rijn, Sijthoff & Noordhoff, 1978.

Tulp (1641)

Nicolaus Tulpius, *Observationum medicarum libri tres*, Amsterdam, 1641.

Tulp (1652)

Nicolaus Tulpius, *Observationes medicae. Editio nova*, Amsterdam, 1652.

Wilkins

Eliza Gregory Wilkins, *The Delphic maxims in literature*, Chicago, University of Chicago Press, 1929.

DIRECTION

Right and left are used in the viewer's sense except when describing parts of a human body in relation to that same body as a whole, in which case they are used in the anatomical sense.

THE QUESTION OF GENRE

ON THE RIGHT of Rembrandt's anatomy-picture of 1632 (Pl. 2) the physician Nicolaes Tulp, doctor of medicine (Leiden) and *praelector anatomiae* to the Amsterdam guild of surgeons, demonstrates a dissection of the forearm of a corpse. To the left of him we see seven surgeons of Amsterdam who are identified as such from the list of names on the paper held by one of them. Each name on the list is numbered, and a corresponding number is painted on the canvas by the head of each of the sitters, so enabling us to identify them. But although the authenticity of the names recorded in the list can be confirmed from other sources,[1] the list itself is thought to be one of three important additions or alterations which, together with numerous minor alterations, make the painting as it now exists no longer the painting which Rembrandt painted.

The grounds for suspecting that the list was added later are, first, that it is superimposed on an anatomical figure which is painted in a Rembrandtian manner but which the list obscures (Pl. 16); and second, that the list includes as its penultimate item the name of the surgeon whose portrait is crammed in on the extreme left edge of the canvas, Jacob Colevelt (Pl. 2). Colevelt's portrait is painted in a different technique from the others, and this fact, together with its unfortunate position, suggests that it also is a later addition by another hand.[2] The list, which records its presence, must have been added later still. The third significant alteration affects the surgeon at the peak of the pyramid, Frans van Loenen: X-ray and infra-red photographs show that he was originally portrayed wearing a broad black hat which, though an important part of the original design, was for some reason painted out, perhaps by Rembrandt himself, at a very late stage in the execution.[3]

In order to see the picture approximately as Rembrandt painted it, we must therefore remove the list of names, restore the anatomical figure, expel the portrait of Colevelt, and reconstruct the hat of van Loenen. Having made these restorations on a photograph (Pl. 1, frontispiece), we find that Rembrandt composed his six surgeons in two triangles, one inner and one outer. The three surgeons who form the inner triangle attend eagerly to various aspects of the demonstration, and therefore remain mentally within the picture. The surgeon at the apex of this triangle peers at the book at the feet of the corpse. The three who form the outer triangle (Pl. 1) seem to look in various directions out of the picture. The hatted surgeon at the apex of this larger triangle looks straight out at the viewer. The original composition (Pl. 1) appears more rational and more coherent than the picture in its present, altered state (Pl. 2), which is spoiled by the addition of one figure, Jacob Colevelt, looking into the picture from a position outside even the outer triangle.

[1] *Mauritshuis* p. 99.

[2] Ibid., pp. 83, 86–87, 102–103, 105.

[3] On the hat: *Mauritshuis* pp. 84–86, 105, and Heckscher n. 48.

In the foregoing characterization of the sitters, we have included a commonplace of the literature on Rembrandt's painting: some of the sitters look out of the picture, while others remain mentally within it. Yet many of those who have accepted this view without question have proceeded to a larger interpretation with which it is not entirely compatible. Rembrandt's picture of 1632 is regarded as a revolutionary composition on the ground that it is a group-portrait which purports to be, in addition, a likeness of an "anatomy lesson": Dr. Tulp is speaking to teach, the surgeons are listening to learn. By contrast, the earlier pictures of this subject, by Aert Pietersz. (1603), Michiel and Pieter van Miereveld (1617), Thomas de Keyser (1619), and Nicolaes Eliasz. (1625) are regarded as group-portraits and nothing more (Pls. 3, 4, 5, 6). Here the praelectors who would, in a lesson, be speaking, have their mouths shut, and most of those who would be paying attention to them are looking away towards the spectator instead. In these earlier pictures the anatomy appears not as a momentary event but as an attribute which indicates the lifelong profession of the sitters. Whether the praelector is speaking or silent, whether the surgeons look at the dissection or unhistorically away from it, they are all immortalized by their painters as members or officers of a guild of surgeons. Rembrandt, according to this view, was the first painter to go beyond this ideal, in that he not only indicated the profession of the sitters, but also gave the impression of a historical event, an "anatomy lesson", taking place before the viewer.[4] The question whether or not such an event ever occurred would not affect the vividness of the impression, nor the painter's achievement in creating it.

The incompatibility between this interpretation of Rembrandt's picture and the detailed description of his sitters' attitudes has usually been overlooked. It is certainly true to say of Rembrandt's inner three surgeons and the praelector that they are depicted as characters in a historical painting: they are all caught up in the same event, they are unaware of the viewer, their attitudes are rational and spontaneous, and they show a sense of the moment. But these qualities are not all found in the outer group of surgeons, who are considered to be looking out of the picture. Their attitudes (Pl. 1) are as unhistorical as the attitudes of those surgeons in the front row of Aert Pietersz.'s composition of 1603 (Pl. 3), who appear to turn 180° away from the anatomy to show their faces to the viewer. In the pose of his outer three surgeons, Rembrandt, like Pietersz., seems to have yielded to the demand of traditional portraiture that he show the viewer sitters' faces which would historically have been hidden as they looked downwards or into depth. This concession has a more important effect in a group-portrait which is modelled on an anatomy than in one which is modelled on a banquet, muster, or committee. For in those three cases, the sitters can let their attention wander out of the picture without defeating the ostensible purpose of the setting. But in anatomy-pictures there is no historically legitimate object for the sitters' attention apart from the anatomy itself: if they look away from the anatomy, it

[4] *Mauritshuis* pp. 98, 102, reflect the general view, which O. Benesch, *Rembrandt,* Lausanne, Skira, 1957, pp. 43–44, states concisely thus: "While in previous Amsterdam group portraits there is always something stiff and constrained about the figures, Rembrandt succeeded in linking them together and breathing organic life and unity into them. They form not only a well-constructed, well-balanced, pyramidal composition in the spirit of Italian art, but also a psychologically unified group listening attentively to Professor [*sic*] Tulp's lecture".

immediately loses its historicity with respect to them, and takes on automatically the nature of an attribute, as it must, according to our analysis, for Rembrandt's outer triangle of surgeons.

Hence, Rembrandt's design of 1632 (Pl. 1), far from breaking with previous traditions, adopts the same compromise as Thomas de Keyser's of 1619 (Pl. 5). In each picture, the sitters are divided by the same criterion: whether, owing to their position in the picture, their looking at the anatomy would or would not produce a marketable facial portrait. If it would, they look at the anatomy, which is therefore historical. If it would not, they look at the viewer, and accept the anatomy as an attribute. By this criterion, de Keyser (Pl. 5) managed to have, out of six sitters, four historical and two attributive, while Rembrandt (Pl. 1), out of seven sitters, had four historical and three attributive. On a simple count of heads, Rembrandt's design, paradoxically, is proportionately less historical, more attributive, more traditional, than de Keyser's.

Qualitatively, on the other hand, Rembrandt's "historical" surgeons (the inner three in Pl. 1) may seem more historical than de Keyser's equivalents (the back three in Pl. 5), but this also is disputable. Rembrandt's subjects are deeply absorbed by the lesson, while de Keyser's show only a shallow interest. But are the former necessarily more plausible historically? On the contrary: once this criterion of "historicity" or implied narrative has been allowed into our criticism, we are even free to remark that since the surgeons in both pictures are well into middle age, they must have heard plenty of anatomy lectures before,[5] and so the detached attitudes of de Keyser's elders are no less realistic than the almost ingratiating zeal of Rembrandt's, as can be confirmed from Pl. 7.

There is another reason for comparing Rembrandt's picture with de Keyser's. The anatomy in each picture has two incompatible functions, historical with respect to some of the sitters, attributive with respect to the others. In order to soften the incongruity between these two functions, de Keyser, an experienced portraitist, has quietened the historical element: his surgeons who do look at the skeleton (Pl. 5) do not pretend to be engrossed in anatomical study, so we are less inclined to complain that his other surgeons do not look at it at all. In this picture one scarcely notices any conflict of genres. The youthful Rembrandt, however, with his training as a historical painter, seems to have rushed into the trap. For by intensifying the historical atmosphere in one part only, he has sharpened the incongruity between the historical heart of his painting and its attributive periphery, so leaving the viewer in two minds as to the subject of the whole. For if in Pl. 1 the inner three surgeons are understood to be paying attention to the lecturer, by the same criterion the outer three ought to seem to be rudely ignoring him. But if it is the outer three who set the tone, the inner three seem to serve merely as attributes to *them*. The unease which many people feel on looking at Rembrandt's painting is a natural result of this unfortunate juxtaposition of two different conventions in one and the same picture.[6]

[5] On the anatomical knowledge gained by one of the surgeons present in Rembrandt's picture, M. Calkoen, see p. 55 below.

[6] Such unease is expressed by, among others, W. F. Bynum, 'Anatomy lecture on the brain', *J. Hist. Med.,* 1968, **23**: 196; T. Copplestone, *Rembrandt,* 4th ed., London, Hamlyn, 1974, p. 33; Christopher Wright, *Rembrandt and his art,* London, Hamlyn, 1975, p. 23.

Hence, although Rembrandt's painting is usually judged superior to the earlier works, the criteria of judgment that are used ought to suggest the opposite conclusion: his Tulp picture, on these terms, is successful neither as a history-picture nor as an attributive group-portrait. This conclusion is the starting-point of our investigation, for it provokes us to wonder whether the fault may lie not with Rembrandt but in the traditional identification of the genre and subject of the picture. These suspicions are indeed confirmed by the following, more minute, examination of the painting.

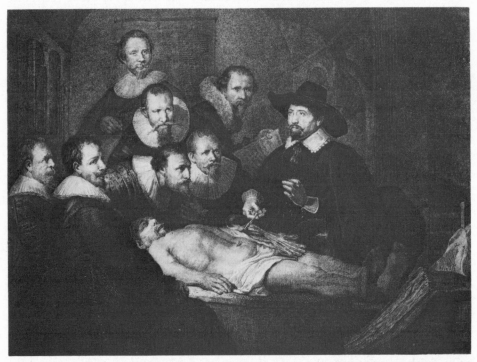

Figure 1. J. de Frey, 'The anatomy of Dr. Nicolaes Tulp' (so called), etching, 1798, after Rembrandt's painting (Pl. 2). *The structure on the right is the etcher's attempt to render the back of the chair on the seat of which the books are placed.*

II

A HISTORICAL PORTRAIT?

For the present purpose it is more convenient to dispense with the division between inner and outer triangles, and instead to take Rembrandt's seven sitters one by one, left to right in the front row, then right to left along the back, referring always to the original design of the picture as reconstructed in Pl. 1.

1. ADRIAEN SLABBERAEN

Adriaen Slabberaen is the surgeon on the left of the picture (Pl. 1), who is seated directly opposite the praelector on the other side of the table. He resembles the surgeon seated in the comparable position in de Keyser's picture (Pl. 5); they are not the same man, but like that surgeon, Slabberaen is one of the sitters who are usually thought to be turning unhistorically towards the viewer, or in other words not paying attention to the lecturer.[7] A different interpretation is proposed here: his eyes are directed not at the viewer, but at the large open book which leans against a pile of smaller, closed books in the lower right corner of the canvas.

This interpretation is no more subject to proof than the traditional one, but a possible objection to it can be refuted. Almost all writers who have referred to the mountain of books locate it (to use the recurring phrase) "at the feet of the corpse", meaning, presumably, on or beyond the end of the dissection-table.[8] If the books were so placed, Slabberaen would certainly not have to turn so far to his right in order to look at them. However, the gap between the under edge of the dissection-table and the bottom edge of the recto page implies that, in three dimensions, the books are supposed to be standing not at the feet of the corpse but on a free-standing structure between the table and the picture-plane.[9] Immediately above the open volume, on the right edge of the canvas, one sees a brown vertical object, in natural light now dim, which looks like the left vertical back-strut of a chair on the seat of which the books are piled. [10] These facts, together with the large page-height of the open volume – approx. 46 cms. on the canvas – suggest that the book is to be understood as almost leaning out through the picture-plane. Hence Slabberaen, in looking at the book, looks at the picture-plane, and therefore in the direction of the viewer.

However, the object of his gaze is the book, not the viewer, and the book is not a symbol but a historical part of normal anatomical equipment. The engraving re-

[7] e.g. *Mauritshuis* p. 98.

[8] In 1887, Triaire (Heckscher [474] p. 14) located the book "au pied du cadavre", but this may have been a metaphor. Riegl (Heckscher [398] text vol. p. 185) placed it literally "zu Füssen des Leichnams", and this phrase recurs in numerous later works such as H. van de Waal's essay (Heckscher [504] p. 104), and *Mauritshuis* p. 99.

[9] As observed by Heckscher p. 67, though contradicted by the inevitable phrase "at the feet of the corpse" in the previous sentence.

[10] This marginal object is often cut off photographs, but is clearly reproduced in (e.g.) *Mauritshuis* pl. VII. It seems to have puzzled J. de Frey, whose etching of Rembrandt's picture (Fig. 1) was published in 1798. De Frey interpreted it as the *right* back strut of a different structure (a chair or something else) which would fill the still unexplained space behind Nicolaes Tulp.

produced in Pl. 8, which depicts an anatomy at Leiden, suggests an anatomy-book was used on such occasions as a prompt-book for the praelector,[11] while the engraved illustrations in the book served also to clarify the dissections and to provide a check against abnormalities.[12] In Rembrandt's painting it is placed where it is – further from the participants than they could reach to turn the pages – precisely in order to give a historical reason for Slabberaen's showing his face to the viewer. In the case of this sitter, Rembrandt does seem to have introduced a device to turn an attributive pose, like that of the corresponding surgeon in de Keyser's picture (Pl. 5), into a historical one (Pl. 1).

2. JACOB DE WITT

The surgeon on the right of Slabberaen, Jacob de Witt, cranes over the cadaver's head in order to follow the course of the forearm muscles which the praelector is demonstrating. Here also the pose is historical.

3. MATHYS CALKOEN

The surgeon who crouches down between Jacob de Witt and Nicolaes Tulp is identified as Mathys Calkoen. On the direction of his gaze there is no agreement: some think he is looking at Tulp's face, others that he gazes thoughtfully into the unfocused distance, and others that he is looking generally at "what the praelector is doing".[13] Much is explained, however, if we assume that his eyes are directed specifically at Dr. Tulp's left hand.[14]

Calkoen bends forward and supports the weight of his trunk with his own left hand. The only reason for adopting such a posture would be to look downwards, at the dissected limb. Now he is looking up, but he has not had time to unbend his spine from its downward inclination. This is not the only sign of haste. He has raised his head to a higher angle than suits the posture of his trunk, but his head merely follows his eyes which already aim higher still. Hence his eyes seem to have darted up with a sudden glance which is now fixed on Nicolaes Tulp's left hand.[15]

Any explanation of Calkoen's sudden change of attention depends on one's interpretation of Nicolaes Tulp's gesture. To catch Calkoen's eye so sharply Tulp must have done something sudden, unexpected, and noteworthy. Yet his gesture has been called "a common gesture", "a stereotyped teaching gesture", "the gesture of restrained speech", "an eloquent gesture with his left hand, the *Quibus dein orditur,* which may be interpreted as [meaning that] he started his oration by setting out

[11] Appendix III no. **14a**, p. 73 below.
[12] Cf. p. 12 below, on Tulp's use of Laurentius.
[13] The interpretations of, respectively: Hofstede de Groot (Heckscher [229] p. 388); Jantzen (Heckscher [255] p. 314) and also Cetto p. 308; and *Mauritshuis* p. 103.
[14] Absent, as far as I know, from the specialist literature, this interpretation was eventually found only in Max-Pol Fouchet's *Lire Rembrandt,* Paris, Les Editeurs français réunis, 1970, pp. 33–34, and in Frederic Hartt's *Art,* vol. 2, London, Thames & Hudson, 1977, p. 261.
[15] H. van de Waal (Heckscher [504]; English version, 'The Syndics and their legend' in his *Steps towards Rembrandt,* Amsterdam, North-Holland, 1974, pp. 247–292) challenged this kind of "frozen moment" interpretation with provocative arguments that are here discounted.

several points".[16] It seems unlikely that such a purely formal gesture could have had such a mesmeric effect on Mathys Calkoen. Hence the attraction of the rival interpretation which appears to have held the field long before the one just described: namely, the idea that Tulp's gesture was an illustration in the living limb of the function of the muscles and tendons being demonstrated in the dead one.[17] This idea deserves closer examination than it has received.

Dr. Tulp's gesture illustrates two anatomical points. His fingers are sharply flexed at each proximal interphalangeal joint, while the whole hand, to judge from the shading of the cuff, is slightly dorsiflexed (or "extended") at the wrist. Since the sharp palmar flexion of the fingers tends to induce the dorsiflexion of the wrist automatically as a synergic action,[18] the latter can probably be discounted as being merely incidental on the finger-flexion, which is therefore the object of the demonstration. There is an anomaly in the portrayal of the fingers: when they are so flexed at the proximal interphalangeal joint, they are normally also flexed at the terminal, but here only the proximal joint is flexed. Such things do occur abnormally in nature,[19] but considering how many opportunities for distortion the painter has at his command,[20] we should *prima facie* attribute any variations to Rembrandt rather than to his model. Rembrandt, therefore, by declining to shade the tips of Tulp's fingers, has divided the chiaroscuro cleanly between the shaded proximal phalanges, and the bright, middle and unguinal phalanges. The effect of this simplification is to emphasize the rigidity of the praelector's fingers.[21] Hence, if Dr. Tulp's gesture illustrates his dissection, he should be dissecting those muscles and tendons in the forearm which flex the fingers: *m. flexor digitorum superficialis* (or *sublimis*) and *m. flexor digitorum profundus*, and the tendons that issue from them to the fingers.

. Unfortunately, the interpretation of the dissection has long been a subject of dispute, and the most recent contributors to the debate have not even considered this identification of the muscles.[22] Nevertheless, there are many independent arguments in its favour. Since the tendons which are visible in the fingers of the corpse have always been interpreted as the tendons which should emanate from precisely these two flexor

[16] The interpretations of, respectively: Riegl (Heckscher [398] text vol. p. 182); R. H. Fuchs, *Rembrandt en Amsterdam,* Rotterdam, Lemniscaat, 1968, p. 25; Heckscher p. 40; *Mauritshuis* p. 100 (slightly emended) and n. 43. The Latin words are quoted from J. Bulwer, *Chironomia or the arte of manuall rhetorique,* London, 1664, f.p. 94: after Bulwer's first illustration, "A. Audientiam facit" follows "B. Quibus dein orditur" ("with which he then begins"). Engraved i is often undotted, whence the false reading *quibusdem* in *Mauritshuis,* loc. cit.

[17] Probably "W. Burger" (Heckscher [77]) had this idea in mind in 1858 when he wrote of Tulp's "geste explicatif" (p. 193), "geste de démonstration" (p. 204). Paul Triaire in 1887 (Heckscher [474] p. 33) also called it a "geste de démonstration", and several later writers took the same line, such as Hofstede de Groot (Heckscher [229] pp. 387–8, "eine erklärende Gebärde") and H. Gerson, *Rembrandt: paintings,* London, Phaidon, 1968, p. 50, although many others rejected it, including those cited in note 16 above.

[18] F. Wood Jones, *The principles of anatomy as seen in the hand,* 2nd ed., London, Baillière, Tindall & Cox, 1941, pp. 231–232.

[19] A. Vesalius, *De humani corporis fabrica,* Basle, 1543, p. 124.

[20] As shown, for example, by the different lengths of the cadaver's right and left limbs in Rembrandt's painting.

[21] Hence the "wooden" effect noted by Gerson, loc. cit., note 17 above.

[22] See Appendix I, pp. 52–54 below.

muscles, the simplest interpretation of the two muscles being demonstrated is to identify them as the muscles which issue those tendons. As argued in Appendix I below, this interpretation is sound anatomically, provided one accepts a certain view (also the simplest) of the orientation of the limb.

According to this interpretation, the muscle Dr. Tulp holds in his forceps is *m. flexor digitorum superficialis,* while *m. flexor digitorum profundus* is the long straight muscle running underneath it (Pl. 9). By lifting the *superficialis* away from the *profundus,* he reveals the way in which the two muscles combine their strength to flex the fingers. Hence the action of Tulp's left hand does illustrate the function of the muscles which he has chosen to display in the corpse. Moreover, this interpretation explains Mathys Calkoen's eagerness, for the mere topographical anatomy of this process is a thrilling drama composed of the three classical constituents, complication, reversal, and resolution. The two muscles originate from the same place on the inside of the elbow joint, but they soon wander apart. Just before they reach the end of their course, their tendons re-converge, and the one runs clean through the other (Pls. 9, 13; Figs. 2, 3) so that the upper (*superficialis*) becomes the lower, and the lower (*profundus*) the upper: a double peripeteia. In the dénouement, the two tendons find separate resting-places on the phalanges (Pl. 13; Fig. 3). But topographical description, however remarkable, is only a prelude to functional demonstration; or, to speak in terms familiar to Tulp, *situs, numerus,* and *figura* lead into *actio* and *usus.* In order to demonstrate the function of these muscles and tendons, the lecturer, we imagine, solemnly raises his free hand, and of a sudden flexes the fingers rigid, so instantly catching the eye of Mathys Calkoen. The fascination on Calkoen's face is designed precisely to show that Dr. Tulp's gesture is something more than an "*allocutio*-gesture".[23] We may therefore say that Calkoen also has a historical role in the picture.

4. NICOLAES TULP

We have already reconstructed part of Nicolaes Tulp's role in the painting from the actions of his right and left hands, but more important still are the thoughts that give his face its meditative expression, and the words that fall from his open lips. These remain to be recovered. Fortunately they are still not quite beyond recall, but they can only be brought back to us through a study of the influences which shaped Nicolaes Tulp as an anatomist and as an Amsterdamer.

Two anatomists have already been proposed as Tulp's immediate models: Casserius and Vesalius.

(i) Julius Casserius of Piacenza (1552?–1616) was professor of anatomy at Padua. At his death in 1616, he left a set of unpublished anatomical illustrations without any text. His successor at Padua was Adrianus Spigelius of Brussels, who, on *his* death in 1625, left an unpublished anatomical text without any illustrations. The two works,

[23] As Heckscher called it (pp. 33, 117). A selection of *allocutio*-gestures is reproduced in E. Panofsky's *Problems in Titian, mostly iconographic,* London, Phaidon, 1969, pls. 83–88. Tulp's gesture is quite different.

though not intended to complement each other, were published together in Venice in 1627 as one doubly posthumous edition.[24] In that edition, the second figure of Casserius's plate XXII (our Fig. 2, p. 10) shows the flexor muscles of the hand, and the belly of *m. flexor digitorum superficialis* is artificially pulled away from *m. flexor digitorum profundus*, as in Rembrandt's painting. It has therefore been suggested that Nicolaes Tulp modelled his dissection on Casserius's.[25] It has been further proposed that the Casserian plate was followed not only by Tulp in his dissection, but also by Rembrandt in his painting of the dissection, on the ground that both pictures are said to show the same anatomical anomalies.[26] We shall examine these proposals in detail later (pp. 13–16 below).

(ii) Andreas Vesalius (1514–1564) is believed to have determined Tulp's choice of pose through the woodcut portrait of himself, dated 1542, which Vesalius prefixed to his *Fabrica* and other books (Pl. 10). In the woodcut, Vesalius is shown demonstrating the flexor-muscles and -tendons of the fingers, as Tulp is in Rembrandt's painting: the muscle-belly which Vesalius offers in his right hand to the viewer is the same, *m. flexor digitorum superficialis*, as that which Nicolaes Tulp, with *his* right hand, holds up for the Amsterdam surgeons to see. Both are demonstrating the divergence and eventual convergence of the finger-flexors. The resemblance between the two pictures has been interpreted as a comparison on Tulp's part between Vesalius and himself, showing Tulp to be "the 'Vesalius redivivus' of the seventeenth century".[27] Again, this suggestion will be further examined below (pp. 16–20).

However, these two anatomists were not the only sources of Dr. Tulp's anatomical knowledge, and before we test their influence on him, some of the others whom he knew should also be mentioned.

(iii) One anatomist who was especially esteemed by Tulp and his contemporaries was Andreas Laurentius or Dulaurens (1558–1609). Laurentius was appointed professor of anatomy at Montpellier in 1586. In 1598, he moved to Paris, and eventually became physician to Marie de Médicis and Henri IV. He wrote several books, on anatomy and medical subjects, which were republished many times up to 1778.[28] The following sources, among others, indicate his reputation in the first half of the seventeenth century.

First, in 1637, Dr. Johannes Antonides van der Linden, then an examiner for the

[24] Daniel Bucretius (editor), *Adriani Spigelii . . . de humani corporis fabrica libri decem, tabulis XCIIX . . . exornati*, Venice, 1627. The *tabulae XCIIX* are in the second part, which has its own title-page: *Iulii Casserii . . . tabulae anatomicae LXXIIX . . . Daniel Bucretius XX quae deerant suppleuit et omnium explicationes addidit*. The numbering of the plates seems to include the title-page.

[25] C. E. Kellett, 'The anatomy lesson of Dr. Tulp', *Burlington Magazine*, 1959, **101**: 150–152.

[26] A. Querido, 'De anatomie van de anatomische les', *Oud Holland*, 1967, **82**: 128–136.

[27] Heckscher pp. 65–76, followed in *Mauritshuis* pp. 100–101, and by many other writers. Tulp possessed the Dutch translation of Vesalius's *Epitome* with Vesalian and Valverdian plates engraved by Pieter Huys, Antwerp, 1568. The copy in Utrecht University Library (shelfmark: *M fol 118 rariora*) bears the inscription "Nicolai Tulpii" on the blank page facing the title-page, as was noted by F. de Feyfer in *Janus*, 1914, **19**: 467. This edition lacks the Vesalius portrait, however.

[28] *L'anatomie universelle . . . par A. du Laurent*, Paris, 1778. There may be still later editions.

9

Figure 2. Francesco Valesio, flexor-muscles and -tendons of the forearm, engraving after a drawing by Odoardo Fialetti, *c.* 1600/1616, after dissections by Julius Casserius for his *Tabulae anatomicae*, Venice, 1627, tab. XXII, fig. 2, this impression printed from the original copper in 1645 for the Amsterdam edition. *The muscle* flexor digitorum superficialis *(BMB) is divided at aaaa into four tendons which cre perforated at CCCC and penetrated by the four lower tendons which issue from the* flexor digitorum profundus *(D).*

Amsterdam college of physicians, and later to be the subject of one of Rembrandt's last etchings (Pl. 12), published a guide to medical literature which was addressed to Pieter Tulp, Nicolaes Tulp's son and a recently qualified doctor of medicine at Leiden.[29] This work, which contains eloquent tributes to the author's colleague Nicolaes Tulp, was re-edited in 1639 by Dr. Vopiscus Fortunatus Plemp, another Amsterdam physician who, since 1633–4, had occupied the chair of medicine at Louvain.[30] Plemp had attended Nicolaes Tulp's public anatomy of 1632, as Rembrandt may have done, and also that of 1638.[31] The choice of anatomy-books which van der Linden recommended to Pieter Tulp was unchanged in Plemp's edition. Considering the closeness and like-mindedness of these three physicians, one would provisionally expect the same choice of anatomy-books to agree with Nicolaes Tulp's own preferences.

The anatomy-books which van der Linden recommended, with Plemp's endorsement, were: the *Historia anatomica* of Laurentius, which was first published in 1589; the *Theatrum anatomicum* of the Basle anatomist Caspar Bauhin (Frankfurt a. M. 1605 and 1621); and the already mentioned *De humani corporis fabrica* of Casserius and Spigelius (Venice 1627). Pride of place, in the judgment of van der Linden and Plemp, should be given to Laurentius, who was said to surpass the others by his methodical organization, clarity, completeness, and care in discussing "controversial, doubtful, and obscure subjects". "Therefore", Pieter Tulp was advised,

> you should start with him [Laurentius], and he should be read through with full attention at least three times: the first time for the bare account of the parts; the second time the same, but comparing it with his plates or – better still – with the very accurate plates of Casserius; and the third time, so that it might stick more firmly in your mind, repeat the second reading [of Laurentius] but link his appendices on problems with their chapters in the text.[32]

Bauhin and Casserius-Spigelius were to be studied outside the anatomy-theatre in order to improve the student's understanding of parts already seen in the cadaver. Bauhin was also to be consulted during the dissection of parts not dealt with in detail by either of the others.

[29] J. A. van der Linden, *De scriptis medicis, libri duo. Quibus praemittitur ad D. Petrum Tulpium manuductio ad medicinam*, Amsterdam, 1637. Van der Linden is mentioned by Nicolaes Tulp (1652), IV, c. 45, p. 371. On van der Linden's career: J. Banga, *Geschiedenis van de geneeskunde en van hare beoefenaren in Nederland*, Schiedam, Interbook, 1975 (facsim. of 1868 ed.), pp. 401–406.

[30] J. A. van der Linden, *Manuductio ad medicinam*, 2nd ed. by V. F. Plemp, Louvain, 1639.

[31] V. F. Plempius, *Fundamenta medicinae*, 3rd ed., Louvain, 1654, II, sectio 5, cap. viii, p. 141. V. F. Plemp dedicated a vernacular anatomy-book to Tulp (cited *Mauritshuis* p. 111), and Tulp called Plemp "a man with a deservedly great reputation": Tulp (1641), I, c. 28, p. 60. On V. F. Plemp's career see Banga, op. cit., note 29 above, pp. 278–286. He is not to be confused (as e.g. by Heckscher, p. 151) with his brother C. G. Plemp, who accused Nicolaes Tulp of avarice (E. H. M. Thijssen, *Nicolaas Tulp als geneeskundige geschetst*, Amsterdam, 1881, pp. 3–4).

[32] van der Linden, op. cit., note 29 above, fol. *5^{r-v}, "In *Anatomica* non unus adeundus: pauci tamen. Et qui? me auctore, *Laurentius, Spigelius, Bauhinus* . . . Atque in his *Laurentius* primus primas teneat. Methodus ei facilis, perspicua, et ad discendum apud quem aptior? Apud quem tam absoluta? Iam controversa, dubia, obscura, quis diligentius tractauit? Quis explicuit melius quam meus anatomicus? *Laurentium* intellego; et praepono (nec impono: quia ex animo ita sentio) omnibus qui eamdem Spartam ornarunt. Igitur auspicato sumatur ab hoc initium, et cum omni studio perlegatur minimum ter. Semel nuda partium historia; iterum illa, sed cum auctoris aut, quod malim, *Casserii* accuratissimis tabulis conferenda; quae, ut firmius haereat, denuo iteretur, et suis quaeque capitibus quaestionum commentaria subnectantur." Repr. in 2nd ed., op. cit., note 30 above, pp. 23–24.

Second, there is a remark published by the anatomist Jean Riolan the younger in 1649. Riolan also coupled the names of Laurentius and Bauhin, not inaptly since their books share a certain likeness due to the fact that each had revised his successive editions in the light of the revisions of the other's. Riolan said,

> Laurentius and Bauhin are judged by all to be the most outstanding and skilful in the art of anatomy, and their works are lauded as being the most perfect and most accomplished, and are preferred to the others. For in this century the purest and truest anatomical science is sought from these two, because they wrote last, instructed by their own observations and thoughts, and also helped by the teachings of their predecessors. So ... in anatomical controversies they are cited and adduced as if they were, in anatomy, the supreme justices and referees from whom no appeal to others is allowed.[33]

Third, William Harvey, Tulp's counterpart as *praelector anatomiae* to the London surgeons, frequently cited Laurentius in the notes for his praelection of 1616.[34] Chapter I of Harvey's *De motu cordis* (1628) opens with a paragraph derived from Laurentius's 'Quaestio de motu cordis', one of the "appendices on problems" which were recommended to Pieter Tulp by van der Linden and Plemp.[35]

Among other evidence, one can state that Laurentius's *Historia anatomica* was regarded as a standard work in universities from Italy to Scotland.[36] A copy of it is depicted in a Dutch *vanitas* still-life.[37] Parts of it were translated from Latin into Dutch in 1634.[38] But most important for our purpose is the fact that Nicolaes Tulp himself stated in print that he had used the plates in Laurentius's book as a "most trustworthy" control for his own findings in the course of dissection.[39] Laurentius's influence on Tulp is therefore likely to have been important.

(iv) In the case-book which Tulp first published in 1641 under the title *Observationum*

[33] Johannes Riolanus, *Animadversiones in theatrum anatomicum Caspari Bauhini,* printed in his *Opuscula anatomica nova,* London, 1649, p. 255, "... cum *Laurentius* et *Bauhinus* in arte anatomica praestantissimi et peritissimi judicentur ab omnibus, eorumque opera tanquam perfectissima suisque numeris absolutissima laudentur, caeterisque praeferantur: nam hoc saeculo ab his duobus, purissima et uerissima petitur scientia anatomica, quoniam postremi scripsere, suis propriis observationibus et cogitationibus instructi atque aliorum praecedentium documentis adjuti. Propterea . . . in rerum anatomicarum controversiis definiendis citantur et producuntur uelut judices et arbitri supremi rei anatomicae, a quibus ad alios prouocare non licet."

[34] *The anatomical lectures of William Harvey . . .,* ed. and transl. by G. Whitteridge, Edinburgh, Livingstone, 1964.

[35] W. Harvey, *An anatomical disputation . . .,* transl. and comm. by G. Whitteridge, Oxford, Blackwell Scientific Publications, 1976, p. 31, quoting from A. Laurentius, *Historia anatomica,* Frankfurt a. M., 1600, p. 352.

[36] An Italian medical professor in the 1630s or '40s told his students "Si quis uestrum plenissimam et elegantissimam desideret humanorum corporum dignitatis enarrationem consulat *Laurentium* libro primo anathomes capitulo secundo qui disertissime omnium anathomicam rem agit", and made many other references to Laurentius (lecture notes in the Wellcome Institute, western MS 488, disputatio II, fol. 1ᵛ). Lectures on Laurentius were given at Edinburgh in 1661, as recorded by A. Cunningham, 'The kinds of anatomy', *Med. Hist.,* 1975, **19**: 1–19, p. 8 and p. 16 n. 52.

[37] W. Artelt (Heckscher [18] p. 1638) with an attribution to Dou. W. Martin, *Gerard Dou,* Stuttgart, Deutsche Verlags-Anstalt, 1913 (*Klassiker der Kunst*) p. XXI as in the manner of Vermeulen or Collyer.

[38] In J. van der Gracht, *Anatomie der wtterlicke deelen van het menschelick lichaem,* the Hague, 1634.

[39] Tulp (1641), I, c. 27, p. 57: near the sacrum of a dissected cadaver he failed to find "pilosa illa filamenta quae depingit Andraeas Laurentius, scriptor alioqui minime infidus". This plate by Laurentius would seem to be that on p. 179 of his Frankfurt 1599 edition, which shows the "horse's tail" effect produced only when a detached spinal cord is soaked in water.

medicarum libri, he showed that he had consulted not only the works of Laurentius and the Casserius-Spigelius book, but also the anatomical works of Caspar Bauhin, Volcher Coiter, Realdus Columbus, Fabricius ab Aquapendente, and others.[40]

(v) Jean Riolan the younger (1580–1657) is also a possible influence on Tulp, since he too is cited in Tulp's book.[41] Furthermore, Tulp's most quoted phrase, "Anatome verus medicinae oculus", appears to be taken without acknowledgement from Riolan's *Anthropographia* of 1626.[42]

(vi) Last, one cannot rule out the possible influence of Pieter Paaw (1564–1617). Paaw initiated the study of anatomy at Leiden, was professor of anatomy while Tulp was a student there, and presided at the delivery of Tulp's doctoral thesis in 1614.[43]

Our list of possible influences on Tulp now contains: Casserius and Spigelius, Vesalius, Laurentius, Bauhin, Coiter, Columbus, Fabricius ab Aquapendente, the younger Riolan, and Paaw. That this list is unexceptional is shown by the fact that substantially the same authorities were used by the London praelector of anatomy, William Harvey.[44] But how, if at all, did these anatomists transfuse their influence through Nicolaes Tulp into Rembrandt's painting? We examine them one by one, returning to the beginning of the list with the book by Casserius and Spigelius.

(i) The possible link between Tulp and Casserius has already been briefly stated.[45] It seems to have several defects. It is incompatible with the Vesalian explanation, while unlike the latter it does not explain why, if Tulp did copy one of Casserius's seventy-seven plates, he chose the plate showing the antebrachial musculature (Casserius's plate XXII). But it is not obvious that Tulp did imitate the Casserian dissection. The distinction between the deep and the superficial finger-flexors had been discussed by virtually all writers on general anatomy, and Casserius's dissection is entirely traditional. His plate XXII, fig. ii (our Fig. 2) shows an early stage in a dissection which Vesalius (Pls. 10, 11) and Vidius[46] had already chosen to illustrate at the next, more revealing stage, in which the origin of the *flexor superficialis* is cut and the belly retracted towards the viewer. These illustrations had been republished in the works of

[40] Tulp (1641), I, c. 27, p. 56 (Bauhin); III, c. 5, p. 191 (Bauhin and Coiter); II, c. 28, pp. 144 (Spigelius) and 145 (Columbus); II, c. 29, pp. 145–6 (Fabricius ab Aquapendente).

[41] Tulp (1652) IV, c. 44, p. 369.

[42] Riolan, *Anthropographia et osteologia,* Paris, 1626, p. 26, "dicere soleo Anatomen esse Medicinae oculum, quo quid agendum, quid vitandum admonemur atque pervidemvs." Cf. Tulp (1641) fols. *2ᵛ–3ʳ, "Anatome, verus medicinae oculus. Cuius lumine, ut irradiantur intima corporis penetralia, sic producuntur eiusdem beneficio quasi in claram lucem abditissimae occultorum morborum caussae: vera mehercule fulcra ac genuina artis medicae stabilimenta." and Tulp (1652), IV, c. 43, p. 367, "post ipsius obitum, omnium oculis exposuit anatome, verus medicinae oculus.", in which "ipsius" is the wife of Rembrandt's former pupil Govaert Flinck. Cf. p. 21 below.

[43] Thijssen, op. cit., note 31 above, p. 2. Paaw is mentioned by Tulp (1641), II, c. 13, p. 120. On Tulp as a student of Paaw see Beverwijck, p. 78 below.

[44] Whitteridge, op. cit., note 34 above, pp. xiv–xviii.

[45] p. 9 above.

[46] Vidus Vidius (Guido Guidi), *De anatome corporis humani libri VII,* Venice, 1611 (published as vol. 3 of his *Ars medicinalis*), p. 195.

Valverde,[47] Bauhin,[48] and Laurentius.[49] Casserius's next plate (his pl. XXIII fig. i) shows precisely this next stage, of which the stage illustrated by Tulp is the logical precursor. The observed resemblance between the demonstrations of Casserius and of Tulp may owe less to cause and effect than to common practice which both record.

The further idea that Rembrandt copied the Casserian engraving is also open to doubt. The first of the anomalies which are claimed to prove the relationship is that the flexor-muscles in each picture originate not in their normal place, the medial epicondyle, but at a point far lateral to it.[50] This certainly appears to be true of Casserius's plate (Fig. 2) in which the medial epicondyle, an important bony landmark near the letter Æ, is made conspicuous by being stripped of the fascia which normally obscures it. To accommodate this lesson, the origin of the flexor-muscles is inaccurately removed to one side. Rembrandt, however, could not have made this dubious concession, for in his painting neither the medial epicondyle nor the origin of the muscles has even been uncovered. What in the painting was formally identified with the medial epicondyle has now been shown to be merely a strip of tendon from the upper arm.[51]

The second anomaly which is said to be shared by Casserius and Rembrandt is their common failure to show the parasagittal (or, on the canvas, vertical) stratification of the flexor-tendons as they leave the belly of *m. flexor digitorum superficialis:* the tendons to the index and little fingers should dive out from underneath the tendons to the middle two fingers, but in both the painting (Pl. 9) and the engraving (Fig. 2, marked aaaa) they seem to be on a level.[52] However, this detail is significant only in morphology, and in 1632, when anatomists were more interested in teleology, it was still too trivial to find a place in the anatomical literature. Moreover, Galen had unwittingly diverted all anatomists' attention from it by remarking, correctly, that the coronal (or, on the canvas, horizontal) angle between each tendon and the next was equal; on their parasagittal relationship he said nothing, and anatomists influenced by him – such as Vesalius, Bauhin, Spigelius – were also silent.[53] The parasagittal stratification seems not to have been published at all until 1685, when it was recorded by, of all people, the painter Gérard de Lairesse in one of his incomparable caricatures for Bidloo's anatomy-book (Fig. 3, marked with arrows).[54] Hence this imprecision of Rembrandt's associates him not with Casserius specifically, but with all anatomists of the time.

[47] J. Valverde de Hamusco, *Historia de la composicion del cuerpo humano,* Rome, 1556, lib. II, plates V, VI, and with the same plate-numbers in the 1568 edition owned by Tulp, see note 27 above.

[48] C. Bauhin, *Vivae imagines partium corporis humani,* Frankfurt a. M., 1620, lib. IV, tab. ix.

[49] A. Laurentius, *Historia anatomica,* Frankfurt a. M., 1599, p. 185.

[50] Querido, op. cit., note 26 above, p. 135.

[51] See p. 53 below.

[52] First noticed by J. Meyer, in Cetto p. 309, accepted by A. Querido, and later endorsed by Doctors Carpentier Alting and Waterbolk, op. cit., note 206 below.

[53] Galen, *De usu partium* I, 18, ed. G. Helmreich, Amsterdam, A. M. Hakkert, 1968 (repr. of 1907–9 ed.), vol. 1, p. 46.

[54] G. Bidloo, *Anatomia humani corporis,* Amsterdam, 1685, tab. 67. Although this feature must have emerged in Bidloo's dissections, he did not think it worth mention in his text, presumably because he could see no significance in it. Gérard de Lairesse's contacts with, and opinions of, Rembrandt are summarized by Seymour Slive, *Rembrandt and his critics,* the Hague, M. Nijhoff, 1953, pp. 159–166.

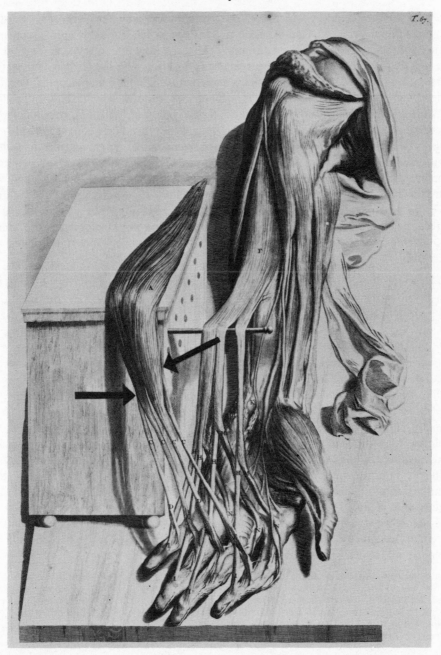

Figure 3. Pieter van Gunst (?), flexor-muscles and -tendons of the forearm, engraving, *c.* 1685, after a drawing by Gerard de Lairesse after dissections by Govaert Bidloo for his *Anatomia humani corporis*, Amsterdam, 1685, tab. 67. *The muscle* flexor digitorum superficialis *(A) is divided into four tendons (CCCC) which are perforated and penetrated by the four lower tendons (HHHH) which issue from the muscle* flexor digitorum profundus *(F). Arrows added on photograph mark the stratification of inner over outer superficial flexor tendons: contrast Fig. 2 at mark aaaa, and see p. 14.*

15

There is other evidence which confirms Rembrandt's independence of Casserius. Among other differences, Rembrandt includes items which Casserius omits, such as a terminal branch of the ulnar nerve running along the little finger, the skin clinging to the fingertips, and, of course, the realistic colouring. The two depictions of the perforation of the superficial flexor-tendons are also completely different: Casserius (Fig. 2, marked cccc) illustrates it as a loose loop through which the deep tendon meanders freely, while Rembrandt, like Leonardo da Vinci (Pl. 13), shows it more accurately as a taut sling which holds the deep tendon firmly on course towards the finger-tip (Pl. 9). There was no published woodcut or engraving from which Rembrandt's illustration could have been copied: he must have used a real limb, whether it was attached to a corpse or separated. But there is then no ground for introducing Casserius as his model. Indeed, if Tulp and Rembrandt had compared their finished picture with Casserius's equivalent engraving, they could only have agreed that their own work was far more accurate – whatever Doctors van der Linden and Plemp would tell the younger Tulp about the "very accurate plates of Casserius".[55]

(ii) *Vesalius.* It can hardly be a coincidence that both Vesalius and Tulp chose to be portrayed demonstrating the flexor-muscles of the fingers (Pls. 10, 2). But what did Tulp mean by modelling his portrait on Vesalius's? Heckscher interpreted the likeness as implying that Tulp was to be thought a "Vesalius redivivus",[56] but for several reasons this seems improbable. There is no evidence that either that sobriquet or a similar one was claimed for Nicolaes Tulp by himself, by his contemporaries, or in fact by anyone before Heckscher (1958). Moreover, it is inappropriate for Tulp, since unlike Vesalius he was not an anatomist. Although, like many qualified physicians of that time, he had a working knowledge of anatomy, he was, as Heckscher remarks, "finally and principally a general practitioner".[57] His part-time appointment as lecturer in anatomy to the company of surgeons could not have led even his most extravagant admirers to rank Nicolaes Tulp with Vesalius. We must look for a different interpretation of Tulp's use of the Vesalian motif: such as, that the demonstration of the flexor-muscles of the fingers was supposed by Nicolaes Tulp, rightly or wrongly, to bear the same meaning for both Vesalius and himself.

The renowned aesthetic beauty of this dissection cannot have escaped the attention of either Vesalius or Tulp. Vesalius had certainly impressed it on his students at Bologna in 1540: according to one of them[58] he demonstrated

> how the [tendons issuing from the] muscles are situated on top of each other in double formation, always four on four [cf. Fig. 3]; and how the lower ones extend to the first joints, and the upper ones to the second and third, in each finger perforating the lower tendons. This was certainly a most beautiful sight. And he showed how a kind of special membrane covered those tendons, which he then separated and followed right up to the joints of the fingers. "On these", he said, "read Galen: *On the use of parts* books I and II, *On the procedures of dissection* book I, and *On muscles*".[59]

[55] Quoted on p. 11 above.

[56] See n. 27 above.

[57] Heckscher p. 75.

[58] Baldasar Heseler, whose notes were published by R. Eriksson, *Andreas Vesalius' first public anatomy at Bologna 1540*, Uppsala, Almqvist & Wiksell, 1959.

But the aesthetic aspect merely reflects a system of ideas about these tendons, which Vesalius's students could not have failed to encounter if they followed up their lecturer's reading-list. For Vesalius's recommendations remind us that our list of influential anatomists (p. 13 above) omitted the two most influential figures in early seventeenth-century anatomy: Aristotle, and his follower in many matters, Galen. Bauhin's *Theatrum anatomicum* (1621) cites Aristotle and Galen more than any other authorities, and many of Laurentius's appendices on "controversial, doubtful, and obscure subjects", which were admired by van der Linden and Plemp,[60] were intended to vindicate Galen against his "neoteric calumniators", Vesalius and Realdus Columbus.[61] Could not the link between Vesalius and Tulp be their common acceptance of the Galenic view, derived from Aristotle, of the hand, the fingers, and the flexor-tendons?

According to a view which was discussed by Anaxagoras, recorded by Aristotle, and elaborated by Galen, the human hand was not a specialist instrument like the claws of the predator or the hooves of the herbivore, but an instrument at a higher level, an instrument for using other instruments, each for a different purpose. In this respect the human hand was the physical counterpart of the human psyche, which, by performing rational thought over an unrestricted range of subjects, was also an instrument for using further instruments. It was this instrumental application of both reason and the hand that had created human civilization and so raised man above the beasts: among other achievements, man alone tamed animals of superior bodily strength and speed, built places of worship, played musical instruments, and recorded thoughts in writing. The faculty by which the hand controlled its subservient instruments was prehension; the hand was therefore "the prehensile organ" ($\H{o}\rho\gamma\alpha\nu\sigma\nu$ $\grave{\alpha}\nu\tau\iota\lambda\eta\pi\tau\iota\kappa\grave{o}\nu$) and its primary part was its prehensile element, the flexor-muscles and -tendons of the fingers. These muscles and tendons therefore had this first importance: that they, together with reason, the divine part of man, acted as the organ of civilization.[62]

But they were also important for a second and intrinsic property: their design was found to be uncannily sophisticated. The intersection of the flexor-tendons was particularly admired for its mechanical artistry. In the argument that all the parts of the body declared the wisdom and goodness of God in the creation of man, the construction of the human hand was one of the classic examples which could not be gainsaid.[63]

[59] Ibid., p. 96, "ostendit . . . quomodo duplici situ musculi super se situati sint quattuor semper super quattuor, et quomodo inferiores tenderent ad primos articulos: superiores autem ad secundos et tertios perforantes semper primos. Certe, hoc erat pulcherrimum uidere. Et quomodo isti tendines simul tecti erant quadam speciali pellicula, quos deinde separabat, et usque ad articulos digitorum perducebat. 'De his' inquit 'legatis Galeni 1. et 2. lib. de usu partium et 1. de administr. anath. Et de musculis membrorum'." In Heseler's nomenclature the "upper" tendon is that of the *flexor profundus*, the "lower" that of the *flexor superficialis*, both being named here from their relative positions *after* they have changed places in the perforation. This could be regarded as the obvious way of naming them from the point of view of a student standing near the feet of the cadaver.

[60] See p. 11 above.

[61] A. Laurentius, *Historia anatomica*, Frankfurt a. M., 1599, lib. II, p. 66, and elsewhere.

[62] Appendix II nos. **1–2**, pp. 57–58 below.

[63] See Appendix II below, *passim*.

Vesalius's reading list for his students, quoted above, would have exposed them to Galen's interminable variations on this subject. Having launched the theme in books I and II of *On the use of parts*, Galen brought it home in the last book (XVII) with the conclusion: "To a genuine investigator of Nature's works, the sight of the undissected arm alone is enough [to arouse admiration] . . . but even an enemy of Nature's, especially if he gazes on the art displayed in its inward parts as I explained it in books I and II, will lie awake at night if he seeks to find something to disparage among the things he has seen."[64] And of the tendons that flex the fingers: "their insertions in the bones and their relations with each other are amazing and indescribable. No words can anyway explain accurately things perceived through the senses alone. Yet one must try to describe them, for until their construction has been explained it is not possible to admire Nature's artistry [as it deserves]".[65]

The flourishing state of Galenic studies in the early sixteenth century made these ideas more familiar then than ever before. In 1536, the anatomist Niccolò Massa wrote: "the composition of the hand and of the instruments [muscles and tendons] which move it is a most beautiful sight which arouses the greatest praise of the good Lord."[66] On the combination of the superficial and deep flexor tendons of the fingers, Vesalius himself wrote with Galenic fervour that it was "a peculiar and rare occurrence . . . due to the marvellous labour of the supreme Creator of the world."[67] It is this miracle of anatomy that Vesalius demonstrates in the woodcut frontispiece to the *Fabrica* (Pl. 10).

It would be too easy to conclude that Vesalius's portrait was intended to show him revealing God's "marvellous labour" in the creation of the human hand. This interpretation could be supported on the ground that portrait-attributes were often selected to illustrate the sitter's piety, but it cannot be said to reflect an anatomical argument congenial to Vesalius. At this time (1542) Vesalius was fiercely obsessed with two ideas about anatomy. He supported the gathering of new facts as against the interpretation of established ones, and the dissection of human as against simian cadavers. These views were stated forcefully and frequently in Vesalius's preface and throughout his text. By comparison, the Galenic lessons of the philosophical and religious value of anatomy received little attention from Vesalius. Therefore, although the words on the hand which we have cited from Galen, Massa, and Vesalius suggest that the finger-flexor motif was able to serve as an illustration of the providence of the Creator, one may doubt whether Vesalius originally intended it to bear that meaning in his portrait, especially since it can be interpreted in other ways. Vesalius's dissection of the human hand and fingers does illustrate his two cardinal ideas about anatomy, and either its elegance or its difficulty alone could also have justified his choice of this dissection as his attribute.

When we look at the portrait through the eyes of Vesalius's contemporaries and followers, however, we see it in a different light, for few if any of them shared his lukewarm attitude to the use of anatomy in the Argument from Design. Their position

[64] Galen, *De usu partium* XVII, 1, op. cit., note 53 above, vol. 2, pp. 442–443.
[65] Ibid., I, 17, vol. 1, p. 42.
[66] Appendix II no. **3**, p. 58 below.
[67] Appendix II no. **4**, p. 59 below.

is epitomized in Abel Stimmer's engraved portrait of the Basle anatomist Felix Platter, dated 1578 (Pl. 14). Platter holds a tome inscribed "VESAL.", while the legend beneath declares "COMPAGO MIRA CORPORIS NOSTRI DEI MIRACVLVM EST SOLERTIAE".[68] For Platter and other admirers of Vesalius, to demonstrate the providence of the Creator was one of the main purposes of anatomy. Since Galen had proclaimed, with a certain prolixity,[69] that the human hand provided irrefutable evidence for precisely this argument, it was the hand, and especially its primary part the finger-flexors, which became in the sixteenth century one of the preferred organs to demonstrate God's manifestation in the human body.[70] In the words of the English *praelector anatomiae* John Banester, the hand was "so notably of the omnipotent Creator created, as that . . . no member more declareth the unspeakable power of almighty God in the creatyng of man."[71] Surely Banester and Platter would have interpreted the hand motif in Vesalius's portrait in this sense.

It is surely in this sense also that we should understand the allegorical design which the surgeon-anatomist Fabricius ab Aquapendente (1533–1619) used on the title-pages of his anatomical works published around 1600.[72] A figure personifying surgery (Fig. 4, right) is identified as such from the three surgical instruments in her care, and the figure personifying anatomy (Fig. 4, left) displays as her attribute the flexor-

Figure 4. Giacomo Valesio, "Anatomia" and "Chirurgia", detail of engraving for Hieronymus Fabricius ab Aquapendente, *De visione voce auditu*, Venice 1600, title-page. *The distinguishing attribute of Anatomia is her differentiation between* m. flexor digitorum superficialis *and* m. flexor digitorum profundus.

[68] "The marvellous construction of the human body is a miracle of the ingenuity of God".

[69] As Jessenius, *Universalis humani corporis contemplatio,* Wittenberg, 1598, c. XXVIII, fol. C4r, complained, "Quinque horum digitorum, sive processuum singulorum utilitatem I de usu part. Gal. prolixe exaggerat, ad quem lectorem remittimus."

[70] The anatomy of the eye was the favourite proof of this point, but it was on too small a scale to be demonstrated in a portrait, unlike the anatomy of the hand.

[71] J. Banester, cited in Appendix II no. **9**, p. 61 below.

muscles and -tendons of the fingers. In her right hand she holds *m. flexor digitorum profundus,* while *m. flexor digitorum superficialis* floats out towards the viewer. This is the same dissection as in the portraits of Vesalius (Pl. 10) and Tulp (Pls. 2, 9), and the fact that here Anatomia herself displays it refutes the idea that the demonstration of these tendons need imply homage to, or rivalry of, Vesalius.[73] Instead, it implies that, if anatomy in general was, in the Galenic metaphor, "a hymn of praise to the gods", the anatomy of the finger-flexors served as its first, most eloquent, and representative part.

(iii) Laurentius. Of all the later sixteenth-century anatomists it was Laurentius who produced the amplest encomium of the hand, in his chapter *de praestantia manus.*[74] Not only Aristotle and Galen but also Cicero and Quintilian were here ransacked to show that the hand was "the most noble and perfect organ of the body", and therefore one of the outstanding "doctors and teachers of divine wisdom". Laurentius did not fail to note the "marvellous artistry" with which Nature perforated the tendons of the *flexor superficialis* in order to provide the tendons of the *flexor profundus* with a passage to the distal phalanges, precisely the point demonstrated in the Vesalius and Tulp portraits. Anyone who saw Vesalius's portrait through the eyes of a follower of Laurentius must have interpreted it as a demonstration, through anatomy, of the power, wisdom, and goodness of God.

(iv) As a reader and admirer of Laurentius alone, Tulp would seem likely to have interpreted the Vesalian dissection in that sense. But the other anatomists whose works he also read interpreted the dissection of the hand in the same way, using phrases derived from Aristotle and Galen. The views of Columbus, Coiter, and Bauhin are given in Appendix II below.[75] The fourth anatomist, Fabricius ab Aquapendente, did not complete his *magnum opus* in which he would have discussed the hand, but what he has left us, a pictorial allegory of Anatomy (Fig. 4), is probably to be interpreted in the same sense, as we have just suggested.

(v–vi) It is therefore no surprise to learn that the last two anatomists named above as having influenced Nicolaes Tulp – Riolan and Pieter Paaw – also eulogized the hand in the words of Aristotle, Galen, or both.[76] Paaw's writing on the hand is typical of his whole approach to anatomy. He had felt an inner drive to study it which he had not felt for his other responsibility, botany: this, he thought, was

[72] *De visione voce auditu,* Venice, 1600; also used with same date for *De formato foetu,* which, however, has a colophon dated 1604.

[73] The interpretation of Heckscher (pp. 73–74), who saw examples of *imitatio Vesalii* in the portraits of (1) Casserius (Heckscher pl. XVII-21; Cetto no. 251); (2) Leo Bontius (on whom see F. Bernardi, *Prospetto storico-critico dell' origine . . . del collegio medico-chirurgico . . . in Venezia,* Venice, 1797, pp. 53, 58) by Leandro Bassano, now in Schwerin (Heckscher pl. XV–19; Cetto no. 245); and (3) Volcher Coiter attributed to Nicolas Neufchâtel in Nuremberg (Cetto no. 244). The pose of the Bontius portrait by Bassano is obviously indebted to Vesalius, but whether this portrait or either of the others has any conceptual relationship with Vesalius is open to doubt.

[74] Appendix II nos. **11** and **14,** pp. 61, 62–63 below.

[75] nos. **7, 8,** and **12,** respectively.

[76] Appendix II nos. **13** and **16.**

either because I was touched by a kind of numinous quality in that divine temple [the human body]; or because man, for whose sake all other things were made, seemed to require more labour for his consideration; or because I judged that God himself intended greater, and more certain, evidence of His wisdom, power, and goodness, to appear in the formation of the human body than elsewhere.[77]

From the point of view of the anatomists who shaped Tulp's anatomical style, the most important of whom were probably Laurentius and Paaw, Tulp's action in Rembrandt's painting must therefore have been interpreted as a deliberate demonstration that anatomy was a path to the knowledge of God. Is this opinion of Nicolaes Tulp's mentors a reliable guide to his own intention in choosing the dissection shown in Rembrandt's picture?

We have little direct evidence of Tulp's views on anatomy. He published no book on the subject, for he was, as we have stated, a general practitioner, whose chief interest was what has become known as pathology. We should not be misled by the fact that Tulp's name for pathology was *anatome* in his Latin writings and *ontleding* in Dutch: when Tulp wrote of *anatome* that it was the "very eye of medicine"[78] and that it "brought forth the truth as it were out of the shadow into the light",[79] he was thinking not of anatomical science, nor of public anatomies on the undiseased cadavers of executed criminals,[80] but of a physician's dissections of his deceased patients, which (he hoped) would enable him to see, and not merely to guess, the causes of each symptom.[81]

But from Tulp's book on pathology we do have occasional glimpses of him at work in the anatomy-theatre. In one chapter he describes, as a prelude to a pathological case, the anatomical properties of the organ known as the ileo-caecal valve. We know that he lectured on this structure at his anatomy of 1632, and at several other anatomies in the 1630s.[82] The style of this anatomical passage is markedly different from the cool, "Hippocratic" tone of Tulp's writings on pathology. The parochial simile, the political analogy, the theological conclusion all suggest that here, for once, Tulp was writing not as Amsterdam's Hippocrates but as its Galen or Laurentius, that is, in the style, perhaps even the very words, which he used in his capacity as the city's *praelector anatomiae*. We must imagine Tulp holding up the ileo-caecal valve to the people of Amsterdam with the following explanation:[83]

[77] P. Paaw, *Primitiae anatomicae,* Leiden, 1615, fol. *2ᵛ, "neque diffiteor in hoc me genere laborasse impensius, sive quod religione quadam tangerer divini istius templi: sive quod homo, cuius causa facta sunt caetera omnia, plus mihi operae ad sui considerationem requirere videretur: sive quod iudicarem ipsum etiam Deum majora certioraque in corporis humani efformatione sapientiae suae, potentiae, & bonitatis voluisse quam in aliis apparere documenta."

[78] Tulp, loc. cit., note 42 above.

[79] Tulp (1652), IV, c. 36, p. 353, with similar remarks at: II, c. 43, p. 174 (p. 168 of 1641 edn.); IV, c. 12, p. 317; IV, c. 29, p. 341; IV, c. 43, p. 367.

[80] *Mauritshuis* p. 94.

[81] As the passages cited in notes 42, 79, above show.

[82] Plemp records the 1632 and 1638 demonstrations, loc. cit., note 31 above. Others are implied by Tulp's words, "aliquoties in theatro anatomico propalam ostensam": (1641), III, c. 21, p. 213.

[83] That Tulp held the "valve" up is inferred jointly from Plemp's objection to this practice, loc. cit., note 31 above, "Decet autem monstrare hanc valvulam intestinis naturaliter in corpore adhuc sitis; nam si exemta sint, posset auditoribus injici suspicio fraudis", and, if we can trust the evidence of Pl. 15, from the use of this method by Adriaen van Valckenburg, the contemporary professor of anatomy at Leiden.

If any chyme flows towards it from the ileum, [the valve] rises up and gives it free transit; and when the flow stops, it falls at once, expressly preventing any chyme from flowing back again from the colon or caecum into the ileum. It is exactly like our canal-locks in Holland: their sluices automatically open and close to an equal degree, and their double doors are so constructed that they open exactly as much in admitting the flow as they resist in pushing against it

O how lucky courtiers would be if they had such a guard [as the ileo-caecal valve] to keep from relapse the power which has flowed to them! Then they would certainly not fall so easily from the heights to the depths, nor would passing moments raise up and hurl down so frequently the achievement of slippery honour, and the confidence which depends on the might of another!

. . . If you are willing to examine [the valve] with care, you will surely penetrate the hidden nature of this mystery, and thus inevitably celebrate Divine Providence in these extraordinary monuments of His wisdom which God has so profusely established within us.[84]

On other occasions when Tulp approached anatomical or physiological topics, similar phrases came to his pen. The human body was the *nobilis humanae fabricae compages*,[85] it possessed an *incomprehensibilis consensus et admirabilis singularum partium inter se harmonia*,[86] this incomprehensible concord made manifest the *impervestigabilis Dei omnipotentis providentia*,[87] or the *impervestigabilis Dei omnipotentis sapientia*,[88] or the *impervestigabilis Dei potentia*,[89] and these manifestations of the inscrutable Deity showed man to be *homo animal perfectissimum*,[90] or *homo animal vere divinum*.[91] These passages seem to strengthen the hypothesis that Tulp's Laurentian treatment of the ileo-caecal valve was typical of his style in anatomy.

As further confirmation that Tulp's anatomies were designed to reveal the presence of God in man, there is Caspar Barlaeus's poem on the new anatomy-theatre at Amsterdam, which was inaugurated in 1639 when Tulp was still the praelector.[92] In the second half of the poem Barlaeus imagines himself to be attending one of Tulp's anatomies, and his final verse is a two-line summary of the lesson which Tulp intended the anatomy to impart.[93] The first line of the couplet will be discussed below, but the second line is relevant here: it is "Believe that God lies hidden in even the smallest part".[94]

[84]Tulp (1641), III, c. 21, pp. 214–9 "Si quid enim excretorum ab ileo effluit, attollit se, concedens illis liberum transitum; at cessante affluxu concidit ilico; impediens expresse, ne quid revertatur iterum a colo aut caeco ad ileum. Plane adinstar nostratium cataractarum, quarum repagula sponte non minus aperiuntur quam clauduntur. Quarumque bipatentes januae ita conformantur ut tantum pateant refluxui cedendo quantum renituntur fluxui obluctando . . . O fortunatos aulicos si tali, contra relapsum, custodia, firmaretur fluxa ipsorum potentia. Non deciderent certe tam facile a summis ad ima. Neque momentanea intervalla attollerent dejicerentque, tam frequenter idem, lubricae dignitatis fastigium, fiduciamque aliena vi innixam. siquidem lubet attente considerare, penetrabis procul dubio in absconditam huius arcani naturam. Et non poteris non celebrare divinam providentiam, et eximia illa sapientiae monumenta, quae in nobis profusissime constituit Deus."

[85] Tulp (1641), II, c. 6, p. 109.

[86] Ibid., I, c. 34, p. 68.

[87] Tulp (1652), IV, c. 54, p. 390.

[88] Ibid. IV, c. 35, p. 349.

[89] Tulp (1641), III, c. 29, p. 232.

[90] Ibid. I, c. 34, p. 68; Tulp (1652), IV, c. 9, p. 311.

[91] Ibid. III, c. 4, p. 188.

[92] The poem is more fully dealt with in Appendix IV, pp. 85–89 below.

[93] On this interpretation see pp. 88–89 below.

[94] "Crede vel in minima parte latere Deum".

If Dr. Nicolaes Tulp taught that even the ileo-caecal valve was one of the "monuments of God's wisdom", and that "even the smallest part [of the body]" revealed to the dissector the otherwise hidden presence of God, there can surely be no doubt that he intended the famous and exquisite intersection of the finger-flexors to carry the same meaning in Rembrandt's picture. Hence the words that we are to imagine coming from his open lips would be some such phrase as: "Behold the wisdom of almighty God which passeth all understanding". From his facial expression we are expected to understand that he is absorbed in the awesome mystery of God's self-revelation in human anatomy.

If we now ask again what historical significance there might be in Dr. Tulp's attitude in the picture, we gain an *argumentum ex consequentiis* which supports the interpretation that has just been proposed. For the three surgeons of the inner triangle, as we have observed, attend to Tulp's demonstration with such great interest that they look like novices learning the first steps in anatomy: hence the title "The anatomy lesson" which is colloquially often given to the picture.[95] But these three sitters were experienced surgeons who must have been attending anatomies since the time of Dr Egbertsz.'s praelectorate. Moreover, the surgeon who seems most absorbed in the "lesson", Mathys Calkoen (lower left of Tulp), must have been familiar with the subject of Tulp's demonstration, since we are told that on at least one occasion he prepared with scrupulous care a dissection of the forearm muscles of a cadaver to enable Nicolaes Tulp to lecture on them at one of Tulp's public anatomies.[96] The object of Calkoen's wonder therefore cannot be only the physical structure of the flexor-muscles, which he already knew: it must also be some other aspect of them which a surgeon of some standing would not mind being portrayed as not having known before. The metaphysical implications of the flexor-muscles fill precisely this role. Thus our interpretation matches together, in a plausible historical unity, the impressive solemnity of Nicolaes Tulp's attitude, and the eager responses of the attentive surgeons.

5. HARTMAN HARTMANSZ.

The next sitter is the surgeon on the left of Dr. Tulp in the back row, Hartman Hartmansz. (Pl. 1). As in the surgeon below him, Mathys Calkoen, his trunk and his head face in two different directions, Hartmansz.'s in a horizontal plane, Calkoen's in a vertical. Since Michaelangelo, this had been a standard device to suggest recent, rapid change of attention. Calkoen's pose implied that he had quickly jerked his head up from the dissection in order not to miss Tulp's dramatic demonstration. The object

[95] Any title would be anachronistic, but this one is misleading as well. "Anatomy lessons" (*lessen*) were given every Tuesday and Friday: they did not require the presence of a corpse. "Anatomies", or "anatomical praelections" (*Anatomie*), did require a corpse, and were held only a few times a year. See e.g. B.W. Th. Nuyens, *Het ontleedkundig onderwijs en de geschilderde anatomische lessen . . . 1550 tot 1798,* Amsterdam, van Kampen, [1927], p. 15. Rembrandt's picture alludes to the latter kind of occasion.

[96] See the quotation from J. J. van Meekeren, p. 55 below. In the Latin translation of van Meekeren's book, *Observationes medico-chirurgicae,* Amsterdam, 1682, by Abraham Blasius (Gerardi filius), the passage includes the words "in anatome aliqua publica ab *Amplissimo D. Nicolao Tulpio* in Theatro publico instituta . . ." (p. 308).

from which Hartmansz.'s attention has been suddenly diverted is an anatomy-book illustrated with Vesalian muscle-figures (Pls. 16, 11, 1).[97] Rembrandt alludes to these much-copied écorchés with no more than a rough sketch: it did not suit his purpose to suggest a particular book, edition, or plate. The point under discussion, the intersection of the finger-flexors, was as clearly illustrated in the beautiful engravings after Vesalius in Valverde's or Laurentius's anatomy-book as in Vesalius's original woodcuts.[98]

The presence of the book in Hartman Hartmansz.'s hands is a characteristic feature of real anatomies. Some members of the audience at a public anatomy, especially if they could not see the corpse, followed the praelector's lecture in illustrated anatomy-books which they brought with them to the theatre (cf. Pl. 17). By this means they could usually get as good an understanding of the anatomical argument as those who could see the corpse; often, indeed, a better understanding, when a complicated structure, obscure to the eye, had been illustrated diagrammatically. But when the topographical anatomy had been explained, and the praelector launched on his eloquent set-piece about its theological implications, there was nothing more to be learned from engravings, and all eyes would turn on the praelector to enjoy his rhetorical performance to the full.

This process provided Rembrandt with a pose for his portrait of Hartman Hartmansz. The image of Hartmansz., like that of Adriaen Slabberaen, was obliged to fill a space in such a position on the canvas that the dissection was not between him and the viewer. Hence, if he had been depicted looking at the dissection, his face would not have been visible and no portrait would have been possible. Therefore Rembrandt has provided for him, as for Slabberaen, a historical excuse for turning towards the picture plane without looking (attributively) at the viewer.

But what exactly is the portrait of Hartmansz. supposed to be looking at? It seems not impossible that he also may be looking at the gesture of Tulp's left hand. But it is perhaps more likely that we are meant to infer from his ruffled brow, divergent stare, and dropped jaw, that the startling implications of Dr. Tulp's demonstration are just dawning on the book-taught mind. While the novel thought sinks in, he forgets the book and gazes blindly into blank space. Through this response to the praelector's revelation, Hartmansz. also, the second of the three surgeons in the outer group, plays a historical, not an attributive, role in Rembrandt's pictorial drama.

6. JACOB BLOCK

Jacob Block is the surgeon to the left of Hartman Hartmansz. He forms the apex of

[97] Heckscher, pp. 67–70, identified this figure with the small woodcuts of the arm in Vesalius's *De humani corporis fabrica*, 2nd ed., Basle 1555, p. 259. But it looks to me much more like one of Vesalius's "dancing" écorchés (Pls. 16, 11), and I have reconstructed it thus in Pl. 1. This woodcut and the immediately following one in Vesalius both illustrate the particular structures being demonstrated by Tulp, unlike the figure adduced by Heckscher which illustrates muscle-fibre in general. A similar woodcut to that identified here was also included in the Miereveld anatomy-picture at Delft (Pl. 4), behind the skeleton in the top left corner, well illustrated by H. L Houtzager, *Medicyns, vroedwyfs en chirurgyns*, Amsterdam, Rodopi, 1979, p. 89.

[98] See notes 47, 49 above. Only the early Paris editions of Laurentius have engravings of artistic interest: the plates in the Frankfurt editions are hack-work copies.

the inner triangle of surgeons. Jantzen first suggested that his eyes were directed towards the folio volume "at the feet of the corpse", and most modern scholars have agreed.[99] However, if our relocation of the book closer to the picture-plane is accepted, this interpretation can no longer stand.[100] I suggest that Block is looking instead, like Calkoen and for the same reason, at the flexed fingers of Nicolaes Tulp's raised left hand. Therefore Block's pose also is historical and not attributive.

Only one sitter now remains to be considered: Frans van Loenen, the hatted figure at the peak of the pyramid (Pl. 1). Before we assess his role in the action, what has so far been proposed about first the genre, and second the subject, of Rembrandt's picture?

Leaving van Loenen out of account, we seem to have verified the view that Rembrandt has here composed a traditionally-commissioned group-portrait in the manner of a historical painting. As in a historical picture, there is a central action, in this case Tulp's demonstration of the metaphysical implications of the flexor-mechanism of the hand. The other characters seem to interpret the action and themselves to the viewer unwittingly, by reacting to it in various historically justifiable ways. Relative to the picture-plane, the sitters are all placed behind the objects of their attention, so that in looking at those objects they yield their portraits to the viewer without offending against historical rationality. Rembrandt has thus avoided the historically irrational attitudes found in the comparable paintings of his predecessors (Pls. 3, 4, 5, 6), and so, by the criterion of historical plausibility, he does appear to have surpassed his older colleagues, de Keyser and Eliasz.

The subject of the picture, as so far elucidated, is a pictorial adaptation of a type of scene which is well attested in the history of anatomy. At Leiden, when Pieter Paaw was about to perform one of his winter anatomies, crowds packed the stalls of the anatomy-theatre, and soon forgot the cold as Paaw kept them constantly astonished by revealing "the ingenious works of God in the human body" and by expounding "the proper office of every part".[101] A similar scene was mentioned by Paaw's pupil Nicolaes Tulp, during a reference to the internal membranous lining of the larynx:

> Nature, which foresees and controls every possibility, has constructed it with such sagacious industry that, whenever I have called attention to this skilfully made work of art in the anatomy theatre, the crowd standing around has always gazed on it with the greatest admiration.[102]

The anatomist Caspar Hofmann referred to the same kind of event in 1636 when he criticized the London *praelector anatomiae* William Harvey on the ground that

[99] Jantzen (Heckscher [255]) p. 314.

[100] See p. 5 above.

[101] A composite account derived from poems by P. Scriverius and P. Bertius, cited in Appendix III nos. **14c, 14d**, p. 73 below. The lines by Bertius translated here are: "Dum plenis monstras cuneis plenoque theatro/daedala in humano corpore facta Dei sive ordine pandis/quodnam sit proprium partibus officium."

[102] Tulp (1652), IV c. 9, p. 311, "tam sagaci industria effinxit provida ac omnium opportunitatum moderatrix natura, ut affabre factum hoc artificium, nunquam nisi cum summa admiratione meminerim in theatro anatomico a circumstante corona conspectum."

Harvey (like Tulp) held public anatomies for the benefit of surgeons, magistrates, and other impressionable laymen:

> If only, Harvey, you would not hold anatomies in front of jacks-in-office, petty lordlings, money-lenders, barbers and such like ignorant rabble, who, standing around open-mouthed, blab that they are seeing miracles![103]

Rembrandt's picture can be checked not only against these texts but also against a second picture: the tiny engraving of 1641 which shows Adriaen van Valckenburg conducting an anatomy in the Leiden anatomy-theatre (Pl. 15). Here also the spectators near the corpse crane forward to catch the master's words and observe what he has to show them, in this case the ileum or its terminal valve.

Hence the devoted attentiveness and wonder which we see on the faces of Rembrandt's surgeons (except van Loenen) is an authentic detail derived from the expressions of spectators at actual anatomies. If the result reminds one of a *Doubting St. Thomas*, a *Judas returning the silver*,[104] or a *"Render unto Caesar"*,[105] it is because the baroque iconography of those subjects was essentially the same as the high moments of a public anatomy: several people marvel at something said or shown by one person. In Rembrandt's adaptation, the greatest change is obviously that of scale: acting, no doubt, on the same instructions as those given to Thomas de Keyser in 1619 (Pl. 5), he has reduced a crowd-scene such as Pl. 8 to a group-portrait of half a dozen sitters (Pl. 1). Other authentic details have been reconstructed as opportunity allowed. For example, the sitters are arranged in tiers recalling the precipitous flights of stalls in an anatomy-theatre: the effect, by which all eyes converge on the praelector from different heights, reproduces the wonderstruck atmosphere of the public anatomies performed by Paaw and Tulp, and derided by Hofmann.

[103] Caspar Hofmann, 'Digressio, in circulationem sanguinis, nuper in Anglia natam', in J. Riolan, *Opuscula anatomica, varia et noua*, Paris, 1652, pp. 357–364, p. 359 "Siquidem ô HARVEE, Anatomiam exerces, non apud Senatorculos, Patriciolos, Foeneratores, Barbitonsores, imperitumque vulgus, quod hianti ore adstans miracula videre gestit . . ."; translation slightly modified from that of G. Whitteridge, *William Harvey and the circulation of the blood*, London, Macdonald, 1971, p. 241.

[104] Keith Roberts in *Burlington Magazine*, 1971, **113**: 353.

[105] E. K. J. Reznicek, 'Opmerkingen bij Rembrandt', *Oud Holland*, 1977, **91**: 75–107, pp. 83–87.

III

AN EMBLEMATIC PORTRAIT?

We proceed to consider the last of Rembrandt's seven sitters.

7. FRANS VAN LOENEN

What place does Frans van Loenen have in this historically-composed group-portrait? Van Loenen is the hatted figure at the apex of the outer triangle of surgeons (Pl. 1). He looks straight at the viewer, and consciously directs our attention by pointing his index-finger at the scene below him. These two actions, of face and hand, are the characteristic traits of the attributive portrait: van Loenen's whole attitude could not be more unhistorical than it is.[106] But if van Loenen's attitude is so blatantly unhistorical, there would have been no purpose in Rembrandt's effort to avoid offending against historical rationality in the attitudes of all the other sitters. Must we accept that Rembrandt's picture is, after all, divided by a discrepancy of genre, between the attributive pose of van Loenen and the historical attitudes of the other six sitters? If so, the rest of the scene serves as van Loenen's attribute, and gives him a prominent role which would seem more suitable for the praelector (cf. Pl. 6). The alternative would be to modify our identification of the picture's genre, and there are in fact several weaknesses in that identification which suggest how it might be adapted to accommodate the troublesome figure of van Loenen.

First, although the pose of each sitter (except van Loenen) may be historical, it does not necessarily follow that the ensemble of sitters is also historical, and in fact it is not. In order to illustrate the successive stages of his argument, Dr. Tulp is portrayed as if he were demonstrating them all at the same time. With his right hand he differentiates the two flexor-muscles of the fingers: this is the first stage of the demonstration, in which the physical form of the flexor-mechanism is explained. With his left hand he demonstrates a later stage, the discussion of the use of the mechanism. Finally, his facial expression shows that he is mentally already at the climax of his exposition: the Galenic and Laurentian view of the hand as organ of prehension, instrument of instruments, unique to man, a miracle of design, and a monument of the wisdom and power of the Creator. The surgeons respond to Tulp in correspondingly disparate ways. Slabberaen, on the left, is still at the first, purely perceptual, phase: he gazes with feline detachment at a technical illustration on the hidden recto page of the folio volume. His neighbour de Witt is also still interested in the mere physical details of the musculature, but the eagerness with which he inspects it suggests that its conceptual significance may very soon be dawning on him. Calkoen and Block, who stare at the gesture of Tulp's left hand, have reached the second stage, and Calkoen is well on his way to the third stage, the revelation which has already left Hartmansz. gaping in amazement and Tulp himself entranced. Therefore the picture as a whole does not

[106] The hand-gesture is of course the typical action of the saint pointing to his attribute in fifteenth- and sixteenth-century painting. Bosch's St. John the Baptist (Madrid) matches it exactly.

capture a split second in a historical (albeit fictitious) narrative.[107] The simultaneous depiction of successive events was, of course, practised by model history-painters such as Leonardo, Raphael, and Titian, but for Rembrandt in the 1630s, the task of the history-painter, as we can deduce it from such paintings as the London *Belshazzar's feast* (*c.* 1635) and the Frankfurt *Samson* (1636), was precisely the opposite: namely, to isolate a single "frozen moment" in a sequence already familiar to the viewer. The Tulp picture, therefore, fails to meet this first criterion of Rembrandtian historicity.

Second, there is the fact that, in a real anatomy, public or private, the first part to be incised was invariably the abdomen.[108] The limbs were not dissected until the head and trunk had reached a spectacular state of spoliation. In Rembrandt's picture, however, the flexor-mechanism of the hand has already been painstakingly dissected, while the rest of the body is still intact. Even if the painting had been a historical picture unified around a single central action, it could not have carried conviction with contemporaries, since the action, through its defiance of the normal sequence of events, would have been one which they knew could never have occurred. This suggests that Tulp deliberately selected this particular dissection for some conceptual significance which it possessed, and not merely to record the historical fact that he had been *praelector anatomiae*. What that significance may have been has already been suggested: the concept of the pre-eminence of the hand, as propagated by Galen, Laurentius, and others.

These defects in the "historical" identification of the picture's genre both point towards the same alternative explanation: that Tulp and the surgeons consciously posed in such a way as to illustrate a pre-selected argument. There is other evidence which points in the same direction.

The iconography of Rembrandt's painting must have been the responsibility of Nicolaes Tulp himself. The choice of Tulp's action in the picture, implying as it does a Galenic or Laurentian interpretation of a Vesalian motif, required a knowledge of anatomy-books written in Latin, knowledge which was presumably outside the educational range of both Rembrandt and the surgeons. It is on Tulp's choice for his own attitude in the picture that the attitudes of the surgeons depend, particularly of Calkoen, Block, and Hartmansz.: they could hardly have looked with such great admiration on the anatomical specimens displayed by Dr. Sebastiaen Egbertsz. or Dr. Johan Fonteyn in their comparable pictures (Pls. 3, 5, 6). Tulp must therefore have determined the attitudes of the surgeons also, and from that point it becomes difficult to define the further limits of his responsibility for the content of Rembrandt's painting. One may therefore compare this picture directed by Nicolaes Tulp (Pl. 1) with another picture for which he had iconographic responsibility: his portrait by Nicolaes Eliasz. or Pickenoy, which is dated 1634 (Pl. 18). Here also Tulp has selected a pose which would illustrate an idea. He looks wistfully at the viewer while he points – again the typical attributive combination – at the melting candle which exemplifies the

[107] Cf. Heckscher p. 33.

[108] Heckscher p. 66. A. Laurentius, *Historia anatomica*, Frankfurt a. M., 1599, I, c. 9, p. 11 ". . . imum ventrem prius seca, mox thoracem, dein caput, tandem artus. Hanc methodum in scholis et sectionibus publicis obseruant anatomici omnes . . ."; A. Piccolomini, *Anatomicae praelectiones*, Rome, 1586, p. 55; etc.

motto carved on an ageless marble monument: "In serving others I myself am consumed". If one had to identify the genre of this picture, one would surely call it an emblematic portrait. If Tulp, in 1634, intended that a portrait over which he had complete iconographic control (Pl. 18) should be composed and understood as an emblem, or illustration of a given concept, could he not have intended, in 1632, that a group-portrait (Pl. 1), in whose choice of iconography his taste was probably dominant, should also have emblematic significance?

Our suggestion is that Rembrandt's painting (Pl. 1) may be not a group-portrait composed as a history-picture, but an emblematic group-portrait. The motto, undisclosed as usual in emblematic paintings, would be a summary of the argument being presented by Dr. Tulp: something like EST DEVS IN NOBIS seems called for.[109] Of course, the "emblem", the dissection of the hand, is not an established one that Tulp could have borrowed from a contemporary emblem-book, as he did with the melting candle in his portrait by Eliasz. (Pl. 18).[110] It is too specialized for such wide circulation. But it is not an entirely original illustration either, since Tulp derived it and its putative meaning from Vesalius and possibly Fabricius ab Aquapendente (Pl. 10; Fig. 4), and it would have been easily understood by anyone who had attended Tulp's public anatomies. In the emblematic scene that emerges, the five surgeons we have considered would be driving home the lesson with the attentive or excited attitudes allotted to them by the iconographic authority, Doctor Tulp. Their individual historical poses can contribute to an emblematic picture, but the emblematic attitude of Frans van Loenen cannot be admitted to a strictly historical picture.[111] Therefore if the whole painting is an enormous emblem-picture, van Loenen can be accepted into the scheme we have already identified for the other surgeons and the praelector: Tulp impresses the argument on the five lower surgeons; they, by their attitudes, confirm its importance; and van Loenen mediates their joint lesson to the viewer.

This interpretation would explain why van Loenen was originally depicted wearing a hat (Pl. 1). Heckscher believed that only the lecturer at an anatomy wore a hat,[112]

[109] "God is within us": Ovid, *Ars. am.* III. 549 and *Fasti* VI. 5, cited by, among others, Laurentius, op. cit., note 108 above, lib. VI, quaestio xxii, p. 242.

[110] Heckscher p. 120. But Tulp's immediate source for the candle-motif has not been traced. Heckscher (p. 177) tentatively suggested P. C. Hooft's *Emblemata amatoria,* Amsterdam, 1611, p. 35, no. 12 (Heckscher pl. XIV–54): there, however, we find only SERVIENDO CONSUMOR. Perhaps Tulp's source was G. Rollenhagen, *Selectorum emblematum centuria secunda,* Utrecht, 1613, no. 31 (with the same word INSERVIENDO, not IN SERVIENDO as reported by A. Henkel and A. Schöne, *Emblemata,* Stuttgart, J. B. Metzler, 1967, col. 1363). However, Frits Graf, '*Aliis inserviendo consumor',* Arcadia, 1969, **4**: 199–201, shows that the motto existed before this date, though without resolving the question of its origin. For further literature see Peter Hecht, 'Candlelight and dirty fingers, or royal virtue in disguise: some thoughts on Weyerman and Godfried Schalcken', *Simiolus,* 1980, **11**: 23–38, pp. 27–28. There may be an unnoticed allusion to this idea in John Donne's poem *The canonization,* v. 21, "We are tapers too, that at our own cost die."

[111] Admittedly, L. B. Alberti liked to see in historical pictures "someone in the story who tells the spectators what is happening, and . . . beckons them with his hand to look . . ." (*On painting and sculpture,* ed. and transl. C. Grayson, London, Phaidon, 1972, pp. 80–83 [*De pictura* book II]). But many painters have not shared Alberti's preference, and in any case his theoretical idea of a *historia* is closer to the modern idea of an emblem-picture than to a historical painting by Rembrandt.

[112] Heckscher pp. 40, 118, 175, where, however, comparisons with academic practice are beside the point, since anatomies at Amsterdam were civic, not academic, affairs.

but our sources do not confirm this view. It seems that hats were worn by most if not all members of the audience in an anatomy-theatre, which was after all a cold public place.[113] If certain group-portraits portray only the praelector as hatted, it must therefore be because the painter wished to single out the most important sitter, the praelector. It would otherwise be even less easy than it is for the viewer to pick him out.[114] But this pictorial device is introduced only in the group-portraits made in the time of Tulp's two immediate predecessors, Egbertsz. and Fonteyn (Pls. 5, 6), whose iconographic innovations Tulp accepted, as we shall eventually see.[115] Therefore the fact that both van Loenen and Tulp are hatted suggests that van Loenen also, although a mere surgeon, is raised to a didactic rank in the picture, as though he also were what his colleague Calkoen actually was, Dr. Tulp's assistant.[116] Van Loenen is presented as unofficial assistant *praelector anatomiae* whose task in the painting is to pass on Tulp's message to the viewer and to posterity. One can imagine many reasons why this misleading implication should have been resented, and the hat painted out.

The primary case for this argument is its ability to account for the actions of all seven sitters with one interpretation. But there is also the argument that this interpretation is no more than we should already have suspected from the evidence of the culture in which the painting was produced. Leiden and Amsterdam, the two cities in which both Tulp and Rembrandt received their training and made their careers, formed "the undisputed centre of European emblem-literature of the early seventeenth century".[117] Again, we read that "the visual arts of the first few decades of the seventeenth century display an overwhelming preference for the expression of ideas, for underlining the importance of salvation, and for an intellectual comprehension of the subjects depicted".[118] This statement too bears out the "emblematic", but not the "historical", interpretation of Rembrandt's picture. Rembrandt's professional interest in emblems is said to have been rather faint,[119] but Dr. Tulp, humanist and physician, was of exactly the class which did most to foster their cult, and according to our hypothesis it was Dr. Tulp who chose the genre and subject of the picture, while Rembrandt merely executed the commission – with precocious virtuosity and whole-hearted understanding of his task. On the evidence adduced so far, then, this task would seem to have been to paint an emblematic portrait of Dr. Tulp and the surgeons teaching and studying anatomy as a revelation of the divine presence in the human body.

[113] See Pls. 8, 15, and 17, and Heckscher p. 25.
[114] As noted by W. Weisbach, *Rembrandt,* Berlin and Leipzig, W. de Gruyter, 1926, p. 303.
[115] p. 38 below.
[116] Cf. p. 55 below.
[117] Sibylle Penkert, 'Zur Emblemforschung', in *Emblem und Emblematikrezeption*, ed. S. Penkert, Darmstadt, Wissenschaftliche Buchgesellschaft, 1978, p. 19.
[118] Hessel Miedema, 'Realism and the comic mode: the peasant', *Simiolus*, 1977, **4**: 205–219, p. 219.
[119] Heckscher p. 120. However, Rembrandt's allegorical etchings (B. 109–11) are close to this genre.

IV

THE DOUBLE EMBLEM

The matter could be left to rest there, were it not that Frans van Loenen's place in the picture, and the picture's place in the history of anatomy, suggest a neater and richer interpretation, a refinement of the one we have proposed. The argument starts with a return to the poem by Caspar Barlaeus which was briefly mentioned above.[120]

In the last verse of the poem, Barlaeus summarized Nicolaes Tulp's message to those who attended his anatomical praelections:[121]

> Auditor, te disce, et dum per singula vadis,
> crede vel in minima parte latere Deum.[122]

Auditor means the listener in the anatomy-theatre, singular being used for plural. *Te disce* is a verbal variant of *nosce teipsum,* "know thyself": the present meaning of the phrase remains vague until the context is better defined. *Et* anticipates the introduction of another lesson, whose substance is allied to the acquisition of self-knowledge. *Dum per singula vadis* begins to specify the sense in which the first lesson, *te disce,* is to be understood. *Crede vel in minima parte latere Deum* is the expected second lesson: it explains more precisely what *te disce* had pithily implied. The meaning of the couplet is therefore as follows: the declared purpose of Dr. Tulp's anatomical orations is that everyone attending his anatomies should seek to "know himself" by recognizing that God is present within the human body.[123]

Is Barlaeus here putting his own words into Tulp's mouth, or is he faithfully reporting the gist of what Tulp actually said? The accuracy of the second line at least is corroborated by other evidence of Tulp's praelections,[124] and evidence from the history of anatomy tends to confirm the accuracy of the first line too. For at some time in the early sixteenth century a new intellectual fashion had appeared among anatomists: the invocation of the Greek proverb γνῶθι σεαυτόν (*nosce teipsum,* "know thyself") to justify the study of anatomy. This proverb was one of two or three inscribed in gold letters on the ancient temple of Apollo at Delphi, but its use in an anatomical sense was apparently not derived from antiquity.[125] Although the origin of this anatomical application of the phrase is obscure, the available evidence points to one of the humanistic and anatomical centres such as Venice, Padua, Paris, or Montpellier in the early 1530s.[126] Over the next 150 years, "know thyself" was used as the

[120] p. 22 above.
[121] Cf. n. 93 above.
[122] "Listener, learn yourself, and while you proceed through the individual [organs], believe that God lies hidden in even the smallest part."
[123] On this interpretation of the couplet see Appendix IV, pp. 85–89 below, especially pp. 88–89.
[124] pp. 21–22 above.
[125] In antiquity, only Julian the Apostate seems to have insisted that γνῶθι σεαυτόν demanded a medical knowledge of the body as well as a knowledge of the soul; but even he did not suggest dissection (*Oratio* VI, 183b–c; cf. Wilkins p. 62).
[126] This paragraph is a composite account based on Appendix III, pp. 66–84 below.

catch-phrase for anatomy. It was exhibited in anatomy-theatres, inscribed on anatomical illustrations and pictures of dissection, and illustrated in anatomical title-pages and frontispieces. It was the text to which anatomists spoke in their inaugural lectures. Again and again it appears in the opening paragraphs of anatomical text-books, and since those books were often reworkings of what the authors had said at their public anatomies,[127] it was probably also conventional to open a public anatomy with an appeal to the Delphic maxim.

What these anatomists meant by "know thyself" is revealed by the context in which they introduced it. After the preliminary prayers for God's favour, a public anatomy would typically begin with an address by the praelector on the subject and purpose of the occasion. This traditionally took the form of a harangue on the pre-eminence (or dignity) of man, *de praestantia sive dignitate hominis*.[128] Man was the microcosm, the sum and peak of the creation, the most perfect animal. The body of man, as the speaker would soon reveal, was a miraculous combination of mutually co-operative organs, made in God's image, and raised above the other animals by certain unique anatomical properties which the praelector would then enumerate. In order to gain knowledge of these divine elements within himself, it was necessary for man to "know himself", as the Delphic oracle had advised, and the path towards knowing oneself in this sense was through anatomy. Hence the honour which the ancients had accorded to the Delphic maxim – here Juvenal's *de caelo descendit* γνῶθι σαυτόν was often cited or alluded to[129] – should be paid to anatomy as the source of this kind of self-knowledge.

Different anatomists emphasized different parts of this doctrine, and organized them in different ways. One notices more uniformity, however, among writers who had read Laurentius's anatomy-book, which was published at the end of the sixteenth century.[130] Laurentius, whom van der Linden and Plemp praised for being methodical,[131] codified the anatomical meanings of γνῶθι σεαυτόν in a

[127] As is shown by the similarity between instructions for, or practices of, praelectors, and the texts of anatomy-books. In the former group: (1) Jean Fernel, *Universa medicina*, Cologne, 1604, vol. 1, *De partium corporis humani descriptione*, lib. I, c. xvi, p. 83, "Qui autem consectioni praeest, enarrata principio humani corporis dignitate, qua id caeteris praestat animantibus, eoque tres in ventres & in artus distributo. . . . Haec praefatus, mox de vniuersa corporis cute deque ei subdito adipe dicere instituat. Quod dum facit iubeat inferiorem ventrem aperire atque detegere"; (2) Nicolas Habicot, *Semaine ou practique anatomique*, Paris, 1610, 'preface anatomique', p. 15 "Or soit en public ou en priué il se faut donner garde que l'excellence des auditeurs, ny la quantité des spectateurs ne facent troubler le discours qu'il conuient faire sur chacune leçon, specialement à la premiere, où il est question de se dilatter sur l'excellence de l'homme, demonstrant les vtilitez qui prouiennent d'vne telle cognoissance, & finallement l'ordre ou methode que l'on veut suiure"; (3) Jean Riolan, *Anthropographia et osteologia*, Paris 1626, lib. I, c.i. p. 1, 'Humani corporis commendatio . . .' with marginal note "Excerpta ex praefationibus quas habui in publicis Anatomiis"; (4) in an autopsy modelled on a public anatomy, as published by Charles Talbot, 'Autopsy on Sir George Douglas, A.D. 1636', *Med. Hist.*, 1978, **22**: 431–437. In the latter group: (1) A. Laurentius, *Historia anatomica*, Frankfurt a.M., 1599, lib. I, "in quo hominis dignitas, anatomes praestantia, utilitas . . . explicantur", pp. 1–35; (2) C. Bauhin, *Theatrum anatomicum*, Frankfurt a.M., 1621, praefatio, pp. 1–4.

[128] See the passages cited in the previous note, and the books cited in Appendix III below.

[129] e.g. Appendix III nos. **2**, **5a**, **22**, **38** below, referring to Juv. *Sat.* XI. 27.

[130] Appendix III no. **11**, pp. 71–72 below.

[131] p. 11 above.

formula which was already familiar from patristic and other texts.[132] In this scheme, anatomy was held to have two uses: *cognitio sui* and *cognitio Dei. Cognitio sui*, knowledge of oneself, was the first use of anatomy. It was supported by the ancient authority of the Delphic oracle. Apart from its intrinsic benefits, which had been enjoyed by the pagans, it also led to the second and more valuable use of anatomy, *cognitio Dei* or knowledge of God, which was possible only for Christians.[133] However, Laurentius introduced no catch-phrase for *cognitio Dei* to match that for *cognitio sui;* for since the divinity to be recognized was to be found within the human self, γνῶθι σεαυτόν could govern both knowledge of oneself and the knowledge of God which came of it.

Hence the bipartite doctrine which Caspar Barlaeus put into the mouth of Nicolaes Tulp – *te disce* and *crede . . . latere Deum*[134] – is nothing more than a summary of the two Laurentian justifications of anatomy. *Te disce* urges knowledge of oneself, *crede . . . latere Deum* urges knowledge of God within oneself. Considering how much Tulp and his colleagues read and admired Laurentius,[135] and considering the fact that what we already know of Tulp's anatomies attests their Laurentian character,[136] we surely cannot put down to mere coincidence, or to Barlaeus's imagination, his ascription of the Laurentian doctrine to Nicolaes Tulp in 1639. The final couplet of Barlaeus's poem must therefore be an accurate record of the apology for anatomy which Tulp put forward at the beginnings of his public anatomies at Amsterdam in the 1630s. Tulp would have been a most untypical *praelector anatomiae* if he had not made some such speech, and the Laurentian formula is exactly the one that we should have expected him to choose.[137]

The anatomical application of "know thyself" had been circulating for nearly a hundred years before it reached Nicolaes Tulp by way of Laurentius, and Tulp was not the first Dutch anatomist to invoke the phrase in the anatomy-theatre. Half a dozen contemporary sources state or imply that "know thyself" was one of the lessons that Pieter Paaw, Tulp's anatomy teacher, impressed on the audiences at his anatomies at Leiden between 1589 and 1617. It was thanks to Paaw and his anatomy-theatre that, in the words of one admirer, "NOSCE TEIPSVM, the mystic wisdom of the venerable Spartan, was first understood in the Athens of Holland."[138]

However, the meaning which Paaw found in "know thyself" was not the same as that assumed by Laurentius and also (as Barlaeus tells us) by Tulp. For Laurentius

[132] Cf. Wilkins pp. 69–70.

[133] Appendix III nos. **11** and **16** below.

[134] p. 31 above.

[135] pp. 9–12 above.

[136] pp. 21–22 above.

[137] The lectures which were given by Johan van Beverwijck to introduce an anatomy at Dordrecht in 1634 and by W. van der Straaten to inaugurate the chair of anatomy at Utrecht in 1636 are particularly telling evidence for this interpretation, since both lectures take γνῶθι σεαυτόν as their text and both contain extensive extracts from Laurentius. Tulp and van der Straaten were born in the same year (1593), Beverwijck in the following year: all three studied anatomy at Leiden as students of Pieter Paaw. On van der Straaten see Banga, op. cit., note 29 above, p. 388, and Appendix III no. **24**, p. 79 below; on Beverwijck and Tulp see Appendix III no. **22**, pp. 77–78 below.

[138] Appendix III no. **14**, p. 72 below; this quotation from no. **14e**. The Spartan was Chilo, the Greek sage who was thought by some to have invented the proverb.

and Tulp the phrase meant "recognize the divinity of man".[139] For Paaw it meant the opposite, "recognize the mortality of man". According to this interpretation, which can be traced back through humanistic and medieval texts to Lucian and Seneca, *nosce teipsum* is synonymous with such better-known, because less ambiguous, mottoes of pessimism as *memento mori, pulvis et umbra, homo bulla*, and *respice finem*.[140] It was in this sense that Paaw used "know thyself" as a motto for anatomy. Hence anatomy appeared to Paaw's audience to show that man was ephemeral, and human life the vanity of vanities.[141]

Paaw's use of "know thyself" in what we may call its pessimistic sense is paradoxical, for as we have seen, he held the same optimistic view of man as Galen, Laurentius, and Tulp. It was Paaw himself who stated that he studied anatomy because he was "touched by a kind of numinous quality in that divine temple [the human body]".[142] The reason for this apparent inconsistency can be left till later:[143] at present we are concerned only with the fact that Paaw did teach "know thyself" in the Leiden anatomy-theatre, and that he intended it in the pessimistic sense "recognize that you are mortal".

Now this pessimistic meaning of "know thyself" was diffused not only through speeches and books but also through images. Since the phrase in this sense was equivalent to a special form of *memento mori*, some of the images which traditionally illustrated *memento mori* also served to illustrate "know thyself". They include those images which illustrated the vanity of human life, such as a corpse, a skeleton, a skull, or a person looking in a mirror,[144] but not, of course, those which illustrated the vanity of impersonal things such as money and flowers. One of the neatest and most popular images for "know thyself" was a skull or skeleton reflected in, or significantly associated with, a mirror, the implication being that a person who looks in a mirror and sees a skeleton or skull sees himself as he really is in the long term, and so comes to "know himself" in the sense that he recognizes his mortality.[145]

The pessimistic iconography of "know thyself" is the clue that leads from the professor of anatomy at Leiden, Pieter Paaw, to the praelector of anatomy at Amsterdam in Paaw's time, Sebastiaen Egbertsz., and to Egbertsz.'s successor in 1621, Johan Fonteyn (the immediate predecessor of Nicolaes Tulp). For we have already shown grounds for suspecting that the Tulp anatomy-picture of 1632 may be an emblematic group-portrait.[146] We have also shown that "know thyself" was everywhere used as a motto for anatomy.[147] We have now shown that "know thyself" was illustrated by such traditional *vanitas* images as a skeleton or skull.[148] Considering

[139] Laurentius: p. 20 and n. 133 above. Tulp: p. 31 above, and further discussion in Appendix IV, pp. 85–89 below.

[140] Appendix V, pp. 90–102 below.

[141] Appendix V no. **18**, pp. 96–97 below.

[142] p. 21 above.

[143] Cf. p. 44 below.

[144] Appendix V nos. **4, 7, 15–17, 19–21, 23–32** below.

[145] Appendix V section III, pp. 98–102 below.

[146] p. 29 above.

[147] pp. 31–33 above, and Appendix III below.

[148] nn. 144, 145 above.

these three points together, can one doubt that both the Egbertsz. group-portrait painted by Thomas de Keyser in 1619 (Pl. 5), and the Fonteyn group-portrait painted by Nicolaes Eliasz. in 1625 (Pl. 6), are emblematic portraits having as their motto the anatomical slogan "know thyself"?

For years these two pictures have been belittled for lacking the dramatic, historically plausible qualities that we find in Rembrandt's sitters, except Frans van Loenen (Pl. 1).[149] But if they were intended to illustrate a concept, and not to reconstruct a historical event, the accusation is misplaced. De Keyser and Eliasz. would be no more at fault for their lack of narrative fluency in Pls. 5, 6, than Eliasz. alone would be for the artificiality of Tulp's pose in Pl. 18. Considered as sitters in an emblematic portrait, the surgeons in Pls. 5 and 6 would be equally well associated with the motto "know thyself" whether they look at their emblematic object or at the viewer. In each case they impress the usefulness of self-knowledge on the viewer: the former teach the lesson by example, while the latter endorse it by their mere presence in the picture. This liberal convention was a godsend to the portrait-painter, who could hardly have hoped otherwise to find rational attitudes for all his sitters while preserving their facial portraits.

We now have a new view of the position in which Dr. Nicolaes Tulp found himself when he came to devise the iconography for Rembrandt's painting of 1632. Either Tulp's or Rembrandt's two immediate predecessors – that is, either Egbertsz. and Fonteyn, or de Keyser and Eliasz. – had transformed the genre of the anatomy-picture from the attributive portrait, which recorded the fact that the sitters belonged to the guild associated with anatomies (Pls. 3, 4), into the emblematic portrait which instead associated the sitters with the underlying rationale of anatomy, *cognitio sui* (Pls. 5, 6). On the evidence of the kind of portrait Tulp was to commission from Eliasz. in 1634 (Pl. 18) we should have expected Tulp to have approved this trend from historical to conceptual representation, and to have continued it in his own anatomy-picture of 1632. Indeed, we have already proposed independent grounds for thinking that Tulp did intend the 1632 picture (Pl. 1) to be conceptually significant, in impressing on the viewer the lesson of the flexor-tendons, which revealed God's works in the human body.[150]

But according to this interpretation, although Tulp followed his predecessors in their choice of genre – the emblem-picture – he reversed their choice of content. For whereas Egbertsz. and Fonteyn had both chosen to illustrate the pessimistic sense of the anatomical motto "know thyself",[151] Tulp, it seems, ignored the motto, and the view of anatomy which he chose to illustrate was the optimistic one which we summarized in Ovid's phrase *est Deus in nobis*.[152] Does this indicate a real rift between Egbertsz. and Fonteyn on the one hand and Tulp on the other, or does the flaw lie only in our interpretation of the sequence?

[149] B. Haak, *Regenten en regentessen, overlieden en chirurgijns*, Amsterdam, Amsterdams Historisch Museum, 1972, pp. 38–44, reflects a long- and widely-held view.
[150] pp. 28–30 above.
[151] pp. 34–35 above.
[152] p. 29 above.

The evidence allows room for reconciliation from both sides. From the side of Tulp's predecessors, Egbertsz. and Fonteyn, it is far from certain that they endorsed the pessimistic interpretation of "know thyself" which their images for the proverb originally illustrated. No anatomist of the time, I believe, saw anatomy exclusively in its pessimistic aspect. Those who did take an exclusive view chose the optimistic sense: for them, *cognitio sui* meant man's *agnitio Dei in se*.[153] But when the need arose to illustrate the proverb in an anatomical context, whether the optimistic or the pessimistic sense was intended, it was the pessimistic images – skull, skeleton, corpse – that were chosen, because they alone illustrated "know thyself" in the physical sense that linked the proverb with anatomy. So the skeleton and skull in Pls. 5 and 6 could have been intended to denote γνῶθι σεαυτόν without further connoting any particular interpretation of it. The particular interpretations favoured by Egbertsz. and Fonteyn could, however, have been read into the pictures by those who had heard the two praelectors expound the phrase to the public in the anatomy-theatre at Amsterdam.

Such an inconsistency, between pessimism in image and optimism in word, may seem far-fetched, but it is quite common among sixteenth-century anatomists. We have already noted Pieter Paaw's self-contradiction,[154] and among other examples one could cite Felix Platter of Basle (1536–1614) and the Frisian anatomist Volcher Coiter (1534–?1600). In Platter's engraved portrait of 1578 (Pl. 14), the legend declares that "The marvellous construction of the human body is a miracle of the ingenuity of God",[155] while the historiated border of the same portrait carries images illustrating the opposite view: Adam and Eve, skeletons, and worm-hollowed human skulls all remind the viewer of the body's subjection to death. In a similar manner, Coiter put the optimistic view of anatomy in the text of his anatomy-book:

> Anatomy offers a view of that omnipotence and justice which the good Lord has used in constructing and forming the bodies of animate beings. Since the providence of the Creator has expressed itself nowhere more certainly than in the structure of the human body, for this reason above all the study of anatomy must commend itself to us[156]

while the illustrations in the same book, designed by Coiter himself, treat the human skeleton as a *vanitas* motif, with the pessimistic legend "O man . . . death itself, as you see, inheres in your bones" (Fig. 5). Such an inconsistency in Egbertsz. and Fonteyn would therefore be well precedented,[157] and despite appearances (Pls. 5, 6) we

[153] e.g. Appendix III nos. **10, 11, 17**, below.

[154] p. 34 above.

[155] p. 19 above.

[156] Appendix III no **8**, p. 70 below.

[157] Hence, to those who were firstly concerned with the image, such as professional painters, anatomy seemed exclusively pessimistic, while to those concerned firstly with the concept, it seemed almost entirely optimistic. Among the former are painters as different as Filippo Napoletano (whose etchings of *zoologie moralisée* are discussed by Philip Hofer, 'Some little-known illustrations of comparative anatomy, 1600–1626', *Essays in honour of Erwin Panofsky*, New York University Press, 1961, pp. 230–237) and Carel Fabritius (with reference to the figure of the dead son looking at an anatomy-book in a painting by him, now destroyed but recorded in a watercolour copy reproduced by Christopher Brown, *Carel Fabritius*, London, Phaidon, 1981, fig. 30, and in *Apollo* 1979, **110**: 478. The fidelity of this watercolour copy is confirmed by the description of the destroyed painting in a catalogue entry of 1862, quoted by Brown (1981) p. 37, and not impugned by the drawing reproduced by Brown as fig. 31, which, since it varies from both the watercolour copy and the description (which agree with each other) seems not to be related to the oil-painting by Fabritius.) In the latter group: almost every genuine anatomist of the sixteenth and early seventeenth centuries.

Figure 5. The human skeleton with pessimistic inscription, anonymous engraving after a drawing by Volcher Coiter for his *Externarum et internarum . . . partium tabulae*, Nuremberg 1572, tab. IV.

must accept that they may have proposed the same optimistic meaning for "know thyself" as was to be put forward later, according to Caspar Barlaeus, by their successor Nicolaes Tulp.[158]

It is the reconciliation with Egbertsz. and Fonteyn from Nicolaes Tulp's side that finally returns us to the question of Frans van Loenen's role in Rembrandt's painting (Pl. 1). The argument is as follows. Rembrandt's picture is the third in a series of emblematic group-portraits of surgeons with a *praelector anatomiae*. In each of the first two in the series, the pictures painted by de Keyser in 1619 and by Eliasz. in 1625 (Pls. 5, 6), we see in the centre one demonstrative hatted figure (the praelector), who demonstrates one motto ("know thyself"), which was put forward to sum up the use of anatomy.[159] But in Rembrandt's picture of 1632 (Pl. 1) there are two demonstrative hatted figures, and Rembrandt's praelector taught (following Laurentius) that anatomy had two uses: *cognitio sui*, which was expressed through the phrase "know thyself", and *cognitio Dei*, which was expressed in some form of words equivalent to

[158] See note 139 above.
[159] pp. 31–35 above.

37

est Deus in nobis.[160] If we read the picture from left to right, the second hatted figure (Dr. Tulp) illustrates the second lesson of anatomy, by using the flexor-tendons to demonstrate *est Deus in nobis.*[161] It remains for the first hatted figure (Frans van Loenen) to demonstrate the first lesson of anatomy, "know thyself", which he does by pointing to the corpse.

In this hypothesis we find the simultaneous fusion of three questions with three answers. The flaw is closed between Tulp's predecessors and himself: far from rejecting their idea of using γνῶθι σεαυτόν as the unifying motto, Tulp accepted it and built a more ambitious structure on top of it. The gesture of Frans van Loenen – a man pointing at a corpse – coincides with the iconography of "know thyself", although we did not use that fact in order to establish the meaning of his action. Finally, we discover why two hats were needed in Rembrandt's picture, but only one in each of the two preceding paintings.

The question of the genre of Rembrandt's painting, it may be recalled, arose from the problem of its relation to the earlier anatomy-pictures by Aert Pietersz., the Mierevelds, de Keyser, and Eliasz. These four earlier pictures (Pls. 3, 4, 5, 6) were grouped together as attributive portraits of a traditional kind, while Rembrandt's contribution (Pl. 1) was kept apart as a new kind of painting, the group-portrait as a history-picture.[162]

Our interpretation, presented above, gives a different view. There is no sharp break in the tradition from Pietersz. to Rembrandt, but if a line has to be drawn anywhere, it should be between the pictures which attribute to the sitters a certain profession, and those which impute the endorsement of a certain concept or concepts; that is, between the predecessors of Thomas de Keyser on the one hand (Pietersz. and Miereveld), and de Keyser with his successors (Eliasz. and Rembrandt) on the other. Pietersz. and Michiel van Miereveld had apparently each been commissioned to portray a whole guild, and had provided recognizable details of an anatomy as attributes which would serve to identify the guild portrayed. In Pietersz.'s picture of 1603 (Pl. 3) these details included the barber's bowl (left) for holding blood or viscera, two pairs of scissors or forceps (right), and the corpse properly presented for dissection of the abdominal cavity. In the Miereveld picture of 1617 (Pl. 4) one sees more again of the typical paraphernalia of an anatomy-theatre, and also a corpse which is being realistically dissected. In de Keyser's picture of 1619 (Pl. 5), however, sitters and attributes have been at once reduced in number, enlarged in significance, and, from a naïvely documentary point of view, distorted by selection. Six surgeons represent the guild as a whole, and the single piece of anatomical equipment shown, a skeleton, was chosen for its capacity to replace numerous superficial details of a dissection-scene with an allusion to one of the fundamental ideas behind anatomy, *cognitio sui.*[163]

[160] pp. 32–33 above.

[161] p. 29 above.

[162] p. 2 above.

[163] However, this suggestion of de Keyser's originality would have to be slightly modified if the equipment in the Miereveld picture of 1617 (Pl. 4) were already intended as a composite *vanitas*-symbol of the double-edged type to be described on pp. 42–43 below. The objects shown around the corpse are (anti-clockwise) a barber's bowl holding a sponge; a smoking taper in the left hand of the surgeon in the left foreground; some probes and forceps across the left thigh of the corpse; a burning candle; a ball of string; an 8vo book

The subtler allusiveness of de Keyser was preserved in the works of both of his immediate successors: in Eliasz.'s picture of 1625 (Pl. 6) and, in a more elaborate form, in Rembrandt's of 1632 (Pl. 1). In all three works we find an abandonment of the attempt to give a literally accurate picture of instruction in anatomy. The tell-tale features are the fewness of the spectators and the premeditated selection of the "anatomical" device in accordance with the iconography of the relevant philosophical ideas. De Keyser's skeleton, Eliasz.'s skull, Rembrandt's dissected forearm attached to an undissected trunk, are all deliberately unrealistic where Pietersz. and Miereveld were, by contrast, positively documentary. How ironic that Rembrandt's picture of 1632 should have been praised for its supposed truth of observation, whereas the two earlier and more accurate pictures were blamed for supposedly lacking it!

One would like to know whether the innovation in Thomas de Keyser's picture of 1619 (Pl. 5) was due to the painter or the praelector, to de Keyser himself or to Dr. Sebastiaen Egbertsz. In matters of iconography, de Keyser could have been as much under Egbertsz.'s orders as Rembrandt in 1632 appears to have been under Tulp's. Dr. Egbertsz. had already been portrayed as praelector in one anatomy-picture, that painted by Pietersz. in 1603 (Pl. 3). Why did he wish to be immortalized twice over? Was it because the 1603 picture, empty as it was of emblematic significance, had become by 1619 unbearably old-fashioned to Egbertsz.'s eyes, irrespective of de Keyser's preference?

As to the innovations in Rembrandt's picture (Pl. 1), although we get the impression that Tulp was a more inspiring orator than his predecessors,[164] we cannot attribute the heightened atmosphere of the 1632 picture merely to the greater eloquence of the praelector. The Rembrandtian element can be separated from the Tulpian by easy stylistic arguments: for example, Rembrandt's anatomy-picture of 1632 (Pl. 1) is to de Keyser's of 1619 (Pl. 5) as Rembrandt's "Rijcksen" double-portrait of 1633 (London, Buckingham Palace) is to de Keyser's Huygens double-portrait of 1627 (London, National Gallery).

We have proposed that the anatomical group-portraits painted at Amsterdam by de Keyser, Eliasz., and Rembrandt between 1619 and 1632 have uninscribed mottoes which express the traditional uses of anatomy. In favour of this hypothesis one can also point to two similar pictures, both produced away from Amsterdam, on which the mottoes were actually inscribed. The first is the earliest group-portrait of a surgeons' guild depicted as present at an anatomy: the anonymous picture in Glasgow which shows John Banester holding an anatomy at Barber-Surgeons' Hall, London, in

with top-edge marked GALENUS; a smoking bowl; some pellets or petals lying in an unfurled paper or cloth; two dissecting-instruments; a branch of bay; a sprig of thyme; a silver pomander; and a knife (in the anatomist's right hand). While only *some* of these objects could be *vanitas*-symbols (taper, candle, bowl, pellets/petals), *all* of them can be explained as functional anatomical implements used either for dissecting the corpse or for sweetening the air. After much vacillation, I feel that the latter, more comprehensive, explanation is the more plausible, and that Houtzager was right to reject the other (op. cit., note 97 above). Even if these objects were *vanitas*-symbols, however, they would not be specific enough to denote "know thyself", as the skeleton does (according to our interpretation) in de Keyser's picture (Pl. 5).

[164] Barlaeus's tribute to Tulp's eloquence, *docti facundia Tulpi* (cf. p. 85 below) is one of many. I have not found any such to Egbertsz., though Tulp (1641), II, c. 13, p. 120, praised his *profunda eruditio*.

1581.[165] Here the motto is taken from Coiter's book, published ten years previously: "Anatomia scientiae dux est, aditumque ad dei agnitionem praebet".[166] The second picture is a portrait of an unidentified German anatomist which was destroyed in the Second World War. The picture was apparently never photographed; the only writer who described it, the medical historian E. Holländer, dated it to the beginning of the seventeenth century.[167] It is said to have portrayed an anatomist dissecting with his right hand, while with his left he pointed to a large notice hanging on the wall. Inscribed on the notice were German verses extolling the uses of anatomy. One wonders if the "large notice" in the Tulp picture was originally intended for the same function.

Because of the long duration of Nicolaes Tulp's praelectorate at Amsterdam (1628–1653), no new anatomy-picture was commissioned there until the 1650s, when Dr. Johan Deyman succeeded to the post of praelector. Although he repeated Tulp's choice of painter, by that time taste had changed again, and the emblematic mode was apparently either abandoned or not enforced.[168] After Nicolaes Tulp died in 1674, there were probably few people left alive who remembered exactly how (if our interpretation is correct) Rembrandt's picture of 1632 was intended to be understood.

So much for the genre of Rembrandt's painting. As it stands, the interpretation presented here is new, but two scholars have in the past discovered separate elements of it. William S. Heckscher suggested towards the end of his study of the subject (1958) that the picture "may be said to approximate an emblematic attitude, in as much as a motto may serve to unlock its enigma" [sic] (pp. 120–121). Prof. Heckscher had already noted both the use of anatomy to demonstrate the presence of God in man, and the anatomical sense of "know thyself" (p. 112), without realizing that these two concepts together might supply the missing motto. The other scholar was a Scottish divine and translator of Kant, William Hastie (1842–1903), who published his interpretation of Rembrandt's picture in 1891.[169] Although Hastie did not use the word "emblem", he interpreted the painting as an emblem-picture designed to illustrate the presence of God in the human body. The manifestation of the "Divine Art" in the flexor-tendons of the fingers, was, in Hastie's words, "the central point of the whole picture, the key to its deeper meaning, *the* lesson in the 'Lesson'." The few writers who have mentioned Hastie's interpretation have tended to reject it,[170] but it seems to explain correctly half of the painting's meaning. However, our hypothesis grew not from these intuitions but from the otherwise inexplicable contrasts of mood to be seen among the surgeons listening to Dr. Tulp.

[165] Glasgow University Library, Hunterian MSS. no. 364 (V.1.1.), frontispiece; Cetto no. 250.

[166] Appendix III no. **8**, p. 70 below.

[167] E. Holländer, *Die Medizin in der klassischen Malerei*, Stuttgart, F. Enke, 1923, pp. 80–82, described this "jetzt in der medizin-historischen Sammlung des Kaiserin-Friedrich-Hauses befindliches Gemälde". Cetto, p. 318, mentions its destruction. Holländer had earlier described a similar (or the same?) picture in his own possession, in the *Katalog zur Ausstellung der Geschichte der Medizin . . . zur Eröffnung des Kaiserin Friedrich-Hauses 1. März 1906*, Stuttgart, F. Enke, 1906, p. 43, no. 1.2.

[168] Rembrandt's 'Anatomy of Dr. Deyman', of which a fragment is in the Rijksmuseum and a drawing in the Rijksprentenkabinet, Amsterdam.

[169] W. Hastie, 'Rembrandt's Lesson in anatomy', *Contemporary Review*, August 1891, **60**: 271–277.

[170] e.g. de Lint (Heckscher [288]) pp. 46–48, in two minds; D. S. Meldrum, *Rembrandt's paintings*, London, Methuen, 1923, pp. 44–45. Hofstede de Groot (Heckscher [299] p. 387) adopted Hastie's nomenclature of the dissected muscles, as did H. L. T. de Beaufort, *Rembrandt*, Haarlem, Tjeenk Willink, 1957, p. 21.

V

THE PARADOX

Leaving behind the question of the genre of Rembrandt's painting, we still have to elucidate the picture's precise meaning inasmuch as its nuances can be recaptured without the aid of direct evidence.

According to the arguments presented above, the picture was designed to illustrate the two anatomical lessons of Laurentius, *cognitio sui* ("know thyself") and *cognitio Dei*.[171] The meaning of *cognitio Dei* is clear: it means *agnosce Deum latentem in te*.[172] But "know thyself", in its metaphysical sense alone (to say nothing of its psychological sense), has as many meanings as there are answers to the question "What is man?". Which of these meanings did Tulp intend to impress on the viewer of his portrait?

Since Tulp's use of the phrase was derived from Laurentius,[173] the obvious answer would seem to be the meaning that Laurentius had favoured. Laurentius's interpretation of the phrase was offered in the form of a miscellany of traditional notions about the uses of anatomy and of self-knowledge. One learns from anatomy that man is a microcosm. In learning the sources of the passions one learns how to conquer them. The co-ordination of the organs is a model for human co-operation, while their subordination teaches princes how to rule and subjects how to serve.[174] These are some of the meanings of "know thyself", which, in Laurentius's words, "the dissection of bodies teaches and (as it were) points out to us with a finger".[175] If Tulp's programme followed Laurentius, these would be the lessons which are also taught and literally pointed out to us by the finger of Frans van Loenen in Rembrandt's painting (Pl. 1).

However, it seems more likely that van Loenen's precept "know thyself" bears a different sense from Laurentius's. For it was, in our view, not the text of Laurentius, but the iconography of the Egbertsz. and Fonteyn group-portraits (Pls. 5, 6), that led Tulp in the first place to instruct Rembrandt to portray Frans van Loenen in the attitude of pointing to the corpse.[176] What had led Egbertsz. and Fonteyn (if we assume that it was they who determined the iconography of their pictures) to choose the skeleton or skull as their attribute was surely the fact that it combined in one image both a "know thyself" motif, which suggested anatomy,[177] and, if we may anticipate the next paragraph, a *vanitas*-motif whose natural habitat was a portrait. Having decided to illustrate the anatomical catch-phrase "know thyself", Egbertsz. and Fonteyn would

[171] pp. 31–38 above.

[172] Laurentius's chapter on *cognitio Dei* is cited in Appendix III no. **11**, pp. 71–72 below, and translated in no. **16**, pp. 75–76 below.

[173] As implied by Barlaeus's poem: see p. 33 above.

[174] Laurentius's chapter on *cognitio sui*, is cited in Appendix III no. **11**, pp. 71–72 below, and translated in no. **16**, pp. 74–75 below.

[175] Laurentius, op. cit., note 127 above, p. 8, "Praeclarum est sane sui ipsius notitiam habere, quod ipsa nos docet & quasi digito indicat corporum sectio . . .".

[176] Cf. p. 37–38 above.

[177] Cf. p. 31–34 above.

have selected the images which illustrated the pessimistic sense of the proverb, not because they preached that sense in the anatomy-theatre – if they did; it seems doubtful[178] – but because the portrait, as a genre, was considered at that time, in some quarters, as a species of the *vanitas*-picture.

A portrait was considered by some to carry, implicit on the sitter's lips, the pessimistic message, "I was once what you [the viewer] are now: a living being. What I am now, you also will be: a skeleton. The portrait shows my face as it was: a skull shows it as it is."[179] This message, in various forms, was sometimes inscribed on the canvas, and often illustrated with a skull or, less commonly, a skeleton or cadaver, in portraits of sitters who had no concern with anatomy (Pl. 19).[180]

But people who did have a professional interest in the anatomical or other properties of the human skull could, as it were, kill two birds with one stone when they came to have their portraits painted. For they could combine, in one image of the skull, both the attribute peculiar to their profession and the common attribute of portrait-sitters in general. This visual conceit was especially popular among northern European physicians and surgeons in the first two-thirds of the seventeenth century, when the medical profession was associated in the public mind with anatomical and pathological dissections. Among other examples there are portraits of this type: of the German surgeon Fabricius Hildanus (Pl. 20), of Charles I's physician Sir Theodore Turquet de Mayerne (Pl. 21), and of the Amsterdam *praelector anatomiae* who succeeded Doctors Tulp and Deyman, Frederik Ruysch (Pl. 22).

This double interpretation of the skull is most clearly illustrated in a progression through three English portraits, all of which were painted within two years either side of 1650. John Evelyn's portrait by Robert Walker (Pl. 23), painted in 1648, includes a skull as a pure *vanitas*-motif, which is clarified by inscriptions of the *memento mori* type.[181] In William Petty's portrait by Isaac Fuller (Pl. 24), painted between 1649 and 1651, the sitter also holds a skull and obviously alludes to the same tradition; but the young virtuoso points with his free hand to Casserius's illustrations of the skull, thus reminding us that Petty was a Leiden student of medicine and, at this time, lecturer in anatomy at Oxford.[182] Here the skull is used in a double sense, as a *memento mori* and as a professional attribute. Third, there is the portrait of John Tradescant the younger (Pl. 25), which is attributed to E. de Critz and dated *c.* 1652. Here, while the skull

[178] Because most anatomists interpreted the phrase in an optimistic sense. Cf. p. 36 above, and Appendix III below.

[179] Roy Strong, *The English icon*, London, Paul Mellon Foundation, 1969, pp. 37–41.

[180] The cumbersome skeleton or cadaver is much less common as a portrait-attribute than the handy skull. A *vanitas*-portrait of Queen Elizabeth I, at Corsham Court, Wiltshire, includes a skeleton (James Pope-Hennessy, *London fabric*, 2nd edn., London, Batsford, 1941, colour frontispiece; R. Strong, *Portraits of Queen Elizabeth I*, Oxford, Clarendon Press, 1963, pp. 153–154, posthumous portraits no. 8, where it is said that "the Queen triumphs over Time and Death", though the reverse interpretation seems equally if not more apt). The Judd portrait at Dulwich includes a cadaver (illustrated by Strong, op cit., note 179 above, p. 39).

[181] The portrait is on loan to the National Portrait Gallery, London.

[182] D. Piper, *Catalogue of seventeenth-century portraits in the National Portrait Gallery*, Cambridge University Press, 1963, no 2924, pp. 275–276. However, the quarto book in the picture cannot be the work identified by Piper, which is a folio: this one is surely Julius Casserius's *Tabulae anatomicae*, Frankfurt a. M., 1632, pp. 16–17, lib. II, tab. III, bound as usual after the text of Spigelius in the same format.

alludes to the tradition represented in its pure form in the Evelyn portrait, the sitter, the former royal gardener, has also, like Petty but more unexpectedly, managed to combine it with an allusion to his own profession, by seizing on the only conceivable connexion between skulls and gardening. A certain medicinal moss was reputed to grow best on the human skull, and a skull crowned with moss is reproduced both in herbals of the time (Fig. 6) and in Tradescant's portrait (Pl. 25).[183] Again, the skull has a twofold meaning, for it would hardly have been included as the attribute of a gardener had not the tradition of the *memento mori* portrait suggested it.

Figure 6. Moss growing on the human skull, anonymous woodcut for John Gerarde, *The herball*, London, 1633, p. 1563.

An earlier picture in the same genre is Nicolaes Tulp's portrait painted by Nicolaes Eliasz. in 1634 (Pl. 18). The skull and the melting candle not only provide the *vanitas*-motifs suitable to a portrait, but also, as the inscription shows, allude to the risks and exertions of the sitter's profession.

It should now be apparent that, if the skull in the Fonteyn group-portrait of 1625 (Pl. 6) and the skeleton in the Egbertsz. group-portrait of 1619 (Pl. 5) illustrate the anatomical catch-phrase "know theyself", that phrase must be interpreted in the sense which its emblems also express in their conventional role as a portrait-attribute, which means the pessimistic sense *memento mori* or "recognize that you are mortal". The argument that leads to this interpretation of the Egbertsz. and Fonteyn pictures has the same implication for Frans van Loenen's gesture in the Tulp group-portrait of 1632 (Pl. 1). But we need not infer, contrary to what Barlaeus tells us, that Tulp deviated from Laurentius's more optimistic interpretation of "know thyself" when he delivered his anatomical praelections at Amsterdam.[184] The Laurentian sense was

[183] Cf. S. Selwyn, *The beta-lactam antibiotics,* London, Hodder & Stoughton, 1980, pp. 2–3; Piper, op. cit., note 182 above, no. 1089, pp. 350–351. The portrait is currently on loan to the Tate Gallery, London.
[184] Cf. p. 31 above.

suitable for the anatomy-theatre, the pessimistic sense for a portrait.

Hence, van Loenen demonstrates the pessimistic lesson of anatomy, the lesson that man is mortal, while Tulp demonstrates the optimistic lesson, teaching that man is divine and therefore immortal.[185] What we called an "inconsistency" in Paaw's view of anatomy[186] is declared to be a genuine dyad, the duality of man's metaphysical status, and this duality is given visible form in the composition of Rembrandt's painting.

The question to which all the foregoing arguments lead is: what is the significance of the juxtaposition, in the painting, of the two lessons of anatomy? Two alternative explanations suggest themselves. According to one interpretation, the two lessons are complementary, and so, by their juxtaposition, present together a complete idea of man as a creature who is earthly in some respects and divine in others. In this sense, van Loenen and Tulp would be *formally* akin to Aristotle and Plato, pointing down and pointing up, in Raphael's fresco in the Vatican. According to the other interpretation, the two lessons would be contrary, if not contradictory, to each other, and would represent man as a metaphysical antinomy, a creature both mortal and not mortal. In this sense van Loenen and Tulp would be *formally* more akin to Democritus and Heraclitus as they respond antithetically to the vanities of the whole world, the one by laughing, the other by weeping, in paintings by Terbrugghen (1628) and Johan Moreelse (before 1636), and in an engraving by Hollar ultimately after two early paintings by Rembrandt himself (Fig. 7).[187] Hence, we must decide whether van Loenen and Tulp are drawing our attention to two separate but compatible aspects of an agreed idea of man, or to two conflicting ideas of man as a whole.

If we accept the former interpretation, it is probable that the two complementary aspects of man are to be identified with the body and the soul, for the distinction between body and soul was a *topos* which faithfully accompanied the anatomical *topos* "know thyself".[188] In this view, Rembrandt's picture would be wholly, like de Keyser's and Eliasz.'s, an illustration of "know thyself", but one in which the self to be known was divided into the body, notified to us by van Loenen, and the soul, notified by Tulp. Doctrinally this would hardly differ from our original interpretation, in which Tulp was thought to be demonstrating God-in-man; for, as Barlaeus said in a lecture at Amsterdam in 1635:

> . . . the soul *is* God, or a particle of His breath. For as He lives, presides, and rules in the universe, so does the soul in the body. As He, who is eternal and immortal, moves the perishable machine of the world, so the soul, which knows not death, moves the body's crumbling clay.[189]

[185] Cf. p. 29 above.

[186] p. 34 above.

[187] A. Blankert, 'Heraclitus en Democritus', *Nederlands Kunsthistorisch Jaarboek*, 1967, **18**: 31–124, with many other examples.

[188] Appendix III nos. **2, 4, 12, 13, 19, 22, 24, 35**, below, and Wilkins pp. 61–64 and *passim*. The key texts are Plato, *Alcibiades I*, 130e–131a and Cicero, *Tusc.* I, xxii, 52, where it is denied that γνῶθι σεαυτόν applies to the body; Cicero *de finibus* V, xvi, 44, where the proverb is said to apply to both body and mind; Cicero *ad Q. f.* III.v.7, where the object is left undefined; and Plutarch *adv. Colotem* 1119, where the object is allowed to be either a blend of body and soul, or the soul only, or only the thinking part of the soul, or the body only. This theme is the subject of a strange story in Arnold Geilhoven's *Gnotosolitos*, Brussels, 1476, fol. 3r, where it is ascribed, apparently without justification, to Macrobius.

Figure 7. Wenceslaus Hollar, Democritus and Heraclitus, engraving, *c.* 1674, after two etchings by J. J. van Vliet after two paintings by Rembrandt.

But although as doctrine this interpretation may be acceptable, as the subject of an emblematic portrait it seems too vague and bland: vague, because the hand was less closely associated with the soul than the brain or heart, and bland because the idea lacks the piquancy, the simultaneous capacity to please and to disturb, that characterizes the ideas which emblems were generally used to convey. We find this quality in Tulp's emblematic portrait by Eliasz. (Pl. 18), where the candle preserves its utility only inasmuch as it is not used, but not in the commonplace idea that man is composed of a complementary mortal body and immortal soul.[190]

[189] C. Barlaeus, *Oratio de animae humanae admirandis,* 1635, in his *Orationum liber,* Amsterdam, 1643, p. 100, "ut dicentes illud, quod pene est verum, falsum tamen dicant. Hi animam Deum esse perhibent, aut divinae aurae particulam. Vti enim ille in Vniverso, ita animus in corpore vivit, praesidet, imperat. uti ille perituram mundi machinam agitat, ipse aeternus & immortalis; ita animus mortis ignarus fragile ac luteum corpus."

[190] However, if it were shown, first, that the Latin oration which Tulp gave in Amsterdam on 2 January 1629 to inaugurate his anatomical praelectorate (Thijssen, op. cit., note 31 above, p. 36) had as its text *nosce teipsum,* which would seem very probable by analogy with note 137 above, *and,* second, that that oration was identical with the oration 'de animi et corporis συμπαθείᾳ' which Tulp made in Amsterdam before 1638 (J. Beverovicius, *Exercitatio in Hippocratis aphorismum de calculo,* Leiden, 1641, p. 186), which would seem possible on the evidence of note 188 above, *then* the relation between body and soul (the subject of the latter oration), being a question raised by the injunction "know thyself" (the supposed subject

The second interpretation, however, which discerns in the picture a conflict of authorities, does perfectly satisfy this requirement. Its second advantage is the fact that the contrast between man's mortality and immortality was already a pervasive theme in many kinds of representational painting, and was especially apt in the portrait, which preserved the appearance of the living sitter long after his or her death. A characteristic example would be the portrait of Sir Thomas Chaloner the elder, which is dated 1559 and attributed to a Flemish hand (Pl. 26).[191] Here the sitter holds a balance of which one pan, containing jewels and a globe, is outweighed by the other, in which rests a book. The last line of the inscription, "Pondus inest menti, caetera vana volant", sums up the emblem, and other verses articulate the thought behind it: worldly possessions vanish like smoke or a click of the fingers, but the thinking mind survives death and gains greater glory in its afterlife.[192]

A second such portrait, closer to Rembrandt's time, is the Holme family portrait, dated 1628, in the Victoria and Albert Museum. Two rebuses painted on the outside of the wings of this triptych (Pl. 27) illustrate a paraphrase of 1 Corinthians XV. 22: on the left, "WEE MUST [DIE ALL (supplied by a clockdial)]" and on the right "YET BY [CHRIST (supplied by a figure of Christ)] LIVE ALL". Many other portraits play on the same contrast either symbolically[193] or through inscriptions, an example of the latter being Dürer's engraving of Wilibald Pirckheimer, with its legend "VIVITVR INGENIO, CAETERA MORTIS ERVNT" (Fig. 8).

Among the many other genres which employ this bipartite motif is still-life painting. Some so-called *vanitas*-pictures, such as that reproduced in Pl. 28, imply that the futility of lives doomed to extinction, as represented by a skull and other objects, is redeemed by the possibility of resurrection, as signified by the presence of ears of corn.[194]

A third and most relevant genre pervaded by these ideas is anatomical illustration. The bipartite motto "VIVITVR INGENIO ..." which appeared in Dürer's Pirckheimer portrait of 1524 (Fig. 8) is conspicuous also in Vesalius's anatomy-book of 1543 (Fig. 9), and the skull-but-corn motif, which was illustrated here in a Dutch

of the former oration), would probably have been the subject of Rembrandt's picture also. On present evidence this seems improbable, since the speech mentioned by Beverwijck was made when he was "starting out in the medical profession" (Beverovicius, loc. cit.): according to Banga (op. cit., note 29 above, p. 288) Beverwijck had returned from study in Italy *c.* 1617, and was already established as city-physician at Dordrecht in 1625, four years before Tulp's inaugural oration. The question remains open.

[191] National Portrait Gallery, London, no. 2445; R. Strong, *Tudor and Jacobean portraits,* London, HMSO, 1969, vol. 1, pp. 45–46. Currently exhibited at Montacute House, Somerset (National Trust).

[192] Strong, ibid., prints the text and gives a not very reliable paraphrase. Is it possible that Chaloner's left thumb and middle finger demonstrate that "click of the fingers" (*crepitus presso pollice dissiliens*) which is mentioned in the poem?

[193] This may be the sense of those portraits in which the sitter is accompanied by a skull (for death) and a flower (for resurrection?): e.g. London, National Gallery no. 1036, portrait of a man, Netherlandish school *c.* 1535 (?); Amsterdam, Rijksmuseum no. 1290. Al, portrait of Pompeius Occo by Dirk Jacobsz. 1531; the Hague, Mauritshuis no. 695, portrait of a woman, Flemish school *c.* 1615. It is only in some cases that we can be sure that the flower is also a *vanitas* motif.

[194] I. Bergström, *Dutch still-life painting in the seventeenth century,* London, Faber & Faber, 1956, pp. 154, 177–178, 182, 307. B. A. Heezen-Stoll, 'Een vanitasstilleven van Jacques de Gheyn II uit 1621', *Oud Holland,* 1979, **93**: 217–250, calls pictures of this type "afwijkende vanitasvoorstellingen", divergent *vanitas*-representations (p. 220).

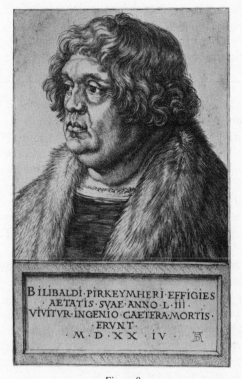

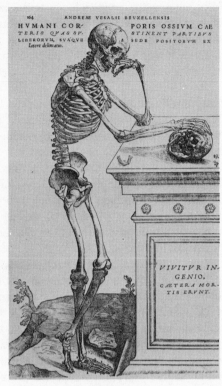

Figure 8.

Figure 9.

Figure 8. Albrecht Dürer, portrait of Wilibald Pirckheimer, engraving, 1524.

Figure 9. Lateral view of the human skeleton, anonymous woodcut after a design by Johan Steven van Kalkar (?) and Domenico Campagnola (?) after dissections by Andreas Vesalius for his *De humani corporis fabrica*, Basle, 1543, p. 164.

still-life of 1659 (Pl. 28), also appears in a Dutch anatomy-book of 1654, where the pessimism of a skull engraved on the title-page is tempered by the presence of a vast swag of vegetation (Pl. 29).

The master-genre on which these others draw is funerary art, of which the contrast between the mortal and the immortal is the central subject. The funerary portrait is a common type, and all the other elements of the contrast are found on a tomb such as that of Archbishop Law of Glasgow, who died in 1632, the date of Rembrandt's Tulp picture. On this monument (Pl. 30), which was erected by the archbishop's widow, we find again the bipartite inscription contrasting death and resurrection; the skull and cross-bones which illustrate the first half of the inscription; and the golden ears of corn which illustrate the second.

In many of these works the contrast is weighted towards optimism: man's earthly remains, his body, possessions, and power, die, but his divine element, mind or soul, lives on. Rembrandt's picture (Pl. 1) also seems to show the same optimistic tendency, for the attention of the surgeons is not suspended evenly between van Loenen and

Tulp, but mostly inclined towards the latter, who teaches the optimistic lesson *est Deus in nobis*. Interpreted thus, Rembrandt's picture would bear out the remark, originally made of a different kind of painting, that Dutch pictures of the early seventeenth century "display an overwhelming preference for . . . underlining the importance of salvation".[195]

Nevertheless, the two poles of the contrast are more equivocally related in Rembrandt's painting (Pl. 1) than in the other works to which we have likened it. For although Tulp's optimistic argument preponderates, van Loenen's pessimistic message still stands, and the juxtaposition of the two conflicting doctrines, both of them considered valid, has the effect not of a compromise, but of a paradox. Man is stated to be, in Hamlet's words, both "the quintessence of dust" and yet "in apprehension how like a god"; or in Tulp's own paradoxical phrase, *homo animal vere divinum*.[196] The subject of the picture is therefore not the two lessons but the antinomial paradox of their co-existence. Each lesson, but especially the more emphatic optimistic one taught by Dr. Tulp, gains greater significance in the face of the assertion of the other.

If this interpretation is correct, Rembrandt's picture of 1632 (Pl. 1) is not only a portrait, but also a "metaphysical painting" comparable to the "metaphysical poetry" that was circulating in Amsterdam at precisely that time. The love of paradox which characterized such literature was Italian in origin, being derived from Ovid, Petrarch, and sundry Cinquecento poets, and this Italian gift was diffused northwards in verse and prose, in Latin and the vernacular, in manuscripts and printed books. It entered the Netherlands both directly from Italy and through the literatures of other nations, notably France, which had already absorbed it.[197] One such literary vehicle was the group of nineteen English poems by John Donne which were translated into Dutch between 1630 and 1633 by Constantijn Huygens, a knight of James I's creation and a personal acquaintance of Donne.[198] One of those at Amsterdam who read with delight the manuscripts of these translations of Donne was the poet Caspar Barlaeus,[199] whom we have already met as the author, in 1639, of the poem in which the two Laurentian lessons of anatomy were ascribed to Dr. Nicolaes Tulp.[200]

It seems not to have been noticed in previous discussions of the work that this short Latin poem by Barlaeus is itself a fine example of the "metaphysical" type, and so, not only in subject but also in treatment, a literary counterpart to Rembrandt's painting as we have interpreted it. The value of Barlaeus's poem in clarifying the mood and

[195] Miedema, loc. cit., note 118 above.

[196] W. Shakespeare, *Hamlet*, II, ii. Tulp (1641), III c.4, p. 188.

[197] Leonard Forster, *The icy fire*, Cambridge University Press, 1969, pp. 1–60, 'The Petrarchan manner', gives an outline sketch of this process. A. E. Malloch, 'The techniques and function of the renaissance paradox', *Studies in philology*, 1956, **53**: 191–203, adds a dash of scholastic argument to the mixture.

[198] J. A. van Dorsten, 'Huygens en de engelse "metaphysical poets",' *Tijdschrift voor Nederlandse taal- en letterkunde*, 1958, **76**: 111–125. Rosalie Colie, 'Constantijn Huygens and the metaphysical mode', *Germanic Review*, 1959, **34**: 58–73. On Huygens and Rembrandt see Slive, op. cit., note 54 above, pp. 9–26.

[199] F. F. Blok, *Caspar Barlaeus: from the correspondence of a melancholic*, Assen and Amsterdam, van Gorcum, 1976, pp. 144–146.

[200] pp. 31–33 above.

meaning of Rembrandt's picture can only be appreciated from a reading of the whole work, which is therefore cited in translation here and in the original language in an appendix below.[201]

Caspar Barlaeus

On the place for anatomies which has recently been constructed at Amsterdam

Evil men, who did harm when alive, do good after their deaths:
 Health seeks advantages from Death itself.

Dumb integuments teach. Cuts of flesh, though dead,
 for that very reason forbid us to die.

Here, while with artful hand he slits the pallid limbs,
 speaks to us the eloquence of learned Tulp:

"Listener, learn yourself! and while you proceed through the parts,
 believe that, even in the smallest, God lies hid."

The poem is a plexus of oxymora, in which good and evil, speech and silence, life and death, Infinite and infinitesimal are pointedly juxtaposed. The couplets, each containing at least one paradox, next within each other like Chinese boxes, so that the enigmatic opening verse epitomizes the paradox of the poem as a whole: that within the quintessentially mortal, the cadavers of executed criminals, man could recognize the divinity in which lay his hope of eternal life. In Rembrandt's painting (Pl. 1) we find the identical subject, a comparable method, and a similar conclusion, but with the more pessimistic tinge that is suitable for a portrait.

While Frans van Loenen, like Dr. Egbertsz. and Dr. Fonteyn, points out the obvious mortality of man, Dr. Nicolaes Tulp reveals the more elusive element that does not die. If our interpretation is correct, it was this metaphysical contrast that the civic anatomist of Amsterdam in 1632 claimed to teach through anatomy. To preserve this lesson for posterity, Nicolaes Tulp entrusted it not to a printer but to a painter, a young man recently arrived in the city from Leiden. The sitters are long dead, but thanks to Rembrandt's art of durable pigments the picture survives today to exemplify its own message. Portrait, history-picture, emblem-picture, "metaphysical" picture, and finally *exemplum sui;* devised by a physician, realized by surgeons, and figured by a painter: such a fusion of genres and federation of skills illustrates the crowning attainment of unity in diversity, that paradoxical and most desirable quality in any work of art.

[201] The edition of the poem published in Appendix IV below and the translation presented here both differ from the transcript and English version published by Heckscher (pp. 112–113).

SYNOPSIS OF APPENDICES

Appendix I (pp. 52–56 below) states the case for the interpretation, offered on pp. 7–8 above, of the dissection which is illustrated in Rembrandt's painting (Pls. 2, 9).

Appendix II (pp. 57–65 below) provides precedents for the ideas about the human hand which, on pp. 20–23 above, are attributed to Nicolaes Tulp. This compilation is intended to make more credible the hypothesis that Tulp's action in Rembrandt's picture is another illustration of the same ideas.

Appendix III (pp. 66–84 below) reveals the tradition of invoking the Delphic maxim "know thyself" as the rationale of anatomy. In some cases the knowledge of oneself that is said to be gained from anatomy is combined with knowledge of God. According to our hypothesis (pp. 37–38 above), Tulp's design for Rembrandt's painting also illustrates the same two forms of knowledge.

Appendix IV (pp. 85–89 below) is devoted to Caspar Barlaeus's poem of c. 1639 on the anatomy-theatre at Amsterdam. The punctuation of our edition of the poem and the commentary on its verses 7–8 provide evidence for the attribution to Nicolaes Tulp of the ideas more fully stated in Appendix III. The commentary also identifies paradox as the poem's chief ingredient, and so documents the hypothesis stated on pp. 41–49 above, that Tulp's intention for Rembrandt's picture was to illustrate a paradox.

Appendix V (pp. 90–102 below) illustrates the tradition of interpreting the Delphic maxim "know thyself" in the pessimistic sense "recognize that you are mortal". This is the meaning attributed on pp. 43–44 above to Frans van Loenen's gesture in Rembrandt's painting.

Appendices III and V, which are devoted to "know thyself", are included because the otherwise very comprehensive monograph on the proverb, *The Delphic maxims in literature* by Eliza Gregory Wilkins (Chicago, 1929), deliberately (p. vi) omits all references from "scientific" literature, which is the subject of the present Appendix III, and greatly underestimates (p. 93) the longevity and force of the pessimistic interpretation which is the subject of Appendix V. Of the 72 items in these two appendices (64 separate + 8 overlapping), 64 were not recorded by Wilkins, and their inclusion here does modify the thought-picture presented in her invaluable book.

However, it is emphasized that the present documentary appendices (nos. II, III, V) are themselves far from exhaustive: a considerable surplus has been omitted, leaving only a representative number of items in each appendix.

APPENDIX I

THE DISSECTION*

The above interpretation of Rembrandt's painting depends to some extent on a particular view of the dissection shown in the painting. Since the identification of the dissected muscles is a matter of dispute, this note is appended to justify the view we have adopted on pp. 7–8 above. Our illustration is Pl. 9.[202]

The currently favoured interpretations of the muscles are due to Jacob Meyer.[203] Meyer's interpretations depend on his view of the orientation of the limb. This view in turn depends on a certain observation which all writers on the subject have thought too obvious to be mentioned. The subject of this observation is the course of the muscle held in Dr. Tulp's forceps. It may be stated thus:

A The muscle, if followed up the limb from the hand to the elbow-joint, passes to the outer, or further, side of the limb after leaving the forceps.

This observation, which is also an interpretation, has invisibly governed almost all discussion of the matter since 1900, when it underlay the remarks by J. K. A. Wertheim-Salomonson (hereafter W.-S.) which were published by E. van Biema.[204] From W.-S. to Meyer and after, scholars have assumed A, drawn various deductions from it, and presented their conclusion as "Rembrandt's anatomical error".

The argument of W.-S.,[205] for example, if reduced into its constituent parts, must have been as follows:

A The muscle arises on the further side of the limb [*observation*].
B The muscle must arise from an epicondyle [*normal anatomy*].
C On the further side, where the muscle arises [*A*] are two yellowish streaks [*observation*].
D Therefore these two streaks are an epicondyle [*deduction from ABC*].
E The hand is supinated [*observation*].
F Therefore the orientation of the limb is as in anatomical position [*deduction from E*].
G Therefore the further side of the limb is the lateral side [*deduction from F*].
H Therefore the two streaks are the lateral epicondyle [*deduction from DG*].
I The muscle is on the same side of the limb as the palm of the hand [*observation*].

*Researched in collaboration with Dr. J. G. Bearn.

[202] The best published illustration is in J. Bolten and H. Bolten-Rempt, *The hidden Rembrandt*, Oxford, Phaidon, 1978, pp. 38–39.

[203] In Cetto, p. 309.

[204] E. van Biema, 'L'histoire d'un chef-d'oeuvre', *Revue de Belgique*, 32nd year, 1900, 2nd ser., **28**: 367–373.

[205] Ibid. p. 370: "Tulp tient dans ses pinces le fléchisseur commun des doigts. La main du cadavre étant représentée en supination extrême, l'épitrochlée doit se présenter à la face interne du bras collé au corps, l'épicondyle à la face externe. Or, la partie du coude montrée par le peintre est l'épicondyle. Rembrandt commet ainsi l'erreur d'insérer le fléchisseur commun des doigts dans l'épicondyle, alors que l'anatomie nous le montre ayant son insertion dans l'épitrochlée." Here "épicondyle" means lateral epicondyle, "épitrochlée" medial epicondyle.

J Therefore a flexor muscle [*normal anatomy*].

K Therefore the flexor muscle arises from the lateral epicondyle [*deduction from CHJ*].

L The flexor muscles should arise from the medial epicondyle [*normal anatomy*].

M Rembrandt's error: the muscle originates from the wrong epicondyle [*deduction from KL*].

Meyer's argument starts *ABCD*, omits *EFGH* and goes straight into *IJL*, the absence of *K* being due to its dependence on the omitted *H*. Then:

M^1 The two streaks are the medial epicondyle [*deduction from DJL*].

C The two streaks are on the outer side of the limb [*observation*].

N Therefore the medial epicondyle is on the outer side of the limb [*deduction from M^1C*].

O When the limb is in anatomical position, the medial epicondyle is on the inner side of the limb [*definition*].

P Rembrandt's error: he has depicted a limb rotated sufficiently outwards from anatomical position to carry the medial epicondyle to the further side [*deduction from NO*].

In the latter argument one finds several flaws: for example, *E* therefore not-*P*, and *P* itself would rule out the observation of *I*. But both arguments overlook a more important point: if *J* is true, *A* itself would be an anatomical error. In other words, if the muscle is a flexor muscle, as all agree, then it should proceed from the forceps to the elbow in a medial direction, and approach the viewer, whereas according to *A* it is observed to proceed laterally and recede into depth. However the limb may be orientated, the proximal end of the muscle should be medial to any more distal part of it. The error is therefore what is silently assumed (the original axiom *A*, that the muscle is misdirected), not what is actually alleged (the misattachment of the muscle *M* or the rotation of the limb *P*). It is not surprising that different anatomists have differently identified "Rembrandt's error", for the "errors" are merely deductions from the real, unnoticed error, and many such deductions could be made.

Hence, "Rembrandt's error" (*A*) would not be absolved if it were shown that *BCD* ... *NOP* were all false. Recently, Drs. Carpentier Alting and Waterbolk (hereafter C.A. and W.) of the University of Groningen challenged *D*: of the many structures on the lateral side of the elbow-joint, the two yellowish streaks are less likely, in their opinion, to be an epicondyle, and more likely to be a characteristic broad double strip of tendon that runs into the cubital fossa.[206] We agree, but whether as tendons or as epicondyle this structure would still be lateral to the muscle in the forceps, the muscle would still have to recede from the viewer in order to approach it (according to *A*), and "Rembrandt's error", the misdirection of the muscle, would remain.

However, just as the real charge against Rembrandt (*A*) was unwittingly concealed behind the unjust charges (*M*, *P*), so the real reason for acquitting him was unwittingly

[206] M. P. Carpentier Alting and Tj. W. Waterbolk, 'Nieuw licht op de ontleedkundige fouten in Rembrandt's "Anatomische les van Dr. Nicolaas Tulp",' *Nederlands Tijdschrift voor Geneeskunde*, 1976, **120**: 1900–1902; and 'Nieuw licht op de anatomie van de "Anatomische les van Dr. Nicolaas Tulp",' *Oud Holland*, 1978, **92**: 43–48.

concealed by an unneeded defence. C.A. and W. thought they were absolving Rembrandt by amending *D*, but they actually did so by assuming not-*A*. Their argument against *D* rests on their silent assumption that the muscle, far from receding as it leaves the forceps (as W.-S., Meyer, and others assumed), instead veers sharply towards the medial side of the elbow, that is, towards the viewer.[207] The same observation is interpreted in the opposite sense.

The reason for this difference seems to be that Rembrandt's painting is ambiguous. As the muscle leaves the forceps and proceeds to the elbow, it tapers and darkens. It seems to a first impression that both these changes are due to recession in perspective. The tapering, however, does not imply recession, for the local shape of the muscle tapers between the belly and the tendon: the tapering is physical, and not, as the layman assumes, optical. The line of the muscle therefore supports the view of C.A. and W. The shading, however, implies otherwise. For if the muscle on the left of the forceps veers towards the viewer, as C.A. and W. suppose, it must face in the same direction as the phalanges of Dr. Tulp's left hand. The latter are illuminated, therefore the muscle on the left of the forceps should be illuminated also, but it is actually dark, whereas the muscle on the right of the forceps should be dark but is actually pale, and even throws off a highlight (brilliant-white, in contrast to the yellowish colour of the tendons). The lighting therefore goes against the interpretation of C.A. and W. The proof of this is the fact that, in the diagram which illustrates their interpretation, Rembrandt's lighting is reversed: the left side is lit, the right side shaded.[208]

It appears that "Rembrandt's error" is simply to have painted part of a muscle slightly darker than the lighting in the picture would require. Since so many trivial causes for this anomaly can easily be imagined, and since there is no other ground for suspecting the orientation, it would surely be a mistake to see in this dark red patch either a wrong claim about the normal direction of a muscle (*M*) or a reason for thinking that the model was wrongly posed (*P*). We therefore accept the conclusion of C.A. and W. on the orientation of the limb: in relation to its own axis, the limb is in anatomical position; in relation to the rest of the body, it is out of anatomical position only in the unimportant sense that the hand rests on the groin instead of beside the trunk.

Having established that the orientation of the limb is practically normal, we proceed to the identification of the muscles. According to the interpretation of C.A. and W., and limiting our discussion to matters which affect the larger interpretation of the picture, the muscles in the forceps are *mm. flexores digitorum superficialis et profundus*; the long, straight muscle that runs underneath them is *m. flexor carpi ulnaris*; and the short muscle which slopes down on the medial or inner side of the incision is *m. palmaris longus*. The nerve which passes to the little finger is regarded as an abnormal form of *n. ulnaris r. dorsalis manus*.[209]

This interpretation can be challenged on three counts. (1) It rests on the assumption *P* that "the entire left arm has been rotated about 75° outwards",[210] but C.A. and W.

[207] Ibid., 1976 p. 1900, and 1978 p. 46.
[208] Ibid., 1976 p. 1901, and 1978 p. 44.
[209] Ibid.
[210] Meyer, loc. cit., note 203 above.

had already undermined this assumption through their withdrawal of *A*. The postero-lateral view implied by *P* must therefore be rejected. (2) It has numerous intrinsic weaknesses. What is called "*m. flexor digitorum profundus*" appears in the diagram of C.A. and W. in a place which is void in the painting.[211] "*M. flexor carpi ulnaris*" is aligned too far laterally for that muscle, and issues an inapt aponeurosis at its distal end. "*M. palmaris longus*" should be very slender and tendinous, whereas here it is a thick muscle-belly. Finally, the variation in the course of the nerve is undesirable. (3) The dissection is irrational. It would mean that Dr. Tulp is distinguishing both of the finger-flexors (together, according to C.A. and W., with one of the wrist-flexors) from the palmar muscle together with the other wrist-flexor. This grotesque arrangement does not distinguish finger- from wrist-muscles, radial from ulnar, or superficial from deep. It teaches nothing to the surgeons or to the viewer. Such a dissection could not have been obtained accidentally, yet it is hard to imagine what reason there could be for bringing it about on purpose.

The interpretation which we propose is simple and unoriginal. It assumes an ordinary right antero-lateral view of the limb, according to which the medial epicondyle is buried behind the triangle of undissected skin at the proximal end of the medial side of the incision.[212] We identify the muscles as follows.

1. *M. palmaris longus* is not shown in the picture. It is absent in many humans,[213] and in dissection, when present, it often comes off with the skin. A comment on this muscle by a surgeon who often worked with Dr. Tulp is relevant here:

> The first flexor is the palm-muscle [*palmaris longus*], which has a nerve-like texture, and is so intimately attached to the skin that, however closely one looks for it, it often cannot be found at all, much less separated cleanly. For we can testify that Mathijs Calkoen, an eminent surgeon of his day, in a certain anatomy conducted very successfully by the physician Mr. Nicolaes Tulp, worked continuously for more than eight hours before he could distinguish the aforesaid muscle from the skin and underparts, and even then only roughly.[214]

Moreover, functionally *m. palmaris longus* would have added nothing to Tulp's demonstration.

2. The sloping muscle previously identified with *m. palmaris longus* is *m. flexor carpi ulnaris*.

3. The long straight muscle previously identified with *m. flexor carpi ulnaris* is *m. flexor digitorum profundus*. Hence the distal aponeurosis and the central alignment in the limb.

[211] See note 208 above.

[212] Carpentier Alting and Walterbolk (1976), op. cit., note 206 above, p. 1900.

[213] *Gray's Anatomy*, 36th British edition, Edinburgh, Churchill Livingstone, 1980, pp. 574–575.

[214] J. J. van Meekeren, *Heel- en genees-konstige aanmerkkingen*, Amsterdam, 1668, c. 62, pp. 375–393, p. 385: "De eerste buyger is de *Palm-spier,* die van een zenuagtige vlies is t'zamen geweven, en aande huyd zoo vast verknoogt, dat dikmaals, hoe nauw men snuffelt, die selve niet gevonden (wy laten staan) veel minder zuyver gescheyden kan worden: want wy moogen met de waarheyt seggen, dat *Matthijs Kalkoen,* in zijn leven aanzienlijk heelmeester, in zeek're ontleeding by de geneesheer, [p. 386] *de Heer Nicolaas Tulp* loffelijk afgeleyt, meer als agt uuren over een boeg, schilden; eer hy de voornoemde spier, hoe wel oneffen genoeg, van de huydt en onderdeelen had afgeschilt." On the additions in the Latin edition see note 96 above.

4. The muscle that was previously identified with *m. flexor digitorum profundus* has no real equivalent in the painting: it is a swollen version of one of the bellies hanging from the bundle in the forceps. This belly is either part of *m. flexor digitorum superficialis* or, less likely, *m. flexor pollicis longus* glimpsed through the gap caused by the raising of *m. flexor digitorum superficialis*.

5. The clump of muscle in the forceps is *m. flexor digitorum superficialis*, probably with a slip of *m. flexor carpi radialis* (the latter suggested by C.A. and W.).

6. The nerve is merely *n. ulnaris r. superficialis manus* following its normal course.[215]

According to this interpretation, Dr. Tulp is lifting the belly of *m. flexor digitorum superficialis* off the belly of *m. flexor digitorum profundus*. This is the simplest interpretation, because it has always been agreed that the tendons which are portrayed in the fingers of the corpse are those which should derive from precisely these two flexor-muscles.[216] The muscles visible in the forearm are merely those which are connected with the tendons visible in the hand. This interpretation is unoriginal, because it was first proposed by W. Hastie in a little-read article published in 1891, nine years before Wertheim-Salomonson's influential conversation with E. van Biema.[217] Finally, it seems to be the most rational interpretation: it gives us Dr. Tulp demonstrating the interaction of the two sets of finger-flexors, a point which had long been appreciated by anatomists;[218] which is illustrated by Tulp's own gesture with his left hand; and which provides a worthy object of Mathys Calkoen's otherwise unaccountable astonishment.[219]

In the experiments on which this note is based, attempts were made to recreate Dr. Tulp's dissection firstly in a limb attached to the cadaver, and secondly in a detached limb from another cadaver. But the most convincing likeness was obtained when a detached limb was placed over an attached limb, and Dr. Tulp also may have used this trick for Rembrandt's convenience.

[215] *Gray's Anatomy,* ed. cit., note 213 above, pp. 1099–1100.

[216] van Biema, op. cit., note 204 above, p. 370 "le peintre apporte un soin méticuleux à préciser le dessin des tendons fléchisseurs des doigts". G. A. Lindeboom, 'Medical aspects of Rembrandt's "Anatomy lesson of Doctor Tulp",' *Janus,* 1977, **64**: 179–203, pp. 192–193.

[217] Hastie, op. cit., note 169 above.

[218] See Appendix II, pp. 57–64 below.

[219] See p. 23 above.

APPENDIX II

THE SPECIAL SIGNIFICANCE OF THE HAND

A. SYNOPSIS

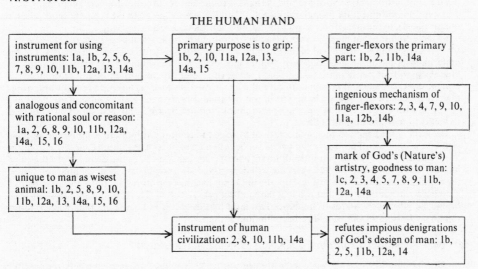

THE HUMAN HAND

instrument for using instruments: 1a, 1b, 2, 5, 6, 7, 8, 9, 10, 11b, 12a, 13, 14a

primary purpose is to grip: 1b, 2, 10, 11a, 12a, 13, 14a, 15

finger-flexors the primary part: 1b, 2, 11b, 14a

analogous and concomitant with rational soul or reason: 1a, 2, 6, 8, 9, 10, 11b, 12a, 14a, 15, 16

ingenious mechanism of finger-flexors: 2, 3, 4, 7, 9, 10, 11a, 12b, 14b

unique to man as wisest animal: 1b, 2, 5, 8, 9, 10, 11b, 12a, 13, 14a, 15, 16

mark of God's (Nature's) artistry, goodness to man: 1c, 2, 3, 4, 5, 7, 8, 9, 11b, 12a, 14a

instrument of human civilization: 2, 8, 10, 11b, 14a

refutes impious denigrations of God's design of man: 1b, 2, 5, 11b, 12a, 14

KEY:

1 Aristotle	B.C.	382–322	**9** J. Banester		1578
2 Galen	A.D.	129–200	**10** A. Piccolomini		1586
3 N. Massa		1536	**11** A. Laurentius		1599
4 A. Vesalius		1543	**12** C. Bauhin		1605
5 J. Lygaeus		1555	**13** P. Paaw		1615
6 J. C. Scaliger		1557	**14** H. Crooke		1615
7 M. R. Columbus		1559	**15** C. Hofmann		1625
8 V. Coiter		1572	**16** J. Riolan		1626

proposed addendum
16.1 N. Tulp 1632

B. TEXTS

1a Aristotle, *De anima* III. 8 (432 a 1), translated.

. . . So the soul is as the hand; for the hand is an instrument with respect to instruments, the intellect is a form with respect to forms, and sense-perception a form with respect to things perceived.

1b Aristotle, *De partibus animalium* IV. 10 (687 a 5– b 24), translated.

Being erect by nature, man has no need of fore-legs, and so in their stead nature has given him arms and hands. Anaxagoras deduced that it was through having hands that man was the most intelligent animal, but it is a more reasonable view that man received hands because he was the most intelligent. For the hands are an instrument, and nature, like an intelligent person, always distributes instruments according

57

to the recipients' ability to use them. It is more fitting to give a flute to a man who can already play one than to teach the art of flute-playing to a man who has a flute. Nature adds the lesser to the greater and more important, not the other way round. If this is the better way, and nature brings about the best of possible states, then it is not that man is the most intelligent animal because he has hands, but rather that he has hands because he is the most intelligent. For the most intelligent animal would be the one which put the most instruments to good use, and the hand is equivalent not to one instrument but to many. It is, as it were, an instrument for [using] instruments. Therefore nature has given the hand, the most versatile of instruments, to the animal able to take up the most various skills [namely, man].

So those who say that man, far from being well constructed, is the worst constructed of all animals – for they say that he is unshod, naked, and without a weapon for self-defence – speak incorrectly. For the other animals have one defence which they cannot exchange for another: they must sleep and do everything without, as it were, taking their sandals off; never lay down their bodily protection, nor change whatever weapon they happen to have. But a man can have many defences and can always change them, and can have any weapon he pleases on any occasion. For the hand is claw and hoof and horn, and spear and sword, and any other weapon or instrument whatever. It will be all these things on account of its ability to seize and hold all of them.

The form of the hand has been well contrived by nature to conform with this role, for it is divided and cleft into many parts. The capacity of united action is permitted by its being divided, but the capacity of divided action would not be permitted if it were a unity. One can use one or two divisions at a time, and in many ways. The joints of the fingers are well constructed for grasping and applying pressure. One of the fingers is placed sideways, and is short and thick, not long like the others; for if it were not so placed, grasping could not occur any more than if the hand did not exist at all. This finger presses upwards from below, the others downwards from above. This must happen if it is to hold things tightly like a strong clamp, the force of the one equalling that of the many

1c ps. – Aristotle, *Problemata* XXX. 5 (955 b 23), translated.

. . . God has provided us with two inner instruments with which we use outside instruments, the hand for the body and the intellect for the soul

2 Galen, *On the use of parts*, books I–II *passim*; book III cc. 1, 10; book XVII c. 1.[220]

Galen's account of the hand starts from Aristotle's ideas quoted above, but provides vastly more anatomical and philosophical detail, and evinces greater and more overt enthusiasm for the teleological implications of anatomy.[221]

3 Nicolaus Massa, *Liber introductorius anatomiae . . . opus sane tam medicis, quam philosophis perutile, ut studiosis lectoribus patebit*, Venice, 1536. Fol. 97[r]:

Sed quod & pulcherrimum est uidere, & non sine Dei optimi benedicti maximis laudibus, est compositio ipsius manus, siue instrumentorum mouentium ipsam manum Sed a prima [iunctura digitorum] procedunt chordae perforantes istas chordas, quae figuntur in secunda iunctura per ligamentum cooperiens ipsas chordas, & per illa foramina transeunt ad tertiam iuncturam digitorum, mouentes ipsas, & uniuntur cum summis extremitatibus ossium digitorum, & ita uidebis quod chordae quae mouent primas iuncturas, mouent etiam tertias. Istas tamen perforationes, & coniunctiones chordarum mirabiles non poteris inspicere, nisi prius incisis tegumentis membraneis[222]

[220] Text edited by G. Helmreich, 2 vols., Amsterdam, Hakkert, 1968 (repr. of Leipzig, Teubner, 1907–9 ed.).

[221] Karl Gross, 'Galens teleologische Betrachtung der menschlichen Hand in *de usu partium*', *Sudhoffs Archiv*, 1974, **58**: 13–24. A picture of Galen lecturing on the uniqueness of the human hand existed in a fifteenth-century Flemish manuscript (published by E. C. van Leersum and W. Martin, *Miniaturen der lateinischen Galenos-Handschrift der Kgl. Oeffentl. Bibliothek in Dresden Db 92–93*, Leiden, A. W. Sijthoff, 1910, illus. 20, from fol. 59[r]) until it was ruined in the second World War (V. Nutton, 'A forgotten manuscript of Galenus latinus', *Studia codicologica*, Berlin, Akademie Verlag, 1977, pp. 331–340, p. 334).

[222] English translation in L. R. Lind, *Studies in pre-Vesalian anatomy*, Philadelphia, American Philosophical Society, 1975, pp. 246–247.

4 Andreas Vesalius, *De humani corporis fabrica*, Basle, 1543. Book II, ch. xliii, p. 305:

Caeterum his primi musculi tendinibus [=of *m. flexor digitorum superficialis*] ubi primo digitorum ossi incumbunt, & priusquam secundum conscenderunt (quanquam secus Galeno uisum fuit) peculiare rarumque ex abundanti id accidit, quod longa sectione diuisi, alium ipsis substratum transmittant tendinem, de quo statim ac praesentis musculi functionem sermoni addidero, sum pertracturus. . . . Quemadmodum autem per uniuersam cubiti longitudinem & bra-[p. 306] chiale secundus musculus [=*m. flexor digitorum profundus*] primo substernitur, ita quoque primi tendinibus secundi tendines subijciuntur Porro ut secundi musculi tendines ad tertium digiti internodium pertingerent, primi iam musculi tendinibus in secundum os necessario insertionem molientibus, operae precium fuit secundi musculi tendines, aut ad tendinum primi musculi latera porrigi, aut quum ipsi recta subijciuntur, incumbentem ipsis tendinem perforari, hacque ratione substratum secundi musculi tendinem transmitti. At . . . [the former alternative being impractical] . . . reliquum profecto fuit, longa sectione superiorem tendinem, qui primi musculi soboles est, a summo rerum Opifice mirabili industria findi, qua sectione secundi musculi tendo uectus, ad tertij ossis radicem pertingeret.[223]

5 Joannes Lygaeus, *De corporis humani harmonia libri IIII*, Paris, 1555. Liber I, excerpt, fol. 4r:

> Principio mundi cum bruta animantia passim
> arbitrio fuerint solo producta Deorum:
> solum hominem demum fabricatum pollice sacro,
> atque adeo afflatum uitali coelitus aura,
> testantur longo diuina uolumina tractu.
> Naturae omniparentis opus mirabile multum
> inde ego perpendens, Homini inter caetera soli
> quippe animal diuum & sapiens, digitosque manusque,
> brachiaque, inspicio melioris tradita causa:
> a quibus ordiri libet, imprimisque fateri
> ignauum humano non esse in corpore quicquam:
> omnia sed uarios constructa decenter ad usus
> [fol. 4v] Hic uero imprimis interpellemus eorum
> sermones, quibus ipsi homini Natura nouerca est
> tristior, at brutis melior materque parensque.
> Nudus homo in lucem lugens excluditur, aiunt,
> abiectus, nec habet quo se defendere possit
> Verum Homo, solum animal sapiens, non indiget armis,
> non rigido cornu, non dente, nec unguibus uncis,
> scilicet ut prompte his se possit ubique tueri:
> cum ratione Manus, rerum Deus ille creator,
> apta homini instrumenta dedit, quibus hostibus impiis
> cominus obsistit, natura ceu sibi ab ipsa,
> prompta arma abripiens

6 J. C. Scaliger, *Exotericarum exercitationum liber xv. De subtilitate, ad Hieronymum Cardanum,* Paris, 1557. Exercitatio cclvi, 'Ratio. Ingenium. Iudicium. Sermo. Manus', fol. 331r:

Manus uero additae: propterea quod intellectus duplex est: ad cognoscendum: & ad faciendum: unde scientia, et ars. Quas non principiis, sed fine distingui, multis in locis est a nobis demonstratum. Iccirco dicere solitus aliquando fueram: Rationem esse manum intellectus: rationis orationem: orationis manum. Manus enim iussa facit: iussa obediunt rationi: ratio uis intellectus est. Aristoteles in tricesima sectione, de intellectu, scientia, manu, organis, multa apposite, acute, sapienter. Vbi etiam dicit, a Deo data omnia: agnoscitque Eum caussam efficientem . . . Aristoteles in tertio De anima, ἡ χεὶρ ὄργανόν ἐστιν ὀργάνων. ὁ δὲ νοῦς εἶδος εἰδῶν.

[223] The corresponding passage in the 1555 Basle edition (p. 366) is much less Galenic: the phrase *a summo rerum Opifice* is omitted.

7 M. Realdus Columbus, *De re anatomica*, Venice, 1559. Lib. V, cap. xxxiii, p. 156:

De musculis summam manum mouentibus. Manus (vt Aristo. & Gal. inquiunt) organum est organorum: eiusque structura admirabilis est summum artificium prae se ferens. Hanc Deus opt. max. homini concessit vt huius ope omnes artes exercere, seque ab externis iniurijs tueri posset; de qua cum Gal. vir eloquentissimus tam longo processu primo *de vsu part.* loquutus fuerit, hoc argumentum lubens praeteribo. Ego de summam manum mouentibus musculis postremo loco verba facturus sum hanc vnam ob causam, quod, cum illorum compago miraculi instar esse videatur, in calce de his loquendum existimaui, vt memoriae magis inhaereant, quae in libri calce leguntur. Cum autem Gal. qui & ipse miram hanc compagem vidit & animaduertit, statim in initio rem hanc tractauerit, non iniuria quispiam huius mei ordinis causam quaeret. Ne existimetis me in finem hanc materiam reiecisse quod illius oblitus fuerim, vt Gal. contigit libro *de vsu part.* de musculis [p. 157] femoris, quos obliuione praeterijt; sed vt superius attigi, dedita opera hactenus distuli, vt res pulcherrimas, & maxime vtiles lectorum mentibus magis haererent ... [p. 158] ... Quartus musculus [=*m. flexor digitorum superficialis*] exortum habet admirabilem: nerueus etenim acutusque nascitur ab interno humeri tuberculo, carnosus postmodum fit, & iuxta cubiti radijque longitudinem defertur. Vbi medium cubitum praeterijt, in angustum tendit, terminaturque in quatuor tendines, teretes, nerueos, ac perforatos, qui sub ligamento brachialis deferuntur, sub quo tamen tres primi musculi non deferunter. Terminum habent hi tendines in secundo articulo quatuor digitorum quos flectunt, & quoniam tendinibus quinti musculi ad tertium articulum quatuor digitorum penetrandum erat, propterea natura hos perforauit, qui neruei sunt, pulchri, pellucidi; resque est & spectanda & admiranda. Hoc autem natua sagax effecit, vt digiti ordine quodam sese consequerentur.

Part of this text was translated by Banester, no. **9** below.

8 Volcher Coiter, *Externarum et internarum principalium humani corporis partium tabulae*, Nuremberg, 1572. 'Introductio ... prohoemium sive praefatio', excerpt, fol. AA1[r]:

... cum summus ille rerum creator mundi fabricam absoluisset, colophonem additurus totumque suum artificium, tanquam in epitomen (vnde philosophi hominem omnium rerum compendium appellant) redacturus, hominem creauit eumque vniuersis dominatorem praefecit ... Vnde quid mirum est, si Deus immensam & incomprehensibilem potentiam in humano genere condendo collocarit? ... Ideo non vt caeteris animantibus homini certa arma creauit, quibus aut vim, vel mortem inferat, vel illatam propulset, sed manum illi dedit organum ante omnia organa, quibus sibi uaria pro necessitate tum instrumenta, tum arma parare eaque pro temporis occasione & arripere & deponere posset

['Introductio ... cap. octavum', excerpt, fol AA3[r]:] In vniuerso corpore contemplanda, est figura, quam Deus homini dedit ad anime infinitas, variasque operationes exprimendas erectam: siquidem cum corpus animae diuinae sit instrumentum, et quasi lucerna, quo vt per lucernam lumen, sic per corpus anime actiones passionesque translucerent, ita componi oportuit, vt omnibus animae actionibus ancillari posset. Hinc factum est quod Deus homini soli inter omnia animalia manus instrumentorum instrumenta concesserit, quibus organa sibi machinatur ad omnes artes exercendas, ad vitam tranquillam, commodam & beatam ducendam, pertinet & huc magna distantia beneficio clauicularum, brachiorum a pectore. Quo vero manus tot adeoque varias actiones ederent, necessarium fuit adiungi corporis formam ad eas operationes exequendas, quam accommodatissimam

9 John Banester, *The historie of man, sucked from the sappe of the most approued anathomistes*, London, 1578.

[Fol. 31[r]:] ... Thus if we wel perpend the construction, and composition of the partes, and bones of the hand, our senses shall soone conceiue the maner of the action, with no lesse admiration, in beholdyng the handy worke of the incomprehensible Creator: who not one mite, or portion of a part hath sited anywhere, that serueth for no end, or vtilitie to the body: for how fit to apprehend are the handes, and how prompt to moue are the fingers, who is it that knoweth not? whiche made Aristotle call them instruments, or organs, before all organs, or instrumentes: and they are prest, necessary, and exquisite ... [verso] ... Finally this his [i.e. Galen's] saying is also worthy to be noted. As man, of all other creatures, is the most sapient, & wise, so also hath he handes, the most conuenient instrumentes to a sapient creature: yet not in that he hath hands, therefore he is the wisest, but because he is wisest, therefore he hath handes: for not handes, but reason instructeth man in artes

60

[Fol. 60ᵛ:] As touchyng the hand so notably of the omnipotent creator created, as that it is most apt, and prompt to all, and euery kynde of art, defence, and safe prouision for the body, so as no member more declareth the vnspeakable power of almighty God in the creatyng of man: because I will nether vse a double labor, nor yet detaine thee with vayne circumstaunce from the summe of the matter, I commit thee to the Hystory of Bones [i.e. fol 31ʳ, quoted above], where out of Galen compendiously we haue noted the noble vse and effourmation of this member.

[Fol. 61ʳ, 'The perforated tendons of the hand':] the end of these tendons is in ye second ioynt of the iii. fingers, which they serue to bow: & because they were to be penetrated by the tendons of the v. muscle, goyng to the iii, ioynt of the foure fingers as shal be sayd, therefore nature perforated these: which be sinewy, fayre, & shynning: a thing notable and marueilous to behold. This prudent nature also wrought, to the end that the fingers after a certaine order should follow one an other.

Indebted to Columbus, no. 7 above.

10 Archangelus Piccolhominus, *Anatomicae praelectiones*, Rome, 1586.

[Liber VII, lectio vii, 'de musculis apprehensoriis, idest, manum mouentibus . . .', conclusion, p. 326:] His paucis & breuiter & dilucide exposita sit mirifica ipsius manus fabrica. Ex quibus, illud manus encomium a maioribus praeditum, verissimum esse cognoscitur, cum promulgarunt, manum esse organum organorum.

[Liber VIII, lectio x, 'de ossibus digitorum', conclusion, p. 377:] Quis est totius manus vsus? Apprehensio; data enim in hunc finem est manus, & vt apprehendat & vt sit, scribente Aristotele, organum organorum, hoc est, organum & instrumentum ipsius mentis in efficiendis instrumentis omnibus ex aliqua materia constantibus, ad aliquam hominis commoditatem & vtilitatem spectantibus. Itaque manus erit mentis instrumentum, quum quibus animantibus caducis mens insit, in eisdem insit manus; & contra. Quemadmodum enim cerebrum est mentis sensitiuae instrumentum, quo vtitur in opera perficienda, quaecumque mens iusserit. Quam mirificum sit manus artificium & opificium, qui id exploratum habere cupit, legat Galeni primos de vsu partium libros, in quibus manuum nobilitatem & sublimitatem ita celebrat, vt omnes legentes & meditantes, in summam admirationem trahat.

11 Andreas Laurentius (Dulaurens), *Historia anatomica humani corporis*, Frankfurt a. M., 1599.

11a Lib. V, cap. xxviii, 'De musculis digitorum quatuor', p. 140:

Manus organi omnium nobilissimi, mirabilem structuram suo loco describemus: ea tantum quae ad historiam musculorum spectant, explicare consilium est. Manus propria actio est apprehensio, vnde ὄργανον ἀντιληπτικὸν dicitur. Non potest autem sine motu fieri apprehensio: fuerunt ergo ad actionem manus musculi necessarii Digitos ergo quatuor flectunt tres musculi; palmaris, sublimis, & profundus. Palmaris . . . Sublimis ab interna brachij apophysi enatus, priusquam ad carpum perueniat, quatuor tendines tanquam habenas emittit Profundus priori substratus, ab eodem exortus tuberculo, in totidem neruosos tendines scinditur . . . [p. 141] Vt autem profundo huic musculo ad tertiam articulationem pateret aditus, natura mirabili artificio sublimis tendines quatuor perforauit.

11b Lib. XII, cap. iii, 'De manuum praestantia', p. 437 – cap. iv, 'De vsu, figura & structura extremae manus', p. 438: see translation by H. Crooke, no. **14a** of this appendix, pp. 62–63 below.

12 Caspar Bauhin, *Theatrum anatomicum*, Frankfurt a. M., 1605.

12a Lib. IV, cap. i, 'De manu', p. 1031:

Cum Deus ter Opt. terque Max. hominem solum inter creata animalia nudum & inerme creasset (cuius nomine Epicurus, Plinius, alijque ethnici Deum imperfectionis & iniustitiae ethnice accusant) ad sui tamen imaginem clementer formasset, ne brutis animalibus inferior foret, rationem & manum ei dedit, quae cęteris animantibus denegauit. Rationem cerebro indidit, quae omnium artium officina & ars ante

artes. Manus vero corporis trunco adnasci voluit, quae ὄργανον est ὀργάνων,vt Philosophus loquitur, siue instrumentum ante omnia instrumenta, data autem homini tanquam animalium sapientissimo, cum organum sit animalium sapientissimo conueniens, & id pro corporis nuditate, ne inermis esset, sed manu sibi varia tum instrumenta, tum arma pro necessitate & sui defensione pararet, & pro temporis occasione & arripere & deponere posset, sicque foret instrumentum ad omnes artes necessarium, paci non minus quam bello idoneum. Cuius actio est apprehensio, quare Galeno ὄργανον ἀντιληπτικὸν dicitur ...

[P. 1032] Verum cum manus actio sit apprehensio, apprehensio autem absque motu fieri non possit, musculis tanquam motus voluntarij instrumentis opus habuit, quare primaria manus pars, quae primo & per se actionem edit, musculus est

Reprinted unchanged in the Frankfurt 1621 edition, pp. 548–549.

12b Lib. IV, cap. xv, 'De musculis digitos quatuor flectentibus', p. 1094:

Flectentium [primus (=*m. flexor digitorum superficialis*)] ... per vlnae et radij anteriorem partem, mediam delatus ... in partes quatuor carnosas diuiditur, quae singulae in tendines exquisite rotundos, nerueos & pellucidos cessant: qui ... delati ad digitorum quatuor os secundum iuxta articuli partem mediam longa sectione diuisi, quo subsequentis & subiecti tendines, qui ad tertium articulum ferri debuere, transmittantur & quo facilius moueant & apprehendant, latiores redditi, paulo post diuisionem in digitorum quatuor ossa secunda inseruntur: quae sane res admiranda spectatuque digna, quod a natura prudenti factum, quo digiti ordine quodam sese consequantur & digitorum recta [p. 1095] inflexio efficiatur.

Derived largely from Columbus (no. **7** above); translated by Crooke (no. **14b** below); and reprinted unchanged in the Frankfurt 1621 edition, p. 578.

13 Petrus Pavius (Paaw), *Primitiae anatomicae de humani corporis ossibus*, Leiden 1615, p. 156:

Manus ... manibus capere & arripere obvia solemus. Hunc usum commode praestare uti manus posset, explicatos discretosque fecit digitos natura, quo etiam minutissima quaeque capere, fingere, forma[p. 157]reque possimus. Quod respiciens Anaxagoras organorum organum manum vocare solebat, dicereque vel solo manuum respectu hominem mereri prudentis solertisque animalis nomen. Nihil etenim pene ingenii solertia aut acumen excogitare potest, manibus quod non aptare perficereque homo queat. Inde videntur Scriptores sacri Summi Dei admiranda expressuri opera, manuum uti voce. *Manus tuae fecerunt & formaverunt me*, inquit Psalmista. Idem, *Dextera Domini excelsa est, dextera Domini fecit fortitudinem &c.*

14 Helkiah Crooke, Μικροκοσμογραφια: *a description of the body of man ... collected and translated out of all the best authors of anatomy, especially out of Gasper Bauhinus and Andreas Laurentius*, London, 1615.

14a The following is translated from Laurentius (no. **11b** above). Book IX, chap. iii [=Laurentius lib. XII, cap. iii], 'Of the excellency of the hands', p. 729:

Man, who is the crowne and pride of Nature that bold and confident worke-mistresse, him I say, God on his birth day did cast out vpon the dust of the earth, naked, vnarmed, and weltring in his bloud, to enioy or rather to deplore an inheritance of sorrow and misery. Yet notwithstanding because he is sent into the world to be a combatant and not a sluggard. He hath armed him with two wondrous weapons, which He hath denied to all other liuing creatures, reason and the hand. His reason is the storehouse of all arts and sciences, the first groundworke and foundation of whatsoeuer the immortall soule is naturally capable or apprehensiue of; an arte it is, as before all arts, so hath it all arts for his subiect or matter whereabout it is occupied. The hand is an instrument, but as it is the first instrument so it is the framer, yea and employer of all other instruments. For not being framed for any one particular vse it was capeable of all: so as it may iustly be compared to the soule, which as the Philosopher saith is, though not in deed yet in power and ability all things. By the helpe of the hand lawes are written, temples built for the seruice of the

62

Maker, ships, houses, instruments, and all kind of weapons are formed. I list not to stand vpon the nice skill of painting, drawing, caruing and such like right noble artes, whereby many of the ancients haue made their names honorable vnto vs, yea and eternized them to the worlds end. By our hands we promise, we call, we dismisse, we threaten, we intreate, we abhorre, we feare, yea and by our hands we can aske a question. By the helpe of the hand although a man be borne vnarmed, yet is he able to safegard himselfe from all other creatures: and all those creatures which come strong and armed at point into the world, how fierce soeuer they be, how able to abide the violence of heauen it selfe, yet are they not safe from the hands of men. For doth not the industry of mens hands preuaile against the hornes of the bull, the teeth of the lyon and the paw of the beare, yea whatsoeuer is comprehended vnder the cope of heauen, by the skill of the hand is brought vnder our subiection and made tributary vnto us.

[P. 730] And therefore Anaxagoras as Plutarch reporteth, marking diligently the curious fabrick of the hands, the postures of the fingers, as they moue either together or apart, the mighty strength, the cleane nimblenesse and the soft delicacy thereof, ascribed vnto them the cause and originall of mans wisedome. How much wiser was Galen who in those melodious hymnes which he wrote to the praise of his Creator, I meane his bookes of the Vse of Parts discoursing very curiously concerning this curious instrument concludeth, that man is not therefore the wisest of all creatures because he hath hands, but because hee is the wisest of all creatures, therfore Nature furnished him with this excellent instrument. It was not the hand that taught men arts but reason, yet the seruant and minister of this reason and wisedome is the hand: they are the vicars or substitutes and suffraganes of the speech, the interpreters of the secret language of our silent conceits, signifying to all men in a few letters as it were by hieroglyphicks what the very thoughts of our heartes are

[Book IX, chap. iv [=Laurentius lib. XII, cap. iv], 'Of the vse, figure and structure of the hand . . .':] The true office of the hand is to apprehend or to holde, and his proper action is apprehension . . . from whence it is called organum ἀντιληπτικόν. The first vse therefore of the hand is to take hold . . . [The shape of the hand is then described.] . . . And this is the manner and proportion of the figure. For the structure if it be diligently attended, it will imprint in vs an admiration of the wonderful skill [P. 731] and workemanship of Nature and it is on this manner. Because the hand was the most noble and perfect organ or instrument of the body: God the Creator moulded it vp of diuers particles, all which for our better vnderstanding we will referre vnto foure kindes. The first kinde is of those which originally and by themselues doe performe an action The first and principall part of the hand is a muscle, because there is no apprehension without motion; now wee know that a muscle is the immediate organ of voluntary motion

14b The following is translated from Bauhin (no. **12b** above). Book X, chap. xxx, 'Of the muscles which bend and extend the forefingers', p. 787:

The first bender [*m. flexor digitorum superficialis*] . . . passeth thorough the middle and anterior part of the ell and the wand [*ulna* and *radius*] . . . and . . . is . . . diuided into four fleshy parts, all which do determine into tendons, exquisitely neruous and transparant . . . and at the second bone of the forefingers nere the middest of the ioynt are diuided with a long section or slit through which the tendons of the next muscle to be described (which lyeth under them [*m. flexor digitorum profundus*]) which were to reach vnto the third ioynt are transmitted. There they become broader that they might mooue more easily and apprehend or take holde the better, and a little after the diuision or section they are inserted into the second bones of the foure fingers. And truly this progresse and insertion of these muscles is an admirable and strange worke of Nature: for they are so seuered, that the fingers in their motion might orderly follow one another, and each of them alone bend inward.

15 Caspar Hofmann, *Commentarii in Galeni de usu partium corporis humani lib. XVII . . . Opus, non medicis tantum sed et philosophis, nec minus philologis paratum*, Frankfurt a.M., 1625. 'Argumentum libri primi et secundi . . .', p. 5:

Iam, quia anima hominis sapientissima est, corpusque habet per quod sapientiam suam prodere potest: omnis ratio videtur suadere, agendum esse primo loco de illa parte, per quam homo est homo. Ea vero est *manus* . . . serviunt hae partes uni actioni, *apprehensioni*, quam manus praestat *Apprehensio* igitur est actio illa, ad quam usus omnium heic dicendarum partium spectat Manus ergo nostra, per quid est manus? per quid apprehendit? per conformationem. Licet autem conformatio haec pertineat ad totam manum, de qua agimus: praecipue tamen pertinet ad summam manum.

['Cap. ii. iii. iv.', p. 7:] Homo, animalium sapientissimus, manus habet animali sapienti convenientes. Quare subito etiam laudat Aristotelem Propter manus homo solus est ... animal sapiens, & propter sapientiam ... divinum Iam ergo in promtu est ratio, cur Gal. ordiatur a manu, quia agit principaliter de homine: utique ab illa hominis parte incipere illum aequum est, qua praecipue est homo. Illa vero est manus, ut 4 quoque Ex. Anat. I ait.

16 Johannes Riolanus, *Anthropographia et osteologia*, Paris, 1626. Lib. I, cap. i. p. 20:

... Nec satis laudatum esset corpus humanum, nisi quorundam calumnias & opprobria in naturam inique iacta, & temere effutita repellerem, quibus diuinum opificium imperfectum esse cauillantur ... [p. 21] ... Has omnes calumnias, & deliramenta refellere facillimum est. Homo, inquit Aristoteles, sicut corpus armis nudum, sic animam artibus destitutam habet, sed pro corporis nuditate manus, pro animae imperitia rationem accepit: quorum vsu & ministerio corpus quidem omni genere armorum munire potest, animam autem omnibus artibus exornare. Nam, vt prudenter ait Philo Iudaeus, pro omnibus brutorum donis ratio homini data est, qua sibi factam iniuriam vlciscatur. Rationi tamen manus additae, quae praesto essent ad iussa capessenda & exequenda, vt intellectus duplex est, ad cognoscendum & ad faciendum, vnde scientia & ars; ita dicere solitus erat Scaliger ... [cf. no. **6**, p. 59 above].

proposed addendum

16.1 The action of Nicolaes Tulp in Rembrandt's painting in the Mauritshuis, the Hague. See pp. 22–23 above.

aftermath

The history of these ideas of the human hand after 1632 need not be traced in detail here. Among the works which would be examined in a thorough study of the subject are John Ray's *The wisdom of God manifested in the works of the Creation*, 3rd edition seen, London, 1701, pp. 286–290; A. G. Plaz, *De corporis humani machina divinae sapientiae teste*, Leipzig, 1725, pp. 24–25; and William Paley's *Natural theology; or evidences of the existence and attributes of the Deity*, 12th edition seen, London, 1809, pp. 143–144, where we read of the intersections of the flexor-tendons of the fingers, "There is nothing, I believe, in a silk or cotton mill, in the belts, or straps, or ropes, by which motion is communicated from one part of the machine to another, that is more artificial, or more evidently so, than this *perforation*". J. F. Hartlaub, in his *Diss. phil. de homine Dei teste*, Jena, 1733, p. 4, refers to a *Demonstratio Dei ex manu humana* by "Donatus", which I have not identified. Pictures which might have a bearing on this theme include Richard Greenbury's double-portrait of Sir Charles Scarburgh and Edward Arris, *c.* 1650 (London, Worshipful Co. of Barbers); J. J. Haid's mezzotint portrait of Lorenz Heister, after a painting by M. W. Fröling; and Joseph Wright of Derby's *Hermit* (Derby, Art Gallery). More recent studies include Charles Bell's Bridgewater treatise *The hand: its mechanism and vital endowments as evincing design*, 2nd edition seen, London, 1833, the subject of which had been specified by the 8th Earl of Bridgewater in his will dated 25 February 1825; G. M. Humphry's lectures *The human foot and the human hand*, Cambridge, 1861, pp. 156–158; Frederic Wood Jones's classic *The principles of anatomy as seen in the hand*, London, Baillière, Tindall & Cox, 1920 and 1941; and successive editions of *Gray's Anatomy* not excluding the current (36th) British edition (Edinburgh,

Appendix II. The special significance of the hand

Churchill Livingstone, 1980, p. 591), where we still find this distant echo of Anaxagoras, Aristotle, and Galen:

Though the repertoire [of the hand] is essentially limited, the scope of the basic movements and the nicety of control with which they can be exercised, are unrivalled perquisites of man. This manual skill, guided by discriminative vision, and directed by a highly imaginative and inquisitive mentality into a seemingly endless range of activities, has enabled mankind to master much of the natural environment, and to create around himself a culture of art, science and technology. The ever-increasing complexity of this artificial environment has carried us far beyond any other form of life of which we are aware.

APPENDIX III

COGNITIO SVI, COGNITIO DEI AS THE RATIONALE OF ANATOMY

A. SYNOPSIS

		cognitio sui	*cognitio sui et Dei*
0	1532 prelude:	François Rabelais, Lyons	
1	1536	N. Massa, Venice	
2	1539–1663		anatomical broadsheets, Venice, Paris etc.
3	1540	L. Vasse, Paris	
4	1543		A. Vesalius, Padua via Basle
5	1545, 1559	T. Geminus, London	T. Geminus, London
6	1555		J. Lygaeus, Bar-sur-Aube via Paris
7	*c.* 1559?	anatomical broadsheet, London (Fig. 10)	
8	1572		V. Coiter, Nuremberg
9	1585	S. Alberti, Wittenberg (Pl. 31)	
10	1588		J. Boeckel, Helmstedt
11	1589–1661		A. Laurentius, Paris
12	1590–1621		C. Bauhin, Basle
13	1593	J. Posthius, Heidelberg via Frankfurt	
14	1609–17	P. Paaw, Leiden (Pl. 8)	
15	1611	C. Bartholin, Wittenberg (Pl. 32)	
16	1615		H. Crooke, London, after Laurentius
17	1626	J. Riolan, Paris (Pl. 33)	J. Riolan, Paris
18	1627	O. Fialetti, Venice (Pl. 34)	
19	1628, 1633	J. Owen, Leiden and Amsterdam	
20	1630		R. Descartes, Amsterdam
21	1633	J. Rehefeld, Erfurt	
22	1634		J. van Beverwijck, Dordrecht
23	1634		J.v.d. Gracht, the Hague, after Laurentius
24	1636, 1638	W.v.d. Straaten, Utrecht	
25	1639		C. Barlaeus, Amsterdam, after N. Tulp
26	1645	after Fialetti, Amsterdam (Pl. 34)	
27	1645	C. Barlaeus, Amsterdam	
28	1646	J. Hoppius, Leipzig	

		cognitio sui	cognitio sui et Dei
29	1647–8	R. Descartes, Egmond, N.-Holland	
30	1650, 1662	M. Hoffmann, Altdorf	
31	1658, 1679	F. Sylvius, Leiden and Amsterdam	
32	1660	M. Bogdanus, Berne	
33	1666	G. Blasius, Amsterdam (Pl. 35)	
34	1668		H. S. Schilling, Dresden (Pl. 36)
35	1670/1680		J. B. Bossuet, Paris
36	1672		P. Barbette, Amsterdam via Leiden
37	1683		G. Franck, Heidelberg
38	1686		A. Everardus, Leiden
39	1688	S. Blankaart, Amsterdam (Pl. 37)	
40	1690	A. Nuck, Leiden (Fig. 11)	

proposed addenda

16.1	1619	S. Egbertsz., Amsterdam (Pl. 5)	
16.2	1625	J. Fonteyn, Amsterdam (Pl. 6)	
20.1	1632		N. Tulp. Amsterdam (Pl. 1)

B. TEXTS

0 François Rabelais, *Pantagruel*, Lyons, 1532 (ed. V. L. Saulnier, Geneva, 1965).

Chapter VII contains Gargantua's letter to his son Pantagruel, a student at the university of Paris. After recommending the study of the liberal arts and natural sciences, Gargantua proceeds (p. 46): "Puis soingneusement revisite les livres des médecins, Grecz, Arabes, et Latins, sans contemner les Thalmudistes et Cabalistes: et, par fréquentes anatomyes, acquiers-toy parfaicte congnoissance de l'aultre monde, qui est l'homme."

A. F. Le Double, in his book *Rabelais anatomiste et physiologiste*, Paris, Leroux, 1899, pp. 30–31, regarded this last sentence as equivalent to γνῶθι σεαυτόν or *congnois-toy toy-mesme*, but it must be admitted that Rabelais does not here explicitly refer to the proverb. Nevertheless, the passage indicates how the anatomical application of the proverb may have come into being: "know the microcosm" meant "know thyself". This connexion is explicit in nos. **8, 10, 11c-e, 16, 17, 24, 34,** and **36** of this appendix.

1 Nicolaus Massa, *Liber introductorius anatomiae ... opus sane tam medicis quam philosophis perutile, ut studiosis lectoribus patebit*, Venice, 1536. 'Prooemium totius operis', cap. I, fol. 3r:

Quales gratias Deo optimo, maximoque adiutori ac protectori meo agere debeam, debeantque philoso-

phi, ac maxime qui medicinam profitentur, si corporis humani particulas omnes sensu noscunt, nequaquam (ut aiunt) lingua dicere, aut calamo scribere possum. Neque mireris, magnifice ac doctissime Hieronyme, si talibus te affari incipio, cum pauci admodum sint, qui anatomiae hac tempestate student, etsi tam vtilis et necessaria philosophis ac pariter medicis sit, age quod etiam & idiotis pulcherrimum ornamentum esset, si seipsos cognoscerent, cum homo a natura ultimus intentus vltimam naturae perfectionem ostendat; quare docte sapiens ille Graecus dicebat, Nosce teipsum. Deo igitur benedicto una mecum gratias agere non desinas, misericordia cuius te philosophum me duce de corporis humani partibus its doctum fecisti vt inuidere nemini nostrae aetatis te oporteat[224]

2 An anonymous text published in anatomical fugitive sheets from *c.* 1539 onwards.

Vetus dictum est, atque id non ab homine, sed a Deo profectum, Nosce teipsum, quo mihi nihil aliud praeceptum esse uidetur, atque admirandam corporis humani compagem, numerum, ordinem, positum uiscerum, eorumque officia subinde contemplanda. Haec enim exacte nouisse non medicorum duntaxat interest, sed et omnium quibus in animo est, diuini opificii miranda consilia, factaque perlustrare. Neque ullum studium sanctius esse poterit, quam si homo in sese descendere tentet, ut cognoscere tandem discat, extra animam nihil inesse homini, quo prae caeteris animantibus in fastum & superbiam sese erigat & extollat. Hac de caussa, humana uiscera, quatenus fieri potuit, in hac tabella expressimus, quo illis qui haec in mortuorum corporibus indagauere, memoriam refricaremus, eos autem qui non admodum erga tam nobilem contemplationem affecti sunt, ad amorem anatomices stimularemus.

The text given here is edited from the broadsheet published in Venice in 1539 by Gianantonio de Nicolinis de Sabio and Giambattista Pederzani, which may have been the *editio princeps*.[225] In the same year it was reprinted in Paris by Jean Ruelle, with a minor alteration: *quam ad admirandam* instead of *atque admirandam* in the first sentence.[226] French translations are found in broadsheets published at Antwerp by Silvestre de Paris,[227] and at Paris by A. de Matonnière:[228] neither is dated, but both are of the sixteenth century. A German translation exists in a sheet of unknown place and date.[229] There is an Italian translation in *Il vero dissegno delli interiori del corpo humano*, Milan, 1663, a broadsheet edited by one Antonio Moneta, "Barbiero, & Professore di Chirurgia".[230] Other editions of the text are known. These broadsheets must have been chiefly responsible for the diffusion throughout Europe of the anatomical application of "know thyself".

3 Lodovicus Vassaeus (Loys Vasse), *In anatomen corporis humani tabulae quatuor*, Paris, 1540. 'Lodoicus Vassaeus lectori', fol. A3[r]:

. . . Nam si absque anatome manca est eruditio, si ad vitam recte instituendam praecipuum est seipsum nosse, cum omnium optime Galenus humanae naturae rationem ac scientiam tradiderit, vt velut in speculo teipsum contemplari liceat, non visus sum mihi melius laborem meum collocare posse quam in ea re, quae iure optimo omnium praestantissima haberi debeat

[224] English translation in Lind, op. cit., note 222 above, pp. 174–175.

[225] The only recorded copy belongs to Messrs E. P. Goldschmidt of London, who have published it in their catalogues no. 127 (1963), pp. 66–67, item 210, and no. 160 (1980), colour plates pp. VI–VII, description p. 76, item 251.

[226] Copy in the library of the Wellcome Institute, London (no. 288.3).

[227] The only recorded copy is in the library of Mons University, Belgium: it has been published by E. Cockx-Indestege, 'Twee anatomische planodrukken . . .', *Scientiarum historia,* 1971, **13**: 92–102. The text varies greatly from that of the 1539 editions.

[228] Copy in the library of the Wellcome Institute, London (no. 292.8).

[229] The only recorded copy is in the library of the Medical Center, University of Michigan: it has been published by L. H. Wells, 'A remarkable pair of anatomical fugitive sheets . . .', *Bull. Hist. Med.,* 1964, **38**: 470–476, figs. 1–2.

[230] Copy in the library of the Wellcome Institute, London.

This passage is also found in the Venice edition of 1549 (p. 9). In the French translation published at Lyons in 1547, Vasse's preface is replaced by one by the translator, Jean Canappe.

4 Andreas Vesalius, *De humani corporis fabrica*, Basle, 1543. 'Ad diuum Carolum quintum . . . imperatorem, Andreae Vesalii . . . praefatio', excerpt, fol. *4r:

Quamuis augurer, ex uniuersa Apollinea disciplina, adeoque tota naturali philosophia, nihil tuae Maiestati gratius acceptiusue procudi posse, historia, qua corpus & animum, ac praeterea diuinum quoddam numen ex utriusque symphonia, & nosmetipsos denique (quod uere hominis est) cognoscimus.[231]

5a Thomas Geminus, *Compendiosa totius anatomie delineatio*, London, 1545. Dedication to King Henry VIII, fol. π 2r:

Quare ad meam Anatomen redeo, ad eamque reuertor, quae inanimatas licet hominis effigies proponat, tamen uiui praeceptoris munere fungitur, docetque quemlibet, qui sui est studiosus, seipsum penitus cognoscere . . . [verso] si caelitus descendit γνῶθι σεαυτὸν, id est nosce teipsum: quis tam erit stolidus qui hoc exercitium diuinum, coeleste ac necessarium esse neget? Per hoc enim homo sui corporis compagem intelligens, etiam in perfectam sui noticiam ducitur, inque seipsum descendit.

5b Thomas Geminus, *Compendiosa totius anatomie delineatio*, London, 1559. Dedication to Queen Elizabeth I, fol. π 1r:

. . . Forasmuche as holye scripture bearing wyttenesse (most honorable Princesse) it pleased the only and almightye God to create man to the similitude of his lykenes, not only in spirite resemblyng the deitye of the eternall father, but also in bodie bearying the shape of Christe oure God and sauioure whose humane nature is nowe inseparably unite wyth the fathers deitye . . . me thinketh doubtles that this well consydered, we can no wayes come soonner to the knowledge of God, then first to learne to knowe our selues. . . . [verso] . . . So that, who so in all partes learneth to knowe himselfe, may therby come to no smale knowledge of God and all his creatures. Woorthely therfore as a holy oracle was written ouer the doore of the temple of Apollo in Delphis. NOSCE TEIPSVM. And Thales the philosopher demaunded what thynge was hardest to be doone, to knowe thyselfe quod he. Whiche as it is moste harde, so is it most woorthy. Also Demonas demaunded when he first profited in the studie of philosophie, then (quod he) when I began to know my selfe. . . .

6 Joannes Lygaeus, *De humani corporis harmonia libri IIII*, Paris, 1555. Dedication, excerpt, fol. 2v:

Caeterum operis utilitas minime obscura: quandoquidem corporis humani cognitio cum ad ualetudinem tuendam, tum ad regendos mores, & et ad multas res maximas in uita iudicandas, plurimum conducit.
<p style="text-align:center">Τὸ γνῶθι σαυτὸν πανταχοῦ 'στι χρήσιμον,</p>
antiquis non abs re-dictum est. Re uera si cognitio aliarum rerum in natura delectat, quanto magis naturae nostrae contemplatione delectari nos conuenit? An ad hominem quicquam magis pertinet, quam ut seipsum cognoscat? Praeclare Galenus anatomiae scientiam ducem nobis esse ad Dei cognitionem dicebat.

The dedication and foreword are dated Bar-sur-Aùbe, 1554.

7 Anon., *Perutilis anatomes interiorum muliebris partium cognitio ac earundem situs, figura, numerus, positio, haud iniucounda cognitu*, London, [*c.* 1559?].[232]

The right half of an anatomical broadsheet with two figures in woodcut, male on the

[231] English translation in C. D. O'Malley, *Andreas Vesalius of Brussels*, Berkeley and Los Angeles, University of California Press, 1964, p. 323.
[232] Copy in the library of the Wellcome Institute, London (no. 296.15).

left (signed "R. S."), female on the right. The female holds a tablet inscribed "Nosce te ipsum. Knowe thy self". See Fig. 10.

Figure 10. "R.S.", anatomical figures, woodcut for an anatomical broadsheet, English, mid-sixteenth century.

8 Volcher Coiter, *Externarum et internarum principalium humani corporis partium tabulae*, Nuremberg, 1572. Dedication to town council of Nuremberg, fol. A2ᵛ:

... scientiam hanc diuinam, quae totius mundi epitomen summique Dei incomparabilem et incomprehensibilem sapientiam, et nostri ipsorum cognitionem complectitur

[Fol. AA2ʳ:] Cap. tertium [i.e. quartum] de anatomiae vtilitatibus. Anatomiae vtilitates ... variae & plurimae sunt. Vtilis est in primis philosophis, quatenus ipsi hanc per se adament artem tum quoad artificium naturae in qualibet animalis parte probe esse expressum demonstrare conentur. Medicis haec ars ita necessaria existit, vt Tertio vtilis est theologis, iurisperitis, historicis, poetis, denique omnibus, qui eruditionis ac sapientiae laudem affectant: nam anatome scientiae verae dux est aditumque ad Dei O.M. omnipotentiam ac iustitiam, quibus in construendis & formandis animantium corporibus vsus est, praebet. Cum nusquam certius, quam in humani corporis structura sese expresserit summi creatoris prouidentia, hoc nomine potissimum anatomes studium nobis commendatum atque gratum esse debet, primo enim aditu, nos in Dei cognitionem adducit rapitque.

Adijciatis vtilitatem insignem quam vnusquisque inde percipit, cum hac in suimet ipsius cognitionem adducitur. Omitto hic breuitatis gratia vtilitates quas inde milites, pictores, & sculptores hauriunt

9 Salomon Alberti, *Historia plerarunque partium humani corporis*, Wittenberg, 1585.

A woodcut on the title-page of this anatomy-book represents a skull with an hourglass and a snake, surmounted by the legend *ΓΝΩΘΙ ΣΑΥΤΟΝ*. See Pl. 31.

10 Johannes Bokelius (Boeckel), *Anatome vel descriptio partium humani corporis, vt ea in Academia Iulia, quae est Helmsteti, singulis annis publicè praelegi, ac administrari solet*, Helmstedt, 1588. 'Dedicatio', fol. A3ᵛ:

Conuincimur enim ex contemplatione fabricae huius, partiumque omnium vsu, diuinum fuisse huius operis Architectum, qui singulari, & sapientia, & arte insigni omnes particulas ita efformauit, & disposuit, vt aptius & praeclarius, vsuique accommodatius inueniri, & excogitari potuisset nihil.

Si quis est mundi ornatus, & vtilitas, vt profecto est maxima, praestat sane his omnibus humanum corpus quod propterea μικροκόσμον nominarunt veteres sapientes, quod in vnum hominem, totius mundi elegantiam, ornatum ac sapientiam concluserit DEVS optimus maximus. Quis igitur hoc opus non admiretur? . . .

Etenim aliarum rerum contemplationi operam dare, sui autem ipsius nullam habere noticiam, aut se ipsum ignorare, turpissimum est, vt habet oraculum Delphicum, γνῶθι σεαυτόν: quod non solum [fol. A4ʳ] ethice, sed et physice intelligendum esse arbitror. Docet enim nos ipsa corporis structura, de humanae naturae fragilitate quam leui momento homo, animal excellentissimum in grauissimos incidat morbos, si corporis neglegentior fuerit, quos maximos etiam vt saepius noticia sui facile euitare, ita in eosdem neglegentia sui incurrere in procliui est

11a Andreas Laurentius (André Dulaurens), *Historia anatomica humani corporis*, Paris, 1589. Not seen. Presumably the first edition of no. **11b** below.

11b A. Laurentius, *Opera anatomica*, 2nd edition, Hanau, 1595. 'In laudem autoris [Laurentii] et operis carmen ad Ioan. Amatum Chauigneum', fol. *4ᵛ:

> Si quod ab aethereo diuinitus illud Olympo
> Descendisse ferunt memorabile γνῶθι σεαυτὸν . . .
> Internam fabricam ac externam nouerit omnem
> Eiusdem methodo expediens breuiore recessus,
> Dicitur is vere numquid cognoscere seipsum? . . .

The writer's name appears at the end of the poem in the form 'Ianus Emichoenus Alvernus'.

['Praefatio', p. 1:] Sapienter Apollinis oraculo (vt est apud Platonem in Alcibiade) quisque incitatur ad sui cognitionem. Qui enim seipsum norit, omnia nouerit; cum in se rerum omnium habeat simulacra. Deum in primis cognoscet, quoniam ad illius imaginem est efformatus

['Primus Anatomes fructus sui cognitio', p. 7:] At sui ipsius cognitio, vt pulcerrima, ita & dificillima [p. 8] Haec itaque prima esto Anatomes vtilitas, hic primus illius fructus, omnibus etiam Ethnicis & Atheis communis, sui ipsius, id est naturae propriae cognitio.

['Secunda Anatomes vtilitas, Dei cognitio', p. 8:] Est altera Anatomes vtilitas, nobis, quibus Euangelicae legis splendor affulsit, peculiaris Dei immortalis cognitio [p. 9] Ad Dei igitur, & sui ipsius notitiam omnibus vtilis est Anatome.

11c-e A. Laurentius, *Historia anatomica humani corporis*, Frankfurt a.M., 1599 and 1600, and Paris, 1600.

In the 1599 edition, lib. I, cap. v, 'Quam sit vtilis Anatome ad sui cognitionem' is on

pp. 7–8, and cap. vi, 'Quam sit vtilis Anatome ad Dei cognitionem' on pp. 8–9. English translation in no. **16** below.

11f André Dulaurens, *Toutes les oeuvres*, transl. by Théophile Gelée, Rouen, 1661.

This late edition of Laurentius's anatomical writings presents a French translation of the chapter on *cognitio sui* on pp. 8–10, and of the chapter on *cognitio Dei* on pp. 10–11.

12a Caspar Bauhin, *De corporis humani fabrica: libri IIII. Methodo anatomica in praelectionibus publicis proposita: ad And. Vesalij tabulas instituta: sectionibusque publicis & priuatis, comprobata*, Basle, 1590. Epistola dedicatoria, fol.α 2v:

... Legimus quin etiam & reges & principes adeo fuisse anatomes studiosos, vt Aegyptiorum reges suis manibus, non solum mortuorum cadauera, sed & viuorum corpora, nocentium tamen, dissecare non abhorruerint, quo abditorum morborum causas perscrutarentur: alii vero, vt seipsos agnoscerent. Quid enim in hac vita praestantius, quam, considerationi & contemplationi naturae suae incumbere, corporis sui [fol. α 3r] fabricam intro aspicere, membrorum ac viscerum miras & artificiosas actiones, ad quas obeundas condita sunt & ordinata omnia, considerare? Haecque iam cognita animo nobiscum voluentes & agitantes, sapientiam & prouidentiam Archetypi nostri ratiocinari & contemplari? Hinc sane praeceptum illud *ΓΝΩΘΙ ΣΕΑΥΤΟΝ* natum esse videtur ... Hoc apophthegma, etsi a plerisque *ἠθικῶς* ad mediocritatis commendatio-[fol. α 3v]-nem referatur, prima tamen fronte, magis a corpore quam ab animo, deductum & natum videtur. A qua sententia, neque adeo eloquentiae parens Cicero ad Q. fratrem, abhorret: Et illud, inquit, *γνῶθι σεαυτὸν*, noli putare ad arrogantiam minuendam solum esse dictum, verum etiam, vt bona nostra norimus. Hic bona corporis magis quam animi, oratorem intellexisse credimus. Atque hoc sibi Pallade epigramma voluit ... [*Anth. pal.* XI, 349] ... [fol.α 4r] Sic apparet, veteres hoc dicto vsos, vt quemlibet admonerent, suam ipsius naturam vt pernosceret. Quid enim philosopho, quid inquam medico turpius, quam in seipso suas partes & membra, earumque compositionem ignorare? presertim vero, cum corpus nostrum ex summa prouidentia & sapientia Archetypi & Protoplastis nostri ter Opt. terque Maximi, ad similitudinem mundi sit efformatum.

12b Caspar Bauhin, *Theatrum anatomicum*, Frankfurt a. M., 1605. Excerpt, fol.)(4v:

Profecto hoc est illud *γνῶτι σεαυτὸν*, quod Socrates, si Platoni credimus, de coelo traxit, & e quo descendisse aperte fatetur Iuuenalis. Referat nunc qui volet cum Cicerone *ἠθικῶς* ad modestiae mediocritatisque commendationem, aut ad ipsam ergastuli animae nostrae attentam & philosophicam inspectionem, semper tamen eo redibit.

Reprinted unchanged in the 1621 edition, fol.)(3r.

13 Johannes Posthius, *Observationes anatomicae*, published in M. Realdus Columbus, *De re anatomica*, Frankfurt a.M., 1593, pp. 496–519. Posthius's preface is dated Heidelberg, 1 August 1593.

[Incipit, p. 497:]*Τὸ γνῶθι σεαυτόν:* non solum ad animum; sed etiam ad corpus referri commode potest, ac debet. Se enim ipsum non nosse videtur, qui corporis sui fabricam non habet perspectam

Repeated almost verbatim in an anatomy lecture given at Aberdeen in 1619/20.[233]

14 The following documents attest that *nosce teipsum* was used as a motto for anatomy by Pieter Paaw (1564–1617), professor of anatomy at Leiden.

[233] Aberdeen University Library MS 150, published in translation by R. K. French, *Anatomical education in a Scottish university, 1620*, Aberdeen, Equipress, 1975.

14a Engraving, anonymous after Jan Cornelisz. van 't Woudt (Woudanus), published at Leiden by Jacob Marcius, 1609 (Pl. 8).

14b Engraving by Willem Swanenburgh after Jan Cornelisz. van 't Woudt (Woudanus), published at Leiden by Andries Clouck, 1610.[234]

These two engravings after two different drawings by Woudanus show the anatomy-theatre of Leiden university and the collection of skeletons which was exhibited in it during the summer. In each picture, six skeletons bearing pennants stand around the circumference of the hall. One pennant in each engraving is inscribed with the phrase *nosce teipsum*. For the other inscriptions see Appendix V no. **18a**, p. 96 below. The anatomy-theatre was designed, administered, and used by Pieter Paaw.

14c P. Scriverius (Schrijver), *In theatrum anatomicum, quod est Lugduni in Batavis, secante et perorante V.C. Petro Pauio med. botanico & anatomico praestantissimo*, 1615, text to an engraving by A. Stock after J. de Gheyn II, showing P. Paaw dissecting, headed *Theatri anatomici academiae lugduno-batavae delineatio*, issued by "Petrus Paaw amsteldamensis" and dedicated by him to the government of the city of Leiden, [Leiden 1615].[235] Excerpt, vv. 61–2:

> Hic, hic disce mori, viator, & te
> nosse ante omnia disce, disce quid sis

For the context of these verses see Appendix V no. **18b**, p. 97 below.

14d P. Bertius, poem dedicated to P. Paaw, published in Paaw's *Primitiae anatomicae. De humani corporis ossibus*, Leiden, 1615, fol. **1ᵛ. The poem ends:

> Debemus cuncti merito tibi: te duce namque
> noscere jam nostras coepimus exuvias.

14e H. Delmanhorstius, *Adorea osteologiae*, a poem dedicated to P. Paaw, published in the same book. Excerpt, fol. **3ʳ:

> . . . virumque cano, cui se sublime Theatrum
> (mystica quo Batavis primum sapientia Athenis
> intellecta senis Spartani, NOSCERE SE IPSVM)
> Lugdunense ANA se TOMICVM, sanctum Amphitheatrum
> obtulit acceptum

14f Henricus Florentius, *In osteologiam . . . Petri Paawi*, published in the same book. Excerpt, fol. **4ᵛ:

> En tibi rimatur causas subtiliter, et te
> non modo mirari, sed quoque scire docet.

[234] No. **14a**, the 1609 engraving (Cetto no. 301), is often attributed to Bartholomaeus Dolendo, e.g. by Cetto, p. 345. It was later re-engraved by F. de Wit (Heckscher, pl. XXXIII-40). No. **14b** is Cetto no. 302.

[235] The poem and the engraving were separately reprinted in P. Paaw, *Succenturiatus anatomicus*, Leiden, 1616. The broadsheet is reproduced in Cetto no. 307 (much reduced) and in J. E. Kroon, *Bijdragen tot de geschiedenis van het geneeskundig onderwijs aan de Leidsche universiteit 1575–1625*, Leiden, S. C. van Doesburgh, 1911, f.p. 50.

15 Caspar Bartholin, *Anatomicae institutiones corporis humani*, [Wittenberg], 1611. A device on the title-page illustrates *nosce teipsum* (Pl. 32).

[Prooemium, p. 1:] ... humani corporis structuram potissimum rimari solemus 1. Ob perfectionem maximam, quae regula est imperfectionis. 2. Quia animalia varia innumera fere sunt, ut iis secandis & rimandis humana aetas his saeculis non sufficiat. 3. Ob usum incredibilem ad neminem non redundantem, qui seipsum & proprium aedificium perno-[p. 2]-scere cupit

This passage was reprinted unchanged in the Leiden 1641 edition (p. 1).

16 Helkiah Crooke, Μικροκοσμογραφια: *a description of the body of man ... collected and translated out of all the best authors of anatomy, especially out of Gasper Bauhinus and Andreas Laurentius*, London, 1615. The following excerpts are translated from Laurentius (nos. **11c-e** above).

[Book I, chap. 5, p. 12]: *How profitable and behooueful anatomy is to the knowledge of mans selfe.* Seeing then that man is a litle world, and containes in himselfe the seeds of all those things which are contained in the most spacious and ample bosom of this whole vniuerse ... whosoeuer dooth well know himselfe, knoweth all things, seeing in himselfe he hath the resemblances and representations of all things. First, he shall know God, because hee is fashioned and framed according to his Image, by reason whereof, hee is called among the diuines, the royall and imperiall temple of God

Wisely therefore did the oracle of Apollo, incite and stirre vp euery man to the knowledge of himselfe, as Plato hath it in his *Alcibiade*. This by the iudgement and consent of all men, is true and sound philosophy. For Demonax being asked, When he beganne to professe philosophy, made answere, When I began to know my selfe. Socrates held it the next point to fury and madnesse, to enquire into high matters, and to search into strange and vncouth businesses, and bee ignorant in the meane while of those things that bee in our selues. This preposterous skill was once very merrily and wittily by an old wife cast in the teeth of Thales the philosopher of Miletum; who as he inconsiderately cast vp his eyes to behold the heauens, fell into a pit; the old wife cried out, Thou foole, thou priest into matters that are aboue thee, & art ignorant of those things that are below thee, nay euen within thee. Surely it was a worthy speech, and not beseeming an old beldame but a philosopher. But this same knowledge of a mans selfe, as it is a very glorious thing, so it is also very hard and difficult. And yet by the dissection of the body, and by anatomy, wee shall easily attaine vnto this knowledge. For seeing the soule of man being cast into this prison of the body, cannot discharge her offices and functions without a corporeall organ or instrument of the body; whosoeuer will attaine vnto the knowledge of the soule, it is necessarie that hee know the frame and composition of the body.

After this manner, Democritus of Abdera, that he might finde out the seate of anger and melancholy, cut in peeces the bodies of beasts, and when he was taxed of the citizens for madnesse in so doing, he was by the censure and determination of Hippocrates, adiudged to [p. 13] be very wise and prudent. Go too then, is not he saide to know himselfe, who can tell how to temper and order the state and condition of his minde, howe to appease those ciuill tumults within himselfe, by the stormes and waues whereof he is pittifully tossed, and how to suppresse and appease those varieties of passions wherewith as it were with so manie furies he is vexed and tormented? But all this anatomy doth verie plainly teach vs. For he that seeth and obserueth the whole body, which by the structure and putting together of sundry parts of diuers sorts and kinds, is (as it were) manifold & full of variety, to be made one by the continuation and ioyning of those parts; he that considereth the admirable simpathy of the parts, their mutuall consent and agreement, their common offices, or officiall administrations one for the helpe of another, how they make not any couetous reseruation to themselues, but do freely communicate each with other; such a man no doubt will so moderate and order the conditions and affections of his minde, as all things shal accord and ioyne in a mutuall agreement, and the inferiors shall obey the superiors, the passions obey the rule of right reason. He that shall diligently weigh and consider the vse of euery part, the fashion, scituation, and admirable workemanship of them all, as also, the organs and instruments of the outward sences, he shall easily perceiue how and after what manner he is to make vse of euery part; then which thing, what can be more excellent, what more profitable?

... If you looke into the seats and residence of the faculties of the minde, you shall finde the rational faculty in the highest place, namely in the brain, compassed in on euery side with a scull; the faculty of anger, in the heart; the faculty of lust or desire in the liuer: & therefore we may gather these lower and inferiour faculties, must bee seruiceable and obedient to the higher, as to the queene and prince of them

all. And if both princes and peasants would weigh and consider the mutuall offices betweene the principall and the ignoble parts, princes might vnderstand how to rule, and peasants how to obey. Princes may learne of the braine how to make lawes, to gouerne their people; of the heart, how to preserue the life, health, and safety of their citizens; of the liuer, they may learn bounty and liberality. For the braine sitting in the highest place, as it were in a tribunall, distributeth to euery organ or instrument of the sences, offices of dignity: the heart like a king maintaineth and cherrisheth with his liuely and quickning heate, the life of all the partes: the liuer the fountaine and well-spring of most beneficall humidity or iuice, nourisheth and feedeth the whole family of the bodie, and that at her owne proper costs and charges, like most a bountifull prince. As for the meaner sort of people, they may easilie vnderstand by the ministering and seruile organs, what bee the limits of seruice and subiection. For the parts that are in the lower bellie do all serue the liuer; the stomacke dooth concoct the meate, the guts distribute and diuide it, the veines of the mesentarie prepare it; the bladder of gall, the milt and the reines, do purge and clense the princely pallace, & thrust as it were out of the kitchin, downe the sinke, all the filth and garbage. The parts that are included within the chest, do serue the heart; those that are in the head, do attend the braine, and so each to others, doe affoord their mutuall seruices. And if any one of them do at any time faile of their duty, presently the whole houshold gouernment goes to ruine and decay.

. . . So that anatomy is as it were a most certaine and sure guide to the admirable and most excellent knowledge [p. 14] of our selues . . . and so much shall suffice for the first profit and commodity that wee may reape by anatomy.

[Book I, chap. 6, p. 14]: *How profitable and helpefull anatomy is to the knowledge of God.* It is no doubt an excellent thing for a man to attaine to the knowledge of himselfe, which thing anatomy and dissection of bodies doth teach vs, and as it were point out vnto vs with the finger; but there is another farre more diuine and vsefull profit of anatomy then the former, proper and peculiar to vs to whom the light of the gospell hath shined, namely the knowledge of the immortall God. That high Father and creator of all things . . . cannot be knowne but by his effects; and all the knowledge of God that can be had, must be deriued not *a priori*, but *a posteriori*, not from any cause or matter preceding, but from the effects and thinges subsequent.

. . . Who is it therefore, that will not honor, reuerence, and admire the author and workeman of so great a worke, if he do attentiuely aduise with himselfe, how wonderfull the fabricke and structure of mans body is? . . . by the view of anatomicall dissection, we see and are able to distinguish the variable and diuers motions of mans body, and those also very strange, and sometime vncouth.

Some of the ancient writers, haue dignified the frame of mans body with the name & title of the Booke of God. For indeede, in all men there appeareth certaine sparkes of a naturall diuinity, or diuine nature; as Heraclitus witnesseth, who sitting in a bakers shop, and perceiuing some of his auditors which desired to speake with him, would not come vnto him into so homely a place, Come in (saith he) for euen heere there be gods also. Iouis omnia plena, All things (saith the poet) are full of Iupiter. For euen in the smallest and most contemptible creature, there is matter enough of admiration; but yet in the frame of mans body, there is (I know not what) something more diuine, as wherein appeareth not onely the admirable power of God, but his wisedome euen past all beleefe, and his infinite and particular goodnesse and bounty to man.

For his power, it is not onely visible but palpable also, in that of so small a quantitie of seede, the parts whereof seeme to be all homogenie or of one kinde; and of a few droppes of blood, he hath framed so many and so diuers particles, aboue two hundred bones, cartilages yet more, many more ligaments, a number of membranes numberlesse, the pipes [p. 15] or trunkes of the arteries, millions of veines, sinnewes more than thirty paire, muscles almost foure hundred; and to conclude, all the bowels and inward parts. His incredible wisedome appeareth in the admirable contabulation or composition of the whole, made of so many parts, so vnlike one to another. Enter thou whosoeuer thou art (though thou be an atheist, and acknowledgest no god at all,) enter I beseech thee, into the sacred tower of Pallas, I meane the braine of man, and behold and admire the pillars and arched cloysters [*concamerata inuolucra* = meninges] of that princely pallace, the huge greatnesse of that stately building, the pedistals or bases, the porches [*suffulcientia atria*] & goodly frontispice, the 4. arched chambers [*sinus quatuor* = ventricles], the bright and cleare mirrour [*speculum lucidum* = septum lucidum], the labyrinthaean mazes and web of the small arteries [*plexus arteriolarum labyrintheos* = rete mirabile or choroid plexus], the admirable trainings of the veines, the draining furrowes [*cerebri elices* = gyri] and watercourses [*aquaeductus* = aqueduct], the liuing ebullitions [?] and springings vp of the sinnewes [*neruorum . . . scaturigines* = origins of the nerves], and the wonderful foecundity of that white marrow of the back, which the wiseman in the Book of the Preacher or *Ecclesiastes* calleth the siluer cord. From the braine, turne the eye of thy minde to the gates of the sun, and windowes of the soule, I meane the eyes . . . [etc. etc.]

75

Lastly, the infinite goodnesse and bounty of God shineth in this excellent workemanship, inasmuch as he hath so well prouided for all the parts, that euery one hath her proper and peculiar vse, and yet all are so fitted and knit together in such an harmonie and agreement, that euery one is ready to helpe another; and any one of them being ill affected, the rest are immediatly drawne to a simpathy and participation with it. Which society and fellowship of the parts, Hippocrates in his booke *de alimento* hath thus breefelie but excellently expressed, σύμπνοια μία, σύρροια μία, συμπαθέα πάντα: one agreement, one confluence, all consenting. To conclude then, these wonderfull and euer-worthy to bee admired workes of God in the composition and frame of mans bodie, are as it were dumbe schoolemaisters, the bookes of vulgar diuinity, and the doctors and teachers of diuine wisedome.

17 Johannes Riolanus, *Anthropographia et osteologia*, Paris, 1626.

In some copies one finds as a frontispiece an engraving by Crispin de Passe which shows Riolan presenting to Louis XIII an open book (symbolically, the *Anthropographia*) inscribed on the recto page *Honora Medicum* and on the verso Γνῶθι σ'αυτόν: see Pl. 33.

In some copies, with or without the above-mentioned engraving, one finds as a literary equivalent a dedicatory letter "AV ROY" (fols. Al-A3ʳ). Excerpt, p. 1:

Sire, Ie presente à vostre Majesté, auec les submissions que doibt vn tres-humble subiet à son Roy, la nouuelle descouuerte, & curieuse recherche du petit monde, qui est le corps humain, le liure de la sagesse humaine, & theologie naturelle, qui apprend à toutes personnes, se cognoistre soy-mesme. C'estoit la seule science de Iuppiter, qu'il feit grauer en lettres d'or, sur le frontispice du temple d'Apollon. C'estoit la leçon qu'vn page donnoit au Roy Philippe pere d'Alexandre le Grand, tous les matins à son leuer. Souuenez vous Philippe que vous este Homme

['Humani corporis commendatio', lib. I, cap. i, excerpt p. 24]: Interrogatus philosophus quando coepisset philosophari, prudenter respondit, quando coepi meipsum cognoscere, τὸ γνῶθι σ'αυτὸν, τοῦ θεοῦ παράγγελμα, καὶ ἀρχὴ καὶ τέλος, πάσης ἐστὶ φιλοσοφίας, καὶ εὐξωίας, inquit Simplicius. Nam in [p.25] humani corporis cognitione humanae diuinaeque philosophiae principium continetur, si Daemonaci philosopho credimus, imo culmen & perfectio, vt eleganti gradatione declarat Agapetus ad Iustinianum, qui se nouit Deum noscet, Deum noscens, Deo assimilabitur, assimilabitur qui Deo dignus erit, dignus erit qui nihil Deo indignum admittit, sed cogitat quae Dei sunt; & quae cogitat loquitur, et quae loquitur facit, vberrimus ex sui cognitione fructus, quem ex anatome comparare & possidere licebit

Quod autem nobis aperit & ostendit admirabilem nostri corporis structuram, simulque nos ad Dei summi opificis cultum & venerationem excitat & inducit, Anatome censetur; quae nihil est aliud quam humanae diuinaeque sapientiae theatrum, lucidissimum speculum, quo nos Deumque intuemur . . . Propterea non puduit Christianos theologos, Lactantium, Ambrosium, Basilium, Chrysostomum, Theodoretum, diuinae prouidentiae validiora argumenta ex nostri corporis fabricatione depromere; nam Deum qui vult nosse, seipsum vt cognoscat necessarium est, inquit D. Chrysostomus, siquidem accurata nostri corporis speculatio; sufficienter te manu deducet ad Dei cognitionem, vt eleganter D. Basilius adiunxit.

'Index capitum', fol. ō1ʳ: "Finis anatomes explicatur. Caput XV. Pag. 85. Ad Dei summi Opificis cognitionem cultum & maiorem venerationem, p. 85. Ad sui cognitionem, p. 86 . . .". This chapter (lib. I, cap. xv) repeats the arguments quoted above from pp. 24-25 of the book.

18 Adrianus Spigelius (van den Spiegel), *De humani corporis fabrica, libri decem*, with engravings after dissections by Julius Casserius, Venice, 1627.

The engraved title-page, designed by the painter Odoardo Fialetti, shows at the top three female figures who personify Diligentia (left), Ingenium (right), and Anatomia (centre). Anatomia holds a mirror and a skull, emblems for "know thyself".[236] The detail is reproduced in Pl. 34.

[236] Cf. Appendix V section III, pp. 98-102 below.

19 John Owen, *Epigrammatum libri tres* in his *Epigrammatum editio postrema*, Leiden, 1628. Lib. I, ep. 79, p. 176:

> Nosce teipsum
> Ethica jungantur physicae, te noscere si vis,
> haec docet anatomen corporis, illa animae.[237]

There are dozens of editions; an Amsterdam edition was issued in 1633. In 1661, the present epigram was written by an anatomy-student at Edinburgh at the end of his lecture-notes on Laurentius (no. **11** above).[238]

20 René Descartes, letter to M. Mersenne, Amsterdam 15 April 1630, in Descartes' *Oeuvres*, ed. Ch. Adam and P. Tannery, vol. 1, Paris, J. Vrin, 1974, letter no. XXI. Excerpts, p. 137:

> l'estudie maintenant en chymie & en anatomie tout ensemble, & apprens tous les iours quelque chose que ie ne trouue pas dedans les liures . . . [p. 144] . . . Or i'estime que tous ceus a qui Dieu a donné l'vsage de cete raison, sont obligés de l'employer principalement pour tascher a le connoistre, & a se connoistre eus-mesme. C'est par la que i' ay tasché de commencer mes estudes; et ie vous diray que ie n'eusse sceu trouuer les fondemans de la Physique, si ie ne les eusse cherchés par cete voye.

The "liures" mentioned here may have included C. Bauhin, *De corporis humani fabrica: libri IIII* (no. **12a** above), which Descartes appears to have paraphrased in 1647/8 (no. **29** below).

21 Johann Rehefeld, *Johannes Rehefeld . . . medicinae lycaeo hierano prof. civitatisque erffurtinae physicus ordinarius omnibus et singulis physiologicae Γνῶθι σεαυτὸν artis studiosis salutem & obficia obfert,* Erfurt, 1633. Excerpt, p. [3]:

> Quoniam itaque D.O.M.A. in nomine Domini, proximo die lunae qvi erit 14 Octobris, ad ea ipsa gressum facturus sum, atque residua ista [p. 4] conlectanea non tantummodo verbis proponere, sed etiam corporis humani structuram ac praecipuas ejjusdem partes in iconibus vel tabulis anatomicis Julii Casserii, Caspari Bavhini, Vidi Vidij, Andreae Laurentij &c oculariter me velle decrevi; cum αὐτοφίαν auscultationi adjunctam ad rerum praelectarum ideas hauriendas ac memoriae & judicio imprimendas plus valere, experientia edoctus fuerim: hocce prius conamen candidis lectoribus, inprimis autem omnibus & singulis Γνῶθι σεαυτὸν Artis studiosis intimare uolui . . . Deprop. è Musaeo 12 Octobr. Anno 1633.

In the British Library's copy, both dates have been postponed by one week in a contemporary hand.

22 Johan van Beverwijck, *Oratie van de nootsakelickheyt der anatomie. Ghedaen tot inleydinghe van de ontledingh des menschelijcken lichaems op den 25 Octob. 1634,* Dordrecht, 1634. Incipit, fol. A2r:

> Mijn Heeren, Het is een oude ende wijse spreucke, de welcke *Plato* ghetuyght, dat ghestelt plagh te werden voor den tempel van Apollo, als weerdigh gheacht zijnde van God ghekomen te wesen, ende die de Poëet *Iuvenalis* seydt dat uyt den Hemel nedergedaelt is, *Kendt u selven.* De rijcke Koningh Croesus van Lydien quam op eenen sekeren tijdt het orakel van den selven Apollo consuleren, hoe dat hy tot de gelucksaligheyt soude komen? kreegh voor antwoort, gelijck *Xenophon* beschrijft, *Indien ghy u selven sult kennen* Ons wesen bestaet uyt ziele ende lichaem. De nature van de ziele, seydt *Hippocrates* is

[237] Cf. Wilkins, p. 96.
[238] Cunningham, loc. cit., note 36 above, with variants *jungatur* and *animi.*

onsichtbaer: daerom en kanse niet ghekent werden, als uyt hare actien ende werckinge: die leert men door het ondersoeck ende de kennisse van al de deelen ende leden van ons lichaem, door de welcke de selfde actien ende werckinge uytgevoert werden. Willen wy dan tot kennisse van onse ziele komen, soo moeten wy alvoren de kennisse van ons lichaem hebben ... [fol A2ᵛ] ... *Socrates* ... *Demonax* ... De philosooph *Thales* ghevraeght zijnde, wat datter swaer was? antwoorde, *Syn selven te kennen* ... alsoo en kan niemant oordeelen van syn lichaem, als door de anatomie, ende ontledinge van al de deelen van het selve. Waerom oock de wijste van de werelt niet alleen van oude tijden, maer oock van dese onse eeuwe haer selven altijt neerstelijck in de anatomie geoeffent [fol. A3ʳ] hebben.

There follow passages on the uses of anatomy to the practitioners of various occupations: similar passages are found in Coiter (no. **8** above), Laurentius (nos. **11** and **16** above), and, later, van der Straaten (no. **24** below). Since both van der Straaten (n. 137 above) and Beverwijck (see below) were (like Tulp) pupils of Paaw (no. **14** above), the resemblance between their speeches may be due to the influence of either Paaw's anatomies, or possibly Tulp's lost inaugural speech of 1629 (see n. 190 above), or both.

Fols. A3ʳ-B1ʳ: the benefits of a knowledge of anatomy to theologians. A6ʳ: "Dewijl oock het voornaemste ooghmerck van een Theologant is, den mensche te brengen tot de kennisse Gods, soo kan hem daer toe mede dienen de anatomie ...". Fols. B1ʳ⁻ᵛ lawyers; B1ᵛ-B2ʳ politicians; B2ʳ-B5ᵛ craftsmen, architects, painters (Dürer and Karel van Mander), sculptors, poets, physicians, surgeons, operators for bladder-stone, apothecaries, and midwives.

Fol. A5ᵛ contains interpolated matter, not part of the speech. (Centre) emblem of Dordrecht; (above) "Ex epigrammate Isaaci Casauboni,

$$\tilde{\Omega} \ \pi\eta\gamma\grave{\eta} \ \sigma o\varphi\acute{\iota}\alpha s \ ! \ \tilde{\omega} \ \tau\acute{\upsilon}\chi os \ [sic] \ \grave{\alpha}\rho\iota\pi\rho\epsilon\pi\acute{\epsilon}s \ \check{o}\nu\tau\omega s$$
$$\tilde{\eta}\nu \ \check{\alpha}\rho\alpha \ \tauo\tilde{\upsilon}\tauo \ \sigma o\varphi\grave{o}\nu \ \Gamma N\Omega\Theta I \ \Sigma EA \Upsilon TON \ \check{\epsilon}\pi os."$$

Below: "Iuvenal. E coelo descendit $\gamma\nu\tilde{\omega}\theta\iota \ \sigma\epsilon\alpha\upsilon\tau\acute{o}\nu$".

Since this edition of the speech is rare (copy in Amsterdam University library), it is convenient to reprint here from fol. B5ᵛ the following passage which is truncated in the later editions (J. v. Beverwijck, *Alle de wercken*, Amsterdam, 1656 and 1660, second sequence of pagination pp. 67–76; *Wercken der geneeskonste*, Amsterdam, 1672, third sequence of pagination pp. 3–12):

Ende, om soo verre niet te loopen [i.e. as ancient Rome], sedert de konsten ende wetenschappen hier te lande hebben beginnen te klimmen op de hooge trappen, daerse noch op vervolgen, hebben de treffelick-ste van 't lant de anatomie by-gewoont, ende is oock van voorname mannen selfs geadministreert gheweest. Gelijckse noch onlanghs in de machtige stadt van Amsteldam [fol. B6ʳ] gedaen is by d'Heer Doctor *Sebastianus Egberti*, Borgemeester aldaer, ende gecommitteerde Raedt van d'Heeren Staten van Hollant; in wiens plaetse ghevolght is, ende die het huyden noch met grooten lof bekleet, d'Heer Doctor *Nicolaes Tulpius* Raedt ende Schepen van de selve stadt, die eertijdts met my gestudeert heeft onder d'Heer Doctor *Paaw*, Professor van d'Anatomie in de Vniversiteyt tot Leyden, voor ons beyde van seer aengename gedachtenis: Wiens ghelijck ick in de administratie van d'anatomie noch binnen, noch buyten 's landts niet gesien en hebbe. Het gene ick van dese myne goede meester, in de publijcke lessen, besondere collegien, ende insonderheyt in syn preparatien ofte bereyden (daer toe hy mede den welgemelten Heere *Tulpius* ende weynigh andere admitteerden) voor de publijcke administratie, als oock van andere buyten 's landts, daer hy my aen recommandeerden, met aenghename moeyten, ende geen kleyne kosten van myn Ouders gheleert hebbe

23 Jacob van der Gracht, *Anatomie der wtterlicke deelen van het menschelick lichaem*, the Hague, 1634. 'Voor-reeden aen den recht-sinnigen ende konst-lustigen leser', fol. A1ʳ:

Onder alle sienlijcke wercken, door de welcke den almoghenden Heer, onsen Godt, sijne ongemeten ende oneyndelijcke wijsheyt kondigh heeft gemaeckt, niet meer te verwonderen, oft hooger te waerderen en is, als 't menschelick lichaem, tot een bequame wooning, ja heerlicken tempel vor de redelicke ende onsterfvelicke siel van hem ghesticht Andere niet minder, onder de ouderlinghen in wetenschap vernaemt, plachten te seggen 't ghebouw des menschelicken lichaems te wesen het alder-volmaeckste ende verhevenste boeck, waer in men de onbegrijpelicke almogentheyt, wisheyt ende goetheyt des scheppers mocht lesen. Veele daer en boven, niet alleen onder de philosophen ende medicijnen, maer oock onder de vorsten ende princen, regeerders des werelts, andere in vernuftheyt ende verstandicheyt overtreffende, hebben sich begeven, met grooten ernst ende lust, tot een aendachtich ende rijpsinnigh aenmercken, ja oock ontleden der menschelicke lichaemen, om door de bestandighe ende volmaeckte kennis der selve, oock meerder ende diepsinniger kennis van haren architect ofte bouw-meester te betrachten So groot geacht ende hoch-ghewaerdeert is, eertijts geweest de anatomie oft ontledinge, ende die door haer alleen te bekomen is, de grondige kennis van 't menschelick lichaem. Andreas Laurentius, Raedt der Koninghs van Vranckrijck, ende sijnen ordinaris medicijn-meester, als oock voor-leser der selve wetenschap inde wijt-vermaerde Academie van Mompelliers, in sijn *Anatomique beschrijvinghe des lichaems*, handelende seer aerdigh ende rijckelick alle de nutticheden deser anatomie, betoont de selve niet alleen noodigh te wesen voor natuyrlicke ende sedelicke philosophen, medicijnen, chirurgiens ende apothekers, maer oock seer dienstich voor alle schilders

The complimentary reference to Laurentius's description of "alle de nutticheden deser anatomie" refers to his Lib. I, cc. v-vi on *cognitio sui* and *cognitio Dei* (nos. **11c-e** above). These phrases are echoed in van der Gracht's earlier coupling of "de bestandighe ende volmaeckte kennis der selve [i.e. the human body], oock meerder ende diepsinniger kennis van haren architect".

24 Gulielmus Stratenius traiectinus (Willem van der Straaten), *In susceptam in academia patria med. pract. & anatomes professionem prologus. Recitatus XV. Kal. apr. anno MDCXXXVI*, Utrecht, 1638.

This inaugural lecture in a chair of anatomy and medical practice occupies 27 pages, of which pp. 4–21 are devoted to the value of anatomy as a source of *cognitio sui*.

Page 3, statement of theme: "quicquid caelum, quicquid terra admiratione dignum habet, eorum omnium analogiam simul penes vos veluti in speculo con-[p. 4]-spiciatis, id operam dabo, perpensurus quam jucunda, vtilis, & necessaria sit nostri cognitio per anatomen." Page 5, the Delphic saying "ut se ipsos noscant. Quod uti fateor, non de solo corpore, verum & de anima intelligendum esse, ita & hoc velim mihi concedi, cuiuis animae cognitioni incumbenti, necesse esse, perspecta vt sit corporis structura, quod ea hujus ergastulo detenta, muneribus suis sine organo corporeo fungi nequeat." Pages 5–10, value of anatomical *cognitio sui* for theologians, lawyers, philosophers; here van der Straaten borrows ideas and phrases from Laurentius (no. **11** above), without acknowledgement. Page 10, value of the same for the uneducated public, "Deus bone, quanto saepe ardore adstant conspecturi lanienam porcorum imprimis, quod horum exta quam minimum ab humanis differre credant! Quam attentas praebent aures iis qui non nisi perfunctorie & crassa Minerva de internorum viscerum natura, situ, vel actione aliquantulum effutiunt.[239] Millies audita est vox annuentium et assentientium istis narratiunculis, quod paria olim in hoc aut illo bruto

[239] A different view was expressed by René Descartes, who went to such events "almost every day" while living in Amsterdam, 1629–30, and defended the practice with the words "ie ne croy pas qu' aucun homme d'esprit m'en puisse blâmer": *Oeuvres*, ed. cit. (p. 77 above, no. **20**), vol. 2, Paris, J. Vrin, 1975, letter no. CLXXVII, p. 621.

animadverterint, quasi nimis stupidam redoleret inscitiam, semet ipsum non nosse."

Pages 12–17, value of anatomy for medicine; pp. 17–21 other justifications; p. 21 conclusion of this part, "Neminem, quippe, credo, asserenti jucundissimam, utilissimam, & maxime necessariam esse nostri, per anatomen, cognitionem non assensurum."

25 C. Barlaeus, 'In locum anatomicum recens Amstelodami exstructum', *c.* 1639. Vv. 7–8: see Appendix IV, pp. 85–89 below.

26 Adrianus Spigelius *et al.*, *Opera quae extant omnia*, ed. by J. A. van der Linden, Amsterdam, 1645.

The engraved title-page is a reimpression of no. **18** above, in which the personification of *Anatomia* has the attributes of *cognitio sui*. See Pl. 34 for the relevant detail.

27 Caspar Barlaeus, 'In anatomiam clarissimi viri Adriani Spigelii, patavini professoris', 1645.[240] Vv. 1–6:

> Horrida mortalis spectacula cernite scenae,
> frustaque queis misere dilaceratur Homo.
>
> Vita salusque istis habitant in partibus, & qua
> vita hominum, sese mors quoque parte locat.
>
> Adspice, qui temet nescis, ferale cadaver,
> nexaque centenis ossibus ossa stupe

28 J. Hoppius, [advertisement for an anatomy to be performed at Leipzig], Leipzig 10 March 1646. Facsimile reproduction in Heckscher, p. 12. Excerpt:

> Ne autem illud pro nostris tantummodo, ad quos quidem primario spectat & pertinet φιλιατρειᾳ invide asservemus, consultum fuit & omnes alios qui demonstratione & cognitione Suiipsius delectantur, in Theatrum Anatomicum admittere.

29 R. Descartes, *La description du corps humain et de toutes ses fonctions*, in his *Oeuvres*, ed. Ch. Adam and P. Tannery, vol. 11, Paris, J. Vrin, 1974. According to Ch. Adam (ibid., p. 221) Descartes composed this work at Egmond, N. Holland, in 1647/8. Preface, p. 223:

> Il n'y a rien à quoy l'on se puisse occuper auec plus de fruit, qu'à tascher de se connoistre soy-mesme. Et l'vtilité qu'on doit esperer de cette connoissance, ne regarde pas seulement la Morale, ainsi qu'il semble d'abord à plusieurs, mais particulierement aussi la Medecine; en laquelle ie croy qu'on aurait pû trouuer beaucoup de preceptes tres-assurez, tant pour guerir les maladies que pour les preuenir, et mesme aussi [p. 224] pour retarder le cours de la vieillesse, si on estoit assez étudié à connoistre la nature de nostre corps Au lieu que, lors que nous taschons à connoistre plus distinctement notre nature

A conventional façade, possibly indebted to Bauhin, no. **12a** above.

30a Moritz Hoffmann, [inscription on the inside over-door of the Altdorf anatomy-theatre, 1650], published by J. J. Baier, *Biographiae professorum medicinae qui in*

[240] Printed on the verso of the engraved portrait of Spigelius which is found in the Amsterdam edition of his and others' works cited in no. **26** of this appendix.

academia Altorfina vnquam vixerunt, Nuremberg and Altdorf, 1728, p. 101.[241]
Incipit:

QVISQVIS ES QVI TE IPSVM NOSSE AMAS
INTVS QVI ET IN CVTE SIS
HVC ADES ET STVDIIS PRAEDITVS FORTIBVS
DISSECTIONES SPECTA HVMANI CORPORIS

30b Moritz Hoffmann, *Mauricius Hoffmann ad demonstrationes partium corporis humani curiose dissecti in theatro anatomico publice exhibendas medicinae atque sapientiae studiosos officiosa hac invitatione frequentes adesse jubet,* Altdorf, 1662. Excerpt, p. [7]:

Quicunque igitur . . . sive medicinae [p. 8] sive sapientiae studio addicti seipsos nosse desiderant, intus & in cute, quod dicitur, qui sint, . . . animae humanae domicilium cognitum habere exoptant . . . ii privatim nomina sua hora X. matut. & I. pomerid. in Theatro apud me profitebuntur, seque spectatores sanctos & attentos promittent, tesseramque introitus pro admissione quotidie ostendendam legitime comparabunt

31 Franciscus (Deleboe) Sylvius, *Oratio inauguralis de hominis cognitione, habita XV Kalend. Octobris Anni a Christo nato MDCLVIII,* published in his *Opera medica,* Amsterdam, 1679, pp. 895–903. An inaugural lecture on Sylvius's taking up of the chair of practical medicine at Leiden, 1658. Excerpts, p. 895:

Enimvero se-ipsum, hominem, undique nosse, omnium hominum interest, ergo et nostra: quapropter si quas de hominis cognitione animo volvo, foveoque cogitationes, inaugurali hac oratione comprehensas paucis persequar, rem & nobis omnibus, hominibus, & augustissimo hoc templo Academico, & expectatione vestra haud indignam me facturum existimavi . . . [p. 896] . . . Utique ad felicitatem quae duceret, viam esse sui ipsius cognitionem, jam olim ipsis Ethnicis ex oraculo delphico innotuisse perhibent. Equidem omnia quodammodo novit qui se rite novit; nam ne se quidem novit, qui caetera ignorat; adeo concatenata est, & indissolubilis tum sui-ipsius, tum aliarum rerum omnium cognitio

32 Martinus Bogdanus, [advertisement for an anatomy to be performed at Berne, 19 December 1660 *et seqq.*], Berne, 18 December 1660. Facsimile reproduction in Heckscher, p. 13, and translation, p. 14. Excerpt:

Tibi, quisquis curiosior fueris intuendum proponam, quae Natura in nobis omnibus occlusit. Neutiquam quod Dei opus odio prosequi videor, sed ut Te ipsum noveris, dum lustrabis oculis & auribus utrumque Palatium in sequiori sexu. Scilicet & id, in quo tuum Spiritum primum concepisti, & id in quo idem, quamdiu vivis, habitat

33 Gerardus Blasius, *Anatome contracta,* Amsterdam, 1666.

The additional engraved title-page (Pl. 35) shows an anatomist who looks into a mirror and sees in it the skeleton that stands behind him. The proposed meaning of the engraving is that anatomy teaches self-knowledge by revealing the mortality of man.[242]

The book is dedicated to three physicians at Leiden (F. Sylvius, J. van Horne, Florentius Schuyl), two at Utrecht (H. Regius, I. van Diemerbroeck), and one at Amsterdam (J. Deyman).

[241] Republished by Cetto (p. 352) and Heckscher (p. 174, n.218), but in each case spoiled by misprints.
[242] Cf. Appendix V section III, pp. 98–102 below.

34 Henricus Sigismundus Schilling, *Tractatus osteologicus, sive osteologia microcosmica, de ossium corporis humani admiranda structura, cui denuo adjicitur discursus physiologico-anatomicus, hominem μικρόκοσμον, sive cognitionem sui considerans*, Dresden, 1668.

The frontispiece (Pl. 36) illustrates an interpretation of *cognitio sui*.

Preface to the *tractatus*, fol. A3ʳ, excerpt: ". . . in doctrina igitur ossium contemplabimur τὸ γνῶθι σεαυτὸν, quod nos non tantum ad originis nostrae miseriam deprimit, sed & ad perfectionis nostrae praestantiam evehit & deducit."

The *discursus* is separately paginated (pp. 24). It is a long essay on γνῶθι σεαυτόν in an anatomical sense. Various interpretations of the phrase are discussed. The author draws extensively on Laurentius and Bauhin (nos. **11** and **12** above).

35 Jacques-Bénigne Bossuet, *De la connaissance de Dieu et de soi-même*, Paris, 1846. The work was probably written between 1670 and 1680. 'Dessein et division de ce traité', p. 1:

La sagesse consiste à connaître Dieu et à se connaître soi-même.
La connaissance de nous-même nous doit élever à la connaissance de Dieu.
Pour bien connaître l'homme, il faut savoir qu'il est composé de deux parties, qui sont l'âme et le corps.
L'âme est ce qui nous fait penser, entendre, sentir, raisonner, vouloir, choisir une chose plutôt qu'une autre, et un mouvement plutôt qu'un autre, comme de se mouvoir à droite plutôt qu'à gauche.
Le corps est cette masse étendue en longueur, largeur, et profondeur, qui nous sert à exercer nos opérations. Ainsi, quand nous voulons voir, il faut ouvrir les yeux; quand nous voulons prendre quelque chose, ou nous étendons la main pour nous en saisir, ou nous remuons les pieds et les jambes, et par elles tout le corps, pur nous en approcher.
Il y a donc dans l'homme trois choses à considérer: l'âme séparément, le corps séparément, et l'union de l'un et de l'autre.

The book is divided into three chapters. The second chapter, which describes "le corps séparément", is a detailed treatise of human anatomy. It presumably draws upon the anatomy lectures of Joseph-Guichard Duverney (1648–1730), which Bossuet attended.[243]

36 Paul Barbette, *Opera chirurgico-anatomica . . . pars III . . . seu anatomia practica*, Leiden, 1672.

Cap. I, 'praefatio', p. 243, incipit "Huc adsis, Teipsum qui cognoscere desideras, parvus declarabit mundus, qualis tibi habendus sit magnus, Creatoris Architectura inemendabilis"

Barbette was a native of Strasbourg who practised as a physician in Amsterdam.

37 Georg Franck von Franckenau, *Nosse Deum nosse se unica sapientia! Ergo ad anatomen suspensi . . . quotidie hora X. & IV. habendam a XV Octobr. MDCXXCIII quotquot corporis sui et sanitatis cognitione ducuntur officiose et peramanter invitat Georgius Francus*, Heidelberg, 1683.

The verso of the title-page is blank except for the words *"ΓΝΩΘΙ CEAYTON!"*.

[243] A. F. Le Double, *Bossuet anatomiste et physiologiste*, Paris, Vigot, 1913.

Appendix III. Cognitio sui, cognitio Dei

[Excerpt, p. 7:] Anatome quin imo est perquam necessaria omni homini ad cognitionem sui ipsius, Dei creatoris, & sacrae scripturae Nam quoad (1.) ex ea miseram vilemque naturae suae conditionem discit, videtque se inter stercus & urinam nasci: quomodo quoque animi mores componat e diversa partium structura.

Quoad (2.) quia per effectus Deus cognoscitur, teste D. Paulo ad Rom. c. I. vers. 20. maxime si respiciamus quod suspiciendis modis mirabiliter creati simus Psalm. 139 vers. 14. Hinc veteres humani corporis fabricam vocavere Dei librum, quia in eo admirabilis Dei potentia, incredibilis sapientia & infinita bonitas lucet ceu fusius laud. C. Sibelius deducit.

Denique quoad (3.) illud probat loco Salomonis sapientissimi regum, & regis sapientissimorum in Ecclesiast. c. XII. Possent et alia, si vacaret, scripturae adduci loca: maxime e Jiobo aliisque. Hocque est verum illud axioma christianum: Nosse Deum, nosse se, unica sapientia! . . . [p. 8] qui Deum, qui vos nosse studetis, tanquam unicam sapientiam, venite & videte stupenda microcosmi

38 Antonius Everardus, *Nova ac genuina animalium generatio, necnon accuratissima corporis humani delineatio anatomica,* Leiden, 1686. 'Typographus [P. van der Aa] ad lectorem', fol.*3^r^ :

Benevole lector, divinum illud, Nosce Te Ipsum, non alibi aeque nos afficit & humilitatem nostram pariter exercet, quam in perscrutatione & indagatione in mysteriorum nostri corporis tam mechanice & affabre a summo naturae Architecto constructi, e tenuissima & vix perceptibili insensilium molecularum coagmentatione & textura ortum trahentis: in qua structura palatium egregium animae ratiocinantis, tanquam in peculiari domicilio appropriato conspiciendum sese exhibet. Quis admirandam plane hujus microcosmi constructionem, extra ultimam Creatoris tanti reverentiam, sine impietate insigni perscrutari potest? Quis mundi hujus machinam insignem vasta mole praeditam inspiciens credat omnia ea, sed excellentiori in gradu in humano corpore esse limitata & brevissimis terminis circumscripta? . . . Quis partes solidas miro artificio in diversas formas & figuras redactas, sua munia differentia obeuntes partesque fluidas ad nutum suum absque violentia disponentes non sine delectatione insigni aspicit?

39 Stephen Blankaart (Blancardus), *Anatomia practica rationalis sive rariorum cadaverum morbis denatorum anatomica inspectio,* Amsterdam, 1688.

The additional engraved title-page (Pl. 37) shows an inquest-dissection of a deceased hospital patient. Below, the legend *"ΓΝΩΘΙ ΣΕΑΥΤΟΝ"*. [244]

40 Antonius Nuck, *Sialographia et ductuum aquosorum anatome nova,* Leiden, 1690.

The added engraved title-page (Fig. 11, p. 84) shows Minerva pointing with her right hand to the words "anatome nova" in the title, and holding in her left hand a book inscribed "Nosce te ipsum".[245] This device is probably due to the publisher, P. van der Aa: cf. no. **38** above.

proposed addenda

16.1 Oil painting by Thomas de Keyser, called 'The anatomy of Dr. Sebastiaen Egbertsz.', 1619. See pp. 34–35 above and Pl. 5 below.

16.2 Oil painting by Nicolaes Eliasz. (Pickenoy), called 'The anatomy of Dr. Johan Fonteyn', 1625. Central fragment alone survives. See pp. 34–35 above and Pl.6 below.

[244] Cetto, no. 186.
[245] Cetto, no. 196.

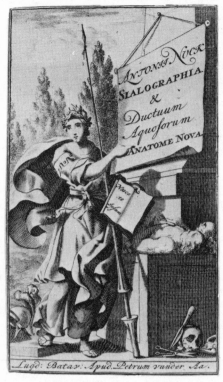

Figure 11. Minerva holding a book inscribed in Latin "know thyself", anonymous engraving for A. Nuck, *Sialographia*, Leiden, 1690, title-page. (See p. 83.)

20.1 Oil painting by Rembrandt van Rijn, called 'The anatomy of Dr. Nicolaes Tulp', 1632. See pp. 31–38 above and Pl.1 above.

aftermath

"Know thyself" continued in use as a motto for popular anatomy long after the seventeenth century. In the later period it was usually divorced from the idea of *cognitio Dei*, which flourished separately. Christoph von Hellwig's elaborate but derivative book *Nosce te ipsum, vel anatomicum vivum* was published in Frankfurt a. M. in 1720; there is a later edition with a foreword dated 1744. In 1879, G. L. Figuier published a work entitled *Connais-toi toi-même: notions de physiologie à l'usage de la jeunesse et des gens du monde.* It went through at least three French editions, and others in Italian translation. Both these authors discussed the meaning of their title, which in Figuier's case was derived from Bossuet (no. **35** above). Finally, in the twentieth century, the physician Frederick Parkes Weber (1863–1962) records that "know thyself" "has been used as a motto for modern 'popular' and often disgusting, so-called anatomical museums, attached to cheap 'panopticons' and dime museums"[246] – a distant degraded echo of Niccolò Massa's words, published in 1536, "docte sapiens ille Graecus dicebat, Nosce teipsum . . .".[247]

[246] F. P. Weber, *Aspects of death and correlated aspects of life,* 4th ed., London, Unwin, 1922, p. 739.
[247] Cf. pp. 67–68 above.

CASPAR BARLAEUS, *ON THE NEW ANATOMY THEATRE AT AMSTERDAM*, 1639

TEXT

Edited from Caspar Barlaeus, *Poemata. Editio IV*, Amsterdam, 1645–6, pars ii, p. 537:

In locum anatomicum recens Amstelodami exstructum

> Qui vivi nocuere mali post funera prosunt,
> et petit ex ipsa commoda morte salus.

> Exuviae sine voce docent, et, mortua quamvis,
> 4 frusta vetant ista nos ratione mori.

> Hic loquitur nobis docti facundia Tulpi,
> dum secat artifici lurida membra manu:

> "Auditor, te disce; et dum per singula vadis,
> 8 crede vel in minima parte latere Deum."

COMMENTARY

(i) *structure*. The opening couplets constitute broadly-stated paradoxes which are repeatedly almost resolved in the following couplets, as the original paradoxes are re-stated in progressively more specific instances. Thus the first couplet refers to society in general, the second to the anatomy-theatre in general, the third to a dissection in the Amsterdam anatomy-theatre, and the fourth to what is taught during a dissection in the Amsterdam anatomy-theatre. This gradual sharpening of focus, from many men (*qui vivi*, v. 1) to the smallest part of an individual man (v. 8), is accompanied by a movement in the opposite direction: as the scope of the subject diminishes, the significance of what is found increases, from health (v. 2) through virtue (v. 4) to divinity and implied immortality (v. 8). Hence the last couplet, which as it were combines the lowest note on one scale with the highest on another, presents a starker paradox than the opening couplets. Since the movement at the beginning of the poem was towards resolution, not intensification, of the paradoxes, this result can be regarded as yet a further paradox.

(ii) *details*[248]

title: the anatomy-theatre constructed in 1639 was in a building off a street in the

[248] Abbreviations of works by Barlaeus cited in this Appendix: *Poemata = Poemata. Editio IV,*

centre of Amsterdam, known then and now as the Nes. This street runs from north to south, east of, and parallel with, 't Rokin. At a point on the east side of the Nes, between it and the Oude Zijds Voorburg Waal, was a square or broad street in which were two large buildings, the greater and the lesser meat-markets. The greater meat-market was a long, low building entirely used by meat-traders. The lesser meat-market, formerly St. Margaret's church, was a taller building of lesser length, of which only part was occupied by trading-pitches. The remainder of this building was occupied by the premises of the Amsterdam college of physicians (*collegium medicum*), and, in the attic storey, by the anatomy-theatre. The exterior of the building is illustrated by O. Dapper. The interior is known only through a rough drawing by Rembrandt in connexion with his 'Anatomy of Dr. Deyman' of 1656 (Rijksprentenkabinet, Amsterdam), in which, as at Leiden (Pl. 8), we glimpse circles of balustraded tiers surrounding the focus, which is decorated above with paired escutcheons. This anatomy-theatre was in use from 1639 to 1690. Before 1639, anatomies took place in St. Antony's weigh-house in the north-west part of the city: there Rembrandt would have seen Dr. Tulp perform. After 1690, the anatomy-theatre returned to St. Antony's weigh-house, though to a different part of it: this theatre is today reconstructed *in situ* as the centre-piece of the Geschiedkundig Medisch-Pharmaceutisch Museum.[249]

2 petit ... commoda: cf. *In ob. Pauwi,* vv. 27–8, words of Death on seeing vivisection, "Indolui ... et tam barbarica commoda caede peti."

2 morte ... salus: cf. Ovid's poem on a *locus anatomicus* (*Tristia* III. 9) v. 24 "hic mihi morte sua causa salutis erit." Another Ovidian description of dissection is in *In ob. Pauwi,* vv. 25–6: cf. Ov. *Met.* VI. 636–7.

3 exuviae: Heckscher (p. 112) translated "skins". Skins of dissected criminals were among the exhibits displayed for moral instruction in the anatomy-theatres of Leiden and Amsterdam (Heckscher p. 98). In *In dom. anat.* v. 18, Barlaeus certainly refers to them: "... haec raptis pellibus aula riget". This meaning of *exuviae,* as "coverings" of some kind, might be supported by Barlaeus's tendency to complement the word with a

Amsterdam, 1645–6, part ii. *In ob. Pauwi = In obitum Petri Pauwi anatomici, c.* 1617, printed in *Poemata* pp. 79–81, and previously, with title 'Prosopopoeja Mortis, in Petrum Pauwium ... jam vita defunctum', in *Poemata ...,* Leiden, 1628, pp. 99–101, and in *Poematum editio nova,* Leiden, 1631, pp. 375–377. *In effig. Spigelii = In effigiem Adriani Spigelii,* in *Poemata* p. 528. *In mens. anat. = In mensam anatomicam,* in *Poemata* p. 207, repr. in Heckscher, pp. 113–114. *In dom. anat. = In domum anatomicam quae Amstelodami visitur,* in *Poemata* p. 249, repr. in Heckscher, pp. 114–115. *De anim. admir. = Oratio de animae humanae admirandis,* 1635, printed in Barlaeus's *Orationum liber,* Amsterdam, 1643, pp. 96–125.

[249] Isaak Commelin, *Beschryving der stadt Amsterdam* in Caspar Commelin (ed.), *Beschryvinge van Amsterdam,* Amsterdam, 1693, book IV, pp. 649–653; Olfert Dapper, *Historische beschryving der stadt Amsterdam,* Amsterdam, 1663, pp. 450–452, engraving after p. 450 (pagination irregular). Rembrandt's drawing is reproduced by Cetto (no. 260) and others. The street name "Nes" is not given on the engraved maps of Amsterdam by Dirk Swart (1623) and Hendrik Hondius (n.d., *c.* 1630), but appears on a seventeenth-century map bearing the name of Nicolaes Visscher as engraver or publisher. Both Swart and Hondius indicate the meat-markets, however. For further complications see Julius Held, *Rembrandt's Aristotle and other Rembrandt studies,* Princeton, Princeton University Press, 1969, p. 76, n. 131.

word for the inner parts of the body, such as *frusta* here; cf. *In effig. Spigelii* v. 5 "exuviis late nostris clarescit et extis", and *De anim. admir.* p. 113 "[anima] patitur corporis exuvias concuti, organa labefactari, nec de abitu, nisi destructo corpore, cogitat". However, *exuviae* can also refer to the remains of the whole human body, sloughed-off by the soul and therefore empty of sense (*Thesaurus linguae latinae,* s.v., col. 2133). This meaning fits the following phrase *sine voce* better, and can probably be parallelled in *In ob. Pauwi* vv. 13–14 "exuvias miserorum, & sicca morte cadentum,/iamque semel poenam corpora passa suam", and in our Appendix III no. **14d,** p. 73 above. On balance, the context seems to call for an ambiguous translation, in which *exuviae* are represented both as the skin which, before dissection, covered over the rest of the body, and as the body which, before death, covered over the soul. Hence "integuments".

3 sine voce: the same paradox is used in *In ob. Pauwi* vv. 5–6.

4 frusta: cf. *De anim. admir.* p. 103 "et cum in frusta secamur, manet illa una [anima]"; Barlaeus, *In anatomiam . . . Spigelii* (Appendix III no. **27,** p. 80 above) v. 2 "frustaque queis misere dilaceratur Homo".

4 ista nos ratione: both Commelin and Heckscher, with an eye to the word order, interpreted *ista ratione* as qualifying *mori,* but since no *ratio moriendi* has been or will be mentioned, *ista* is left without a reference, and the translator is obliged to supply one: hence Commelin's version "schoon de afgestorven leeden/ons raden, dat men moet ontvlieden zulk een schand" (Caspar Commelin, *Beschryvinge van Amsterdam,* Amsterdam, 1693, book IV, p. 654) and Heckscher's "warn us not to die for crimes" (p. 112). However, *ista ratione* does make sense if it is taken to qualify *vetat,* with *ista* looking back to *quamvis mortua*: although the *frusta* are dead, and therefore (one might suppose) inarticulate, it is really by virtue of that deadness (*ista ratione*) that they serve us as a warning.

5–6 Hic loquitur: does Barlaeus mean only that Tulp in person speaks in the anatomy-theatre (M. Tóth-Ubbens, in *Mauritshuis,* p. 92)? or does he also, as Heckscher (p. 29) suggests, imply that Rembrandt's portrait of Dr. Tulp "speaks" to those who see it hanging in the anatomy-theatre (if it was there)? One could argue against the latter interpretation that the poem does not describe the picture accurately, since the poem uses *nosce teipsum* in an optimistic sense (see v. 7n. below, on *et*) but the picture represents the proverb in the pessimistic sense, according to our hypothesis (see p. 43 above). However, this argument is not conclusive, and whether or not the poem describes the painting is surely less important than the equivalence of each to the other, in different art forms. Both treat the same subject – the metaphysical paradox of man, mortal yet divine – in an appropriately paradoxical style using the juxtaposition of opposites.

6 cf. the poem by "Petrus Monauius medicus vratislauensis" *In Fel. Plateri opus*

anatomicum v. 34 "dum secat artifici mortua membra manu".[250]

7–8 Here, I suggest on the following grounds, Barlaeus is not speaking only *in propria persona,* but also paraphrasing the introduction to Nicolaes Tulp's anatomical praelections, as delivered in the Amsterdam anatomy-theatre.

(a) The structure of the poem. Each succeeding couplet provides a specific instance to support the claim made in the previous couplet. Hence, just as the fact that Tulp "speaks" in the Amsterdam anatomy-theatre (couplet 3) documents the assertion that anything is taught there at all (couplet 2), so what Tulp says (couplet 4) would document the claim that he "speaks" there at all (couplet 3).

(b) The lessons of this couplet, *cognitio sui* and *cognitio Dei,* were commonly proposed as the lessons of anatomy, especially by Laurentius, an anatomist whose works Tulp and his colleagues greatly admired. See pp. 9–12 above, and Appendix III above, pp. 71–72.

(c) According to the following argument, this couplet was already understood in the seventeenth century to depend on *loquitur* in v. 5. When the present poem was inscribed inside the next anatomy-theatre at Amsterdam (*c.* 1690), vv. 5–6, the verses referring to Nicolaes Tulp, were omitted, having become obsolete with his retirement in 1653. If Barlaeus had been thought to be speaking *in propria persona* in vv. 7–8, the omission of vv. 5–6 would not have made necessary any further change. But in fact the following couplet from *In mens. anat.* (vv. 7–8) was substituted for the omitted "Hic loquitur . . ." couplet:

> Frons, digitus, ren, lingua, caput, cor, pulmo, cerebrum,
> ossa, manus vivo dant documenta tibi.[251]

Here the phrase *dant documenta tibi,* like *loquitur* in the "hic loquitur . . ." couplet, requires a following passage in which the reader is told (in this case) what the *documenta* teach. Such a passage does indeed follow *documenta dare* both in its original context:

> ossa, manus vivo dant documenta tibi.

> Adspicis hic coram sanum quodcunque vel aegrum est,
> et mala naturae deficientis habes.

> Quo vitio pars quaeque ruat, qua lege resurgat,
> discis et humani fata stupenda fori.

and in another poem by Barlaeus, on Johan van Beverwijck's book on urinary calculi, which begins:

> Traximus e saxis rigidae primordia vitae,
> istaque nascendi semina Pyrrha dedit.

> Hinc documenta damus, qua simus origine nati,
> et praefractum aliquid quilibet intus habet.[252]

[250] Printed in Felix Platter, *De corporis humani structura et vsu,* Basle, 1583, fol. α 3r.
[251] Caspar Commelin (ed.), *Beschryvinge van Amsterdam,* Amsterdam, 1693, pp. 652–654.
[252] J. Beverovicius, *De calculo renum et vesicae liber singularis,* Leiden, 1638, fol. *8v, reprinted in *Poemata* p. 557.

In the translation of the poem on p. 49 above, vv. 5 and 6 are reversed in order to clarify the dependence of VV. 7–8 on *loquitur* in v. 5.

7 te disce: a variant of *nosce teipsum*. Cf. Benedictus Figulus (Benedikt Töpfer?), *Pandora magnalium naturalium aurea et benedicta,* Strasbourg, 1608, fol. **3ᵛ "Ja alle *Creata* sind Buchstaben darinnen gelesen wirdt, wer der Mensch ist, dann vor allen dingen soll ihm ein jeder das *Nosce te ipsum* trewlich lassen befohlen sein, dass er sich selbst lerne, wie *Aristoteles Chymicus* zu *Alexandro Magno* gesagt: *Disce te ipsum & habebis omnia."* For Barlaeus's use of variation cf. Appendix III no. **27**, p. 80 above, "qui temet nescis". He may have varied the phrase here in order to avoid the pessimistic overtones of *nosce teipsum* (cf. Appendix V below), which would have been out of place in the present optimistic context: see next note.

7 et: establishes that *nosce teipsum*, paraphrased as *te disce,* is intended here in an optimistic or neutral sense such as Laurentius's (cf. pp. 32–33, 71–72 above), not in the pessimistic sense (cf. p. 34 above, pp. 90–102 below). The latter sense would have required *at* in place of *et,* and more explanation.

APPENDIX V

THE PESSIMISTIC INTERPRETATION OF "KNOW THYSELF"

A. SYNOPSIS

I. *Interpolation of "know thyself" where tradition suggests "recognize that you are mortal"*

A	consolation literature		
1	mid-1st cent.A.D.	Seneca	
2	1st/2nd cent.A.D.	Plutarch	
B	triumph literature		
3	14th cent.	*Gesta romanorum*	
C	Philip of Macedon and the slave		
4	1581	J. Borja	Fig. 12
5	1626	J. Riolan	

II. *Miscellaneous examples*

6	1st/2nd cent.A.D.	Plutarch	
7a	1st/2nd cent.A.D.?	mosaic from Via Appia	Pl. 38
7b	date unknown	carnelian ringstone	
8	2nd cent.A.D.	Lucian	
9	date unknown	Menander?	
10	10th cent.	Liudolf, Duke of Swabia	
11	1508	Erasmus	
12	1522	W. Pirckheimer	
13	1548	G. Corrozet	
14	*c.* 1550?	O. Fine	
15	1550/1600	English finger-rings	Pl. 39
16	1585	S. Alberti	Pl. 31
17	1582/90	J. Hoefnagel	
18	1609/15	P. Paaw	Pl. 8
19	1611	C. Bartholin	Pl. 32
20	1621	G. Fabricius Hildanus	
21	1668	H. S. Schilling	Pl. 36
22	1683	G. Franck	

III. *The "death-in-a-mirror" motif*

A	"certain"		
23	152[9?]	L. Furtenagel	Pl. 40
24	*c.* 1630?	J. Ribera	Fig. 13
25	*c.* 1640/1660?	J. Jordaens	Pl. 41

B	probable independently of A		
26	c. 1625?	N. Tournier?	Pl. 42
27	c. 1625?	T. Bigot?	
28	1626	N. Renieri	Pl. 43
29	1627	O. Fialetti	Pl. 34
30	1666	G. Blasius	Pl. 35
C	probable dependently on A and B		
31	later 17th cent.	anon. still-life painter	Pl. 44
32	before 1661?	S. Luttichuys	Pl. 45

proposed addenda

19.1	1619	S. Egbertsz	Pl. 5
20.1	1625	J. Fonteyn	Pl. 6
20.2	1632	F. van Loenen after N. Tulp	Pl. 1

B. TEXTS

I. *Interpolation of "know thyself" where tradition suggests "recognize that you are mortal".*

A consolation literature. Cf. Cicero, *Ep. ad fam.* V. 16. 2 "Est autem consolatio peruulgata quidem illa maxime quam semper in ore atque in animo habere debemus, homines nos ut esse meminerimus"; anon., *Cons. ad Liuiam* 367 "sed mortalis erat"; Seneca, *Ep.* LXIII. 15 "nunc cogito omnia et mortalia esse et incerta lege mortalia"; S. Ambrose, *De obitu Valent.* XLVIII (Migne, *P.L.*, xvi, col. 1434) "homo natus est, humanae fuit obnoxius fragilitati"; S. Jerome, *Ep. ad Paulam super obitu Blaesillae filiae* (Migne, *P.L.*, xxii, col. 468) "hominem te esse memento!" [cf. *B* below].

1 L. Annaeus Seneca, *Ad Marciam de consolatione* ed. Ch. Favez, Paris, E. de Boccard, 1928. Cap. XI:

Mortalis nata es mortalesque peperisti; putre ipsa fluidumque corpus, et ... sperasti tam inbecilla materia solida et aeterna gestasse? Decessit filius tuus, id est decucurrit ad hunc finem ad quem quae feliciora partu tuo putas properant: hoc omnis ista quae in foro litigat, in theatris <spectat>, in templis precatur turba dispari gradu uadit; et quae diligis et quae despicis unus exaequabit cinis. Hoc uidere licet illa pythicis oraculis adscripta uox: NOSCE TE. Quid est homo? Quodlibet quassum uas et quolibet fragile iactatu ...'. Quid est homo? inbecillum corpus et fragile, nudum, suapte natura inerme, alienae opis indigens, ad omnis fortunae contumelias proiectum [253]

2 Plutarch, *Consolatio ad Apollonium*, c. 116, translated. Excerpt:

If, then, a man shows excessive grief when he is about to die or when his children have died, must he not manifestly have forgotten that he is [only] a man and that the children he begat were mortal? For it is not like a sensible man to be unaware that man is a mortal animal and that he is born to die There are two of the inscriptions at Delphi which are most necessary to life: "Know thyself" and "Nothing in excess"; for all the others depend on these. These are in harmony and accordance with each other, and

[253] Cf. Wilkins, p. 58.

the one seems to be revealed to the full through the other. For the avoidance of excess is contained in knowing oneself, and knowing oneself in the avoidance of excess So anyone who keeps in mind these oracular precepts will easily be able to adapt them to all the affairs of life . . . and not go beyond what is fitting either by boasting superiority or by being humbled and cast down in wailing and lamentation through weakness of spirit and fear of death[254]

B　triumph literature. Cf. Arrian, *Dissertationes Epicteti* III. 24. 85　ὑπομιμνήσκοντες ὅτι ἄνθρωποί εἰσιν;　Tertullian, *Apologeticus* XXXIII "Hominem se esse etiam triumphans in illo sublimissimo curru admonetur. Suggeritur enim ei a tergo 'Respice post te! hominem te esse memento'"; S. Jerome, *Epistola ad Paulam super obitu Blaesillae filiae* (Migne, *P.L.* xxii, col. 468) "monitor quidam humanae imbecillitatis apponitur, in similitudinem triumphantium quibus in curru retro comes adhaerebat per singulas acclamationes ciuium dicens 'Hominem te esse memento!'"; S. Isidore, *Etym.* XVIII. ii. 6. "ut ad tantum fastigium euecti mediocritatis humanae commonerentur"; Zonaras, *Chronicon* VII. 21 (Migne, *P.G.*, cxxxiv, col. 612).

3　*Gesta Romanorum*, 14th cent., ed. H. Oesterley, Berlin, 1872. Cap. 30, p. 328:

Rex quidam erat qui statuit pro lege, quod victori de bello redeunti fieret triplex honor et tres molestie Secunda molestia erat, quod iste servus eum colaphizabat ne nimis superbiret, et dicebat "Nosce te ipsum et noli superbire de tanto honore! Respice post te et hominem te esse memento!".[255]

C　Philip of Macedon and the slave. Cf. Aelian, *Var. hist.* VIII.15

ᾤετο δεῖν αὐτὸν ὑπομιμνήσκεσθαι ὑπό τινος τῶν παιδίων ἕωθεν ὅτι ἄνθρωπός ἐστι, καὶ προσέταξε τῷ παιδὶ τοῦτο ἔχειν ἔργον.

4　Juan de Borja, *Empresas morales*, Praga, 1581. Fol. 100ᵛ:

Hominem te esse cogita. No ay cosa mas importante al hombre Christiano que conoçersse, porque si se conoçe no sera soberuio viendo que es poluo y çeniça, ni estimara en mucho lo que ay en el mundo viendo que muy presto lo ha de dexar. Tener esto delante los ojos es el mayor remedio que puede hauer para no descuydarsse ni dexar de hazer lo que deue, y haziendo lo assi passara la vida con quietud, porque los trabajos que le suççedieren conoçera que los mereze y passar los ha con paciencia, y las prosperidades no le eleuaran conociendo que se le dan sin merezerlas. Preciaronsse los antiguos (aunque no tuuieron fee), tanto de este conocimiento para conseruar la virtud, que se escriue de aquel gran Philippo Rey de Maçedonia que despues de hauer vencido en la batalla de Cheronea con esta gloria no se en soberueciese mas de lo neçessario mando que cada mañana quando le despertassen la primera cosa que le dixessen fuesse: Leuantate Rey y acuerdate que eres hombre: cosa muy digna de traer siempre en la memoria, y es lo que seda a entender en esta vltima empressa de la muerte, con la letra, HOMINEM TE ESSE COGITA, que quiere decir, ACVERDATE QVE ERES HOMBRE.[256]

The image which corresponds to this text is a skull (Fig. 12).

5　Johannes Riolanus, *Anthropographia et osteologia*, Paris, 1626. 'AV ROY', p. 1:

. . . se cognoistre soy-mesme. C'estoit la seule science de Iuppiter, qu'il feit grauer en lettres d'or, sur le frontispice du temple d'Apollon. C'estoit la leçon qu'vn page donnoit au Roy Philippe pere d'Alexandre le Grand, tous les matins à son leuer. Souuenez vous Philippe que vous estes Homme

[254] Cf. Wilkins, ibid.
[255] Cf. Wilkins, pp. 79–80.
[256] Cf. Wilkins, p. 232.

Figure 12. Emblematic image to illustrate *"Hominem te esse cogita"*, anonymous engraving for J. de Borja, *Empresas morales*, Praga, 1581, fol. 101[r].

II. *Miscellaneous examples*

6 Plutarch, *De E apud Delphos* 394C, translated. Excerpt:

> ... "Know thyself" seems to be a kind of antithesis to "Thou art", and yet, in a sense, in harmony with it. For the latter is uttered in awe and reverence to the god as an eternal being, while the former is a reminder to mortal man of the nature and weakness of his situation.

7a A mosaic from the Via Appia, now in the Museo Nazionale Romano, shows a skeleton pointing to the words *ΓΝΩΘΙ CAYTON.*[257] See Pl. 38.

7b A carnelian ringstone, apparently ancient, carved with a skeleton and the inscription *ΓΝΩΘΙCEAYTON,* is recorded as having passed through the collections of Praun, Mertens-Schaafhausen, and Rhodes. The Rhodes gems were dispersed privately, and the whereabouts of the present gem seems to be unknown.[258] The design may be related to that of **7a**.

[257] Cf. Wilkins, pp. 58–59. R. Paribeni, *Le terme di Diocleziano e il Museo Nazionale Romano*, Rome, Libreria dello Stato, 1928, p. 64, no. 49 (1025).

[258] G. Treu, *De ossium humanorum larvarumque apud antiquos imaginibus capita duo*, diss. Berlin, 1874, p. 18, no. 50. C. W. King, *Handbook of engraved gems*, 2nd ed., London, 1885, p. 179.

8a Lucian, *Dialogues of the dead* 3 (otherwise 2), 'Pluto', tr. M. D. Macleod, Loeb edition vol. 7, London, Heinemann, 1961, pp. 14–19.

The dead Croesus, Midas, and Sardanapalus lament the loss of their respective wealth, gold, and luxury. Menippus pesters them with reproaches: they had expected people to worship them, treated free men with contempt, and "forgotten all about death". He leaves them with the words: "Bravo, go on. You keep up your whimperings, and I'll accompany you with song, with a string of 'Know Thyself's for my refrain. That's the proper accompaniment for such lamentations."

8b Lucian, *Dialogues of the dead* 12 (otherwise 14), 'Philip and Alexander', ibid., pp. 60–67.

The shade of Philip welcomes the shade of Alexander to the underworld, and points out the falsity of Alexander's former claim to be immortal. Philip ends: "Won't you learn to forget your pride, and know yourself, recognize that you are now dead?".

Although the advice in each case is that the dead should recognize themselves as such, it is implicitly retrospective. The reproach is uttered only because they had not recognized their mortality while alive.[259]

9 *Comparatio Menandri et Philistionis,* in *Menandri sententiae,* ed. S. Jaekel, Leipzig, Teubner, 1964, p. 111.[260] Lib. II, vv. 166–174 translated:

Menander.

On death

If you want to know yourself,
look at the tombs as you walk along.
In them are the bones and powdery dust
of kings, dictators, philosophers,
of men who were proud of their family or their wealth
or their fame or personal beauty.
None of these things did time allow them:
in a common underworld all mortals dwell.
Looking on these things, "know thyself".

The date of this work is unknown. Some scholars place it in the 4th/6th centuries A.D., while allowing that it may contain verses by Menander himself (342/1–293/89 B.C.).

10 Epitaph of Liudolf, Duke of Swabia (died 957), formerly in S. Albanuskirche, Mainz:[261]

SISTE VIATOR ITER PER ME TV GNOTI SEAVTON
NAM QVOD ES HOC FVERAM QVOD SVM NVNC ET ERIS
NON MIHI LIVDOLFO TOTVS SVFFECERAT ORBIS
NVNC SPECVS HOC CINERI SVFFICIT HICQVE SAT EST
HINC VT IS ETERNAM REQVIEM MIHI DET ROGO DICAS
OMNIA QVI FECIT MEQVE VEHI VOLVIT.

[259] Cf. Wilkins, p. 58.
[260] Cf. Wilkins, pp. 57–58.
[261] F. X. Kraus, *Die christlichen Inschriften der Rheinlande,* part ii, Freiburg i.B. and Leipzig, 1894, pp. 99–100, no. 223.

11 Erasmus Roterodamus, *Adagiorum chiliades tres, ac centuriae fere totidem*, Venice, 1508.

I. dcxv, 'NOSCE TEIPSUM', fol. 74ᵛ: "Citatur a gnomologis graecis ex Antiphane senarius εἰ θνητὸς εἶ βέλτιστε θνητὰ καὶ φρόνει. Eandem sententiam sic extulit Pindarus, θνατὰ θνατοῖς πρέπει"

12 Bilibaldus Pirckeymherus (Wilibald Pirckheimer), *Apologia seu podagrae laus*, Nuremberg, 1522. Excerpts, fol. CIʳ:

[Podagra.] . . . demonstro, quam euanidum formae bonum, quam facile corporis pereat robur, quam fluxi sint honores, quam opes labiles, quam generis nobilitas nihil, quam inanis sit omnis omnium mortalium gloria, ac ita efficio, ut homines se homines esse meminerint, nec diis se conseant ęquales . . . [fol. C3ʳ] . . . [doceo] cunctaque certo termino metiri, seipsum cognoscere, finem qui omnem manet carnem assidue pre oculis habere

13 Gilles Corrozet, *Le conseil des sept sages de Grece*, Lyons, 1548. 'Les dits de Chilo', p. 24:

Nosce teipsum
Congnoy toymesme, en considerant comme
Tu es mortel, debile, & fragile homme.

La plus grande science, que lhomme puisse auoir, cest congnoistre soymesme: car sil sçait toutes les sciences humaines, & il ne se congnoist, il est ignorant. L'homme en se congnoissant, recongnoist Dieu pour son createur & seigneur: & luy, creature mortelle, & seruiteur inutile Ce commandement estoit anciennement escri à lentrée du portail du temple d'Apolo en Delphos, à fin quil fust imprimé en la memoire des hommes.

14 An engraving representing the head of a fool wearing a fool's cap and collar, but whose face is replaced by a map of the world attributed to Oronce Fine (1494–1555). The design illustrates the vanity of the world, and this message is made explicit by such pessimistic inscriptions as "vanitas vanitatum . . ." and, surmounting the whole "NOSCE TE IPSVM".[262]

15 Two English, Elizabethan, gold finger-rings in the Victoria and Albert Museum London.

15a (museum no. M 18/1929) has a revolving bezel which is decorated with a skull of enamelled gold and inscribed "NOSSE TE IPSVM".

15b (museum no. 920/1871) also has a setting decorated with a skull of enamelled gold, around which is inscribed "† NOSSE TE YPSVM" (Pl. 39). But it also bears a second inscription, an optimistic one to counter the pessimistic Delphic maxim: "† DYE TO LIVE", inscribed around the outer lateral surface of the setting.[263]

16 Salomon Alberti, *Historia plerarunque partium humani corporis*, Wittenberg, 1585.

A woodcut on the title-page represents a skull with an hourglass and a snake, surmounted by the legend *ΓΝΩΘΙ ΣΑΥΤΟΝ*. See Pl. 31.

[262] Mentioned by Gillian Hill, *Cartographical curiosities*, London, British Library, 1978, p. 39; an impression from the Bodleian library was in the exhibition of the same title at the British Library, London, 1978–1980, no. 45.

[263] Cf. F. Parkes Weber, op. cit., note 246 above, p. 756.

17 Joris Hoefnagel, *Missale romanum* (illuminated by J. H., 1582–90), Vienna. Österreichische Nationalbibliothek, cod. 1784. Fol. 107ʳ:

ΓΝΩΘΙ ΣΕΑΥΤΟΝ

VIVE MEMOR LETHI PASCENDIS VERMIBVS ESCA
ET QVOD FORMATVS PVLVERIS PVLVIS ERIS.

The verses are illustrated by two "vanitas" images: the half-consumed corpses of a man holding money-bags and of a woman looking at herself in a mirror (cf. section III of this appendix, p. 98 below).[264]

Among the many pessimistic motifs on this page, there is one other which alludes to "know thyself":

"ILLE EST MAXIME SEIPSVM SCIENS QVI SE ESSE EXISTIMAT NIHIL."[265]

18a Two engravings, published in 1609 and 1610, show the interior of the anatomy-theatre of Leiden university with six skeletons, bearing pennants, standing around the circumference: cf. Apendix III no. **14**, p. 73 above. The inscriptions on the pennants were selected to remind visitors of "de brooscheydt ende nieticheydt vande menscheliche lichamen".[266] One of the inscriptions in each engraving is *nosce teipsum*. The full list of inscriptions is as follows, reading from left to right:

	1609 (Pl. 8)	1610
i.	PVLVIS ET VMBRA SVMVS.	MORS ULTIMA LINEA RERUM.
ii.	Omnes eodem cogimur aequa lege necessitas sortitur insignes et imos.	NASCENTES MORIMUR.
iii.	NOScE TE IPSVM.	PRINCIPIUM MORIENDI NATALIS EST.
iv.	HOMO BVLLA.	MORS SCEPTRA LIGONIBUS AEQUAT.
v.	Mori vltimum. Vita Breuis.	PULVIS et UMBRA SUMUS.
vi.	MEMENTO MORI.	NOSCE TE IPSUM.

The context indicates that *nosce teipsum* here means "know that you are mortal". The inscriptions were presumably chosen by Pieter Paaw, the director of the anatomy-theatre; cf. no. **18b** of this appendix.[267]

18b P. Scriverius (Schrijver), *In theatrum anatomicum, quod est Lugduni in Batavis, secante et perorante V.C. Petro Pauio med. botanico & anatomico praestantissimo*, [Leiden, 1615]. Bibliographical details in Appendix III no. **14c**, p. 73 above. Excerpts, vv. 61–65, 91–7:

[264] Th. A. G. Wilberg Vignau-Schuurman, *Die emblematischen Elemente im Werke Joris Hoefnagels*, Leiden, Universitaire Pers, 1969, vol. 1 pp. 238–239, and vol. 2 fig. 8.

[265] Presumably a quotation: cf. Arnold Geilhoven, *Gnotosolitos*, Brussels 1476, fol. 2ᵛ, col. i "Ille vere solus est se sciens qui nichil se esse credit."

[266] J. J. Orlers, *Beschrijvinge der stad Leyden*, Leiden, 1614, p. 149.

[267] Th. H. Lunsingh Scheurleer, 'Un amphithéâtre d'anatomie moralisée', in *Leiden University in the seventeenth century*, Leiden, Universitaire Pers, 1975, pp. 216–277.

Hic, hic disce mori viator, & te
nosse ante omnia disce, disce quid sis.
Quam res lubrica vita tota nostra est!
Quid speras, homo vane, quidque spiras,
quidve altum sapis?
Ne te fallere posse crede mortem;
per mendacia mille, perque fraudeis
haec te prosubiget, tuoque demet
personam capiti, nihilque fies
qui comptis modo crinibus nitebas.
Hei! quam gaudia vana, quam caduca!
Hei! quam solstitialis herba vita est!

19 Caspar Bartholin, *Anatomicae institutiones corporis humani*, [Wittenberg], 1611.

A device on the title-page (Pl. 32) shows a skull and crossbones surmounted by a two-headed figure, one of whose heads is young, the other old. On the left is the inscription "Nosce Teipsum." and on the right "Memento mori.".

20 Wilhelm Fabry von Hilden (Fabricius Hildanus), *Spiegel dess menschlichen Lebens*, Berne, 1621.

The book contains a woodcut of the following design:[268] [*within a decorative border*] "NOSCE TE IPSVM | [black letter] Erkenn dich selbst zu aller frist, | Gedenck auch dass du sterblich bist. | [woodcut: on a pedestal, (left) a winged hourglass with (above) a vessel emitting smoke or vapour; (centre) an open-mouthed human skull with cervical vertebrae *in situ*; (right) a flowering plant in a flask of water and a withered plant outside it] | [printed on the side of the pedestal] MEMENTO MORI."

The author of this book, which is a long treatise in verse on moral subjects, was a superior surgeon who was also interested in anatomy (Pl. 20). He corresponded with Pieter Paaw, who had shown him round the Leiden anatomy-theatre in 1611.[269] His interest in anatomy would have brought him into contact with the pessimistic sense of "know thyself" which is illustrated in the present woodcut. Cf. nos. **16, 18, 19** of this appendix.

21 Henricus Sigismundus Schilling, *Tractatus osteologicus, sive osteologia microcosmica . . . cui denuo adjicitur discursus . . . hominem μικρόκοσμον, sive cognitionem sui considerans*, Dresden, 1668.

The frontispiece (Pl. 36), and parts of the text, illustrate the pessimistic sense of "know thyself". Cf. Appendix III no. **34**, p. 82 above.

22 Georg Franck von Franckenau, *Nosse Deum nosse se unica sapientia! . . .*, Heidelberg, 1683.

[268] Reproduced by E. Hintzsche, *Guilelmus Fabricius Hildanus 1560–1634*, Hilden, Rönsberg, 1972, p. 70.

[269] Wilhelm Fabry (Fabricius) von Hilden, *Von der Fürtrefflichkeit und Nutz der Anatomy*, Aarau, H. R. Sauerländer, 1936 (Veröffentlichungen der Schweizerischen Gesellschaft für Geschichte der Medizin u. der Naturwissenschaften, no. X), p. 188.

Excerpt, p. 7: "Anatome quin imo est perquam necessaria omni homini ad cognitionem sui ipsius Nam ... ex ea miseram vilemque naturae suae conditionem discit, videtque se inter stercus & urinam nasci ...". Cf. Appendix III no. **37**, pp. 82–83 above.

III. *The "death-in-a-mirror" motif*

A skull (or skeleton) together with a mirror was sometimes used in painting to represent "know thyself" in the pessimistic sense. The motif had its origin in depictions of the sin of vanity: vanity was forgetfulness of mortality, "know thyself" a reminder of it. In some examples the skull (or skeleton) is reflected in the mirror; in others they are merely juxtaposed.

The following ten examples are divided into three groups. In group *A*, the interpretation "know thyself" seems inescapable, in group *B* independently probable, and in group *C* a reasonable deduction from analogy with the first two groups.

A

23 Laux Furtenagel, Portrait of Hans Burgkmair and his wife, 152[9?]. Vienna, Kunsthistorisches Museum, Gemäldegalerie no. 167.

The sitters hold before them a mirror in which they see two skulls. On the frame of the mirror there are two inscriptions: "ERKEN DICH SELBS" on the side, and at the top "O MORS". See Pl. 40.

24 A lost painting, formerly in the Orleans collection, where it was recorded in 1786 in an engraving by Jacques Couché (Fig. 13).[270] Although engraved as a self-portrait by Caravaggio, the painting was a version of a painting by Ribera of which five other versions have been published. The composition has been dated to the early 1630s.[271]

The picture shows a man looking in a mirror; behind him, a skull. The man has been identified as Socrates, who was generally portrayed in seventeenth-century painting with a mirror, symbol of his famous self-knowledge.[272] However, one of the surviving versions of the painting bears an old inscription "SCVLAPIO", and since Aesculapius, in at least one source, was also associated with "know thyself",[273] this identification, as *difficilior interpretatio*, may be correct. Whichever name we give to the man, "know thyself" would be the theme of his attributes.

The surviving versions of the painting lack the skull. If it was not an original part of the Orleans picture, it must have been added by someone (perhaps Couché himself)

[270] J. Couché, *Galerie du Palais Royal*, vol. 1, Paris, 1786, 'Portrait de Michel Ange Amerighi de Caravagge peint par lui même'.

[271] N. Spinosa, *L'opera completa di Ribera*, Milan, Rizzoli, 1978, p. 127, nos. 234–238.

[272] Delphine Fitz Darby, 'The wise man with a looking-glass', *Art in America*, 1948, **36**: 113–126. A. Pigler, 'Sokrates in der Kunst der Neuzeit', *Die Antike*, 1938, **14**: 281–294.

[273] Achilles Bocchius, *Symbolicarum quaestionum . . . libri quinque*, Bologna, 1574, pp. 116–7, lib. II, symb. LIIII.

who was familiar with the traditional use of the mirror and skull to denote "know thyself" as a reminder of mortality.[274]

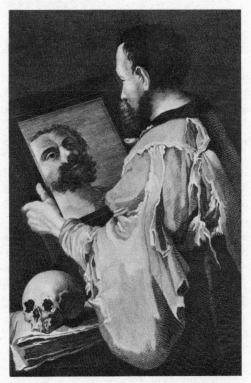

Figure 13. Jacques Couché, "Portrait de Michel-Ange Amerighi de Caravagge peint par lui-même" (so called), engraving, *c.* 1786, after a painting by Jusepe de Ribera, *c.* 1630/1635, printed in the *Galerie du Palais Royal*, Paris, 1786.

25 An illustration of "know thyself" by Jacob Jordaens, dated in the 1640s or 1650s. The illustration survives in two autograph drawings, an engraving after one of them (Pl. 41), and several painted and drawn copies. One of the autograph drawings, in the Ashmolean Museum, Oxford, has a cartouche inscribed "KENT V. SELVEN." The other, in the Morgan Library, New York, has a blank cartouche which, in the engraved version, is inscribed "NOSCE TEIPSVM".[275]

A woman combs her hair before a mirror held by a fool; an ancient philosopher draws her attention to a skull, and utters the following words, which are printed on the engraving:

[274] Though Couché's engravings of the Orleans pictures are generally accurate, they contain enough variations – in the plates of Titian's 'Death of Actaeon' and of Annibale Carracci's 'St. Roch' in the Fitzwilliam Museum, for example – to justify doubts about the faithfulness of this engraving.

[275] R. A. d'Hulst, *Jordaens drawings*, vol. 1, London and New York, Phaidon, 1974, pp. 289–291, nos. A 203, A 204, figs. 218, 219. On the Morgan drawing and its affiliations: F. Stampfle, *Rubens and Rembrandt in their century*, New York, Pierpont Morgan Library, 1979, pp. 59–60, no. 24.

Stulta, quid ad speculum fastus assumis inanes,
atque tibi forma, quae peritura, places?
Hic cernis quod eris, quodque es. Quid credere cessas?
Quae loquor, haec forsan iam dabit hora fidem.

B

26–28 Three paintings by a trio of Caravaggists, *c.* 1625.

26 is in the Ashmolean Museum, Oxford, where it is ascribed to Nicolas Tournier (Pl. 42).[276] It shows a woman dressed in antique costume and wearing the chaplet of a priestess. With her left hand she holds up a balance in equilibrium, while with her right she supports a mirror. In front of the mirror, and reflected in it, is a skull resting on a book.

27 is in the Galleria Nazionale d'Arte Antica, Rome. It is attributed to the "Candlelight Master" (Trophime Bigot?).[277] The composition is different from that of the Oxford picture (Pl. 42), but the iconography is essentially the same. The figure wears a white turban in place of a chaplet.

28 is an over-door painting by Niccolò Renieri (Regnier) now in the Galleria del Daniele, Palazzo Reale, Turin (Pl. 43). It is dated 6 June 1626. A replica is at the Landesmuseum, Troppau.[278] The subject is the same as that of the other two pictures (nos. **26, 27**), except for the fact that Renieri's figure is bare-headed.

The co-existence of these six attributes in each picture – antiquity, the woman, the head-dress (except in **28**), the balance, the skull, and the mirror – is explained if we identify the woman as the ancient Pythia, or Delphic priestess of Apollo, demonstrating the Delphic maxims μηδὲν ἄγαν and γνῶθι σεαυτόν. The balance would illustrate μηδὲν ἄγαν "nothing in excess", while the mirror and skull would illustrate γνῶθι σεαυτόν, "know thyself", as they do in *A* above.

The mirror-and-balance motif may be derived from the Alciati emblem which illustrates the sayings of the seven sages.[279] There, however, the balance illustrates *optimus in rebus modus est (ἄριστον μέτρον ἐν πᾶσιν)*, not *nihil nimis (μηδὲν ἄγαν)*:

[276] Ashmolean Museum, *Catalogue of paintings,* Oxford, Visitors of the Museum, [1972], p. 160, no. 204, as a syncretic "Allegory of justice and vanity". *Summary catalogue,* Oxford, Ashmolean Museum, 1980, p. 93, as the same. E. Wind also considered it a pastiche, but meaning "Truth presenting her mirror to the vanities of the world" (Ashmolean Museum *Annual Report,* 1939, p. 30); however, there are many differences between the Oxford picture and the passage of Ripa's on which this interpretation depends (1611 edition, p. 530). B. Nicolson, *The international Caravaggesque movement,* Oxford, Phaidon, 1979, p. 61 as a 'Vanitas' by an imitator of Honthorst.

[277] *La peinture en Provence au XVIIe siècle* (Musée des Beaux-Arts, Palais Longchamp, Marseilles), Marseilles, J. Laffitte, 1978, p. 8 no. 7 with repr. and lit., as 'Vanitas' or 'Allégorie sur la mort', *c.* 1625. Nicolson, op. cit., note 276 above, p. 21 as the same. E. Panofsky, 'Et in Arcadia ego', in R. Klibansky and H. J. Paton (eds.), *Philosophy and history,* Oxford, Clarendon Press, 1936, pp. 223–254, fig. 4 and p. 235, as a 'Vanitas' picture. B. Nicolson and C. Wright, *Georges de la Tour,* London, Phaidon, 1974, reproduce the Oxford and Rome pictures together as figs. 78, 80, both entitled 'Vanitas'.

[278] Pier Luigi Fantelli, 'Nicolò Renieri "pittor fiamengo"',' *Saggi e memorie di storia dell' arte,* 1974, **9**: 79–115, p. 105, no. 108, fig. 44 (Turin version) and no. 111, fig. 43 (Troppau version), both entitled 'Allegoria della Sapienza'.

[279] A. Alciati, *Emblemata,* Padua, 1621, emblema CLXXXVII, pp. 784–786.

> Optimus in rebus modus est, Cleobulus ut inquit:
> hoc trutina examen, siue libella docet.
>
> Noscere se Chilon Spartanus quemque iubebat:
> hoc speculum in manibus, uitraque sumpta dabunt.

29 A design for a title-page by Odoardo Fialetti (1573–1638), which was printed in Venice in 1627 and in Amsterdam in 1645. Bibliographical details in Appendix III no. **18,** p. 76 above.

The figure of Anatomia holds a mirror in one hand, a skull in the other: see Pl. 34. "Know thyself" was a traditional motto for anatomy (cf. Appendix III above), so we would have reason to interpret the mirror and skull in that sense even without the aid of section III. *A* of this appendix.

30 The additional engraved title-page of an anatomy-book by Gerardus Blasius, published at Amsterdam in 1666. Bibliographical details in Appendix III no. **33,** p. 81 above.

The engraving shows an anatomist who looks into a mirror and sees in it the skeleton that stands behind him: see Pl. 35. The reason for interpreting the scene in the sense "know thyself" is the same as in the previous example. Incidentally, Blasius was a great admirer of Nicolaes Tulp.[280]

C

31 A *vanitas* painting, apparently Dutch and probably of the third quarter of the seventeenth century.[281]

See Pl. 44. Among the reminders of mortality is a skull looking at its reflection in a mirror. The painter may have intended the motif only as a vague reminder of mortality, but since the other motifs show his awareness of their meaning (for example, the travelling-bag to illustrate life as a journey),[282] we should probably interpret the skull and mirror in the sense "know thyself", by analogy with III. *A* and *B* above.

[280] His *Commentaria in syntagma anatomicum . . . Veslingii,* Amsterdam, 1659, was dedicated to Tulp and three of Tulp's close colleagues, including Arnold Tholincx. In his *Anatome medullae spinalis . . . ,* Amsterdam, 1666, fol. A3ᵛ, Blasius copied word for word a sentence from Tulp's *Observationum . . . libri* (1641), I, c. 27, p. 56, with a dignified acknowledgment.

[281] One of two unattributed but perhaps related *vanitas* still-life paintings which include the skull-in-a-mirror motif. This one was offered for sale at Christie's, London, on 14 December 1979, lot 125 as "French school, circa 1660", and again on 18 December 1980, lot 168 as "E. Colyer". The other is in the Musée du Louvre, inv. no. 1946–15, included in the catalogue of the French school (text vol., 1972, p. 413; plate vol. II, 1974, no. 961), reproduced in colour in *Stilleben in Europa,* Münster, Westfälisches Landesmuseum, and Baden-Baden, Staatliche Kunsthalle, 1980, no. 124, pp. 212–213.

[282] Bergström, op. cit., note 194 above, p. 170, on a painting by P. Steenwyck in the Prado. The same motif appears in an etching by Bramer (Hollstein no. 4), and elsewhere.

32 A *vanitas* painting by Simon Luttichuys (1610–1661?), signed, not dated.[283]

See Pl. 45. Again, a skull reflected in a mirror illustrates the pessimistic meaning of "know thyself".

proposed addenda

19.1 identical with Appendix III no. **16.1,** p. 83 above.
20.1 identical with Appendix III no. **16.2,** p. 83 above.
20.2 identical with Appendix III no. **20.1,** p. 84 above.

[283] With Bernard Houthakker, Amsterdam, in 1979. L. J. Bol, *Holländische Maler des 17. Jahrhunderts,* Brunswick, Klinkhardt & Biermann, 1969, p. 309 and pl. 283.

INDEX

A number preceded by Pl. or Fig. refers to the Plate or Figure so numbered. A number alone refers to the page so numbered, including any pertinent footnote on that page. A number followed by *n* refers to a footnote or footnotes alone on the page so numbered. 'A. of Dr. T.' refers to Rembrandt's 'Anatomy of Dr. Tulp'. Institutions are indexed by place, not by name.

A

Aa, Pieter van der, 83, 84, Fig. 11
Aberdeen, University, 72; University Library, 72*n*
Actaeon, 99*n*
Adam, 36
Adam, Charles, 77, 80
Aelian, 92
Aesculapius, 34*n*, 98
Agapetus I, *pope*, 76
Aimé, Jean, *of Chauvigny (?)*, 71
Alberti, Leon Battista, 29*n*
Alberti, Salomon, x, 34*n*, 66, 71, 90, 95, Pl. 31
Alciati, A., 34*n*, 100, 101
Alexander *the Great*, 76, 89, 92, 94
allocutio-gesture, 8
Altdorf, 80, 81
Amatus, Joannes, *Chavigneus*, 71
Ambrose [Ambrosius], *St.*, 76, 91
Amsterdam, vii, 8, 9, 11, 21, 29*n*, 30, 34, 39, 40, 42, 43, 44, 45*n*, 48, 49, 78, 79*n*, 81, 82, 102*n*; college of physicians, 11, 86; corporation (guild) of surgeons, 1; anatomy-theatres, *see* anatomy-theatres; Amsterdams Historisch Museum, ix; Geschiedkundig Medisch-Pharmaceutisch Museum ix, 86; Nes, Rokin, Oude-Zijds Voorburg Waal, St. Margaret's Church, St. Antony's weigh-house, meat-markets, 86; Rijksmuseum, 40*n*, 46*n*; Rijksprentenkabinet, ix, 40*n*, 86; Six collection, x; Universiteits Bibliotheek, x, 78
anatome, as "eye of medicine", 13, 21; as pathology, 13, 21, 42, 83, Pl. 37; as physiology, 8, 22
Anatomia (personifications), xi, 19, 20, 76, 101, Fig. 4, Pl. 34
anatomical abnormalities, 6, 7; in painting, may be distortions, 7*n*, 9, or misinterpretations, 54, 55
anatomical equipment, 5, 38, 39*n*, 86
anatomical fugitive sheets, 66, 68–70, Fig. 10
anatomical illustrations: by Casserius, 8, 9, 10, 13, 14, 16, 77, Fig. 2; by G. de Lairesse, 14, 15, Fig. 3; by Vesalius, 9, 13, 16, 24*n*, 46, 47, 72, Pl. 11, Fig. 9; other, 13, 14, 16, 19, 20, 32, 68, 69, 77, Pl. 13, Fig. 4, Fig. 5; by Rembrandt, *see* Rembrandt van Rijn
anatomical method, 18, 28, 32*n*; *see also* anatomical equipment; anatomy, comparative; vivisection
anatomical museums, disgusting so-called, 84
anatomical nomenclature, 17*n*, 52*n*
anatomical praelections (public anatomies), 6, 12,

21, 23*n*, 24–26, 29–34, 36, 37, 43, 72, 77, 78, 80–82, Pl. 8, Pl. 15, Pl. 17
anatomical science, 12, 18, 21, 67–84
anatomy, of internal organs: **bones** (whole or part), epicondyle, medial, 14, 52, 53, 55, 60, 61, Fig. 2; epicondyle, lateral, 52, 53; *épitrochlée*, 52*n*; phalanges of fingers, 7, 20, 58, 59, 63; ulna and radius, 60, 62, 63; *see also* skeleton, skull; **joints**, elbow, 8, 52*n*, 53; of fingers, 58, interphalangeal, 7, 16, 58, 59, 60, 61, 63; wrist, 7; **muscles and tendons**, *m. flexor digitorum superficialis (sublimis)*, 7–10, 13–20, 23, 24, 35, 38, 52*n*, 54, 56, 58–64, Pl. 1, Pl. 2, Pl. 9, Pl. 10, Pl. 11, Pl. 13, Fig. 2, Fig. 3, Fig. 4; *m. flexor digitorum profundus*, 7–10, 13–20, 23, 24, 35, 38, 54–56, 58–64, Pl. 1, Pl. 2, Pl. 9, Pl. 10, Pl. 11, Pl. 13, Fig. 2, Fig. 3, Fig. 4; *m. flexor carpi ulnaris*, 54, 55, Pl. 1, Pl. 2, Pl. 9, Pl. 10; *m. flexor carpi radialis*, 55, 56; *m. flexor pollicis longus*, 56; *m. flexor palmaris longus*, 23, 54, 55, 61; *see also* hand; **nervous system**, brain, 3*n*, 45, 61, 74, 75; spinal cord, 12*n*, 75, 101*n*; *n. ulnaris*, 16; *n. ulnaris r. dorsalis manus*, 54, 55; *n. ulnaris r. superficialis manus*, 56; eye, 6, 19, 75; **viscera**, 74, 75, 87; ileum, 26; ileo-caecal valve, x, 21, 22, 23, 26, Pl. 15; larynx, 25; heart, 12, 45, 75; abdomen, 28, 38
anatomy-book: used by *praelector anatomiae*, 5, 6, 25, Pl. 2, Pl. 8; used by spectators, 24, 39*n*, Pl. 17. *See also* book, in painting *and* Rembrandt van Rijn
anatomy, comparative, 18, 36*n*, 74, 79
anatomy lessons, 2, 23, 77
anatomy-theatres: Altdorf, 80, 81; Amsterdam (in St. Antony's weigh-house, pre-1639 and post-1690), 36, 42, 86, 88; Amsterdam (above lesser meat-market, 1639–1690), 22, 23*n*, 49, 51, 80, 85–89; Bombay (Grant Medical College), ix, 3, Pl. 7; Delft, 24*n*, Pl. 4; Dordrecht (?), 77, 78; Erfurt ("Musaeum"), 77; Leiden (University), ix, x, 6, 21*n*, 25, 26, 33, 34, 73, 86, 96, 97, Pl. 8, Pl. 15; Leipzig, 80; London (Barber-Surgeons' Hall), 39, 40; in general, 11, 21, 26, 30–33, 38, 44, Pl. 17
Anaxagoras, 17, 57, 62, 63, 65
Angeli, F., *see* Filippo Napoletano
Anthologia Palatina, 72
antibiotics, 43
Antiphanes, 95
Apollo, 31, 34*n*, 69, 71, 74, 76, 77, 92, 95, 100; *see also* Delphi; Pythia
Apollonius, 91

103

Index

Argument from Design, 18, 19, 21
Aristotle, 17, 20, 44, 57, 58, 59, 60, 61, 62, 64, 65; pseudo-Aristotle, 58; "Aristoteles chymicus", 89
Arnold van Geilhoven, 44n, 96n
Arrian, 92
Arris, Edward, 64
Artelt, W., 12n
Athens, 33, 73
attributes, attributive features in portraits etc., 2, 3, 6, 27, 28, 29n, 35, 38, 42, 43

B

Baden-Baden, Staatliche Kunsthalle, 101n
Baerle, Caspar van, see Barlaeus
Baier, J. J., 80, 81
balance, 46, 100, 101
Banester, John, 19, 39, 57, 60, 61
Banga, J., 11n, 33n, 46n
Bar-sur-Aube, 69
Barbette, Paul, 67, 82
Barlaeus, Caspar, v, 22, 31, 33, 37, 39n, 41, 43, 44, 45n, 48, 49, 51, 66, 80, 85–89
Bartholin, Caspar I, x, 34n, 66, 74, 90, 97, Pl. 32
Bartholin, Thomas, x, Pl. 15, Pl. 29
Basil [Basilius], St., 76
Basle, 11, 19
Bassano, Leandro [Leandro da Ponte], 20n
Bauhin, Caspar, 11, 12, 13, 14, 17, 20, 32n, 44n, 57, 61, 62, 63, 66, 72, 74, 77, 80, 82
Bearn, J. G., v, vii, 52n
Beaufort, H. L. T. de, 40n
Bell, Sir Charles, 64
Benesch, Otto, 2n
Bergström, I., 46n, 101n
Berlin, Kaiserin Friedrich-Haus, 40n
Bernardi, F., 20n
Berne, 81
Bertius, P., 25n, 73, 87
Beverwijck, Johan van [Johannes Beverovicius], 32n, 33n, 44n, 45n, 46n, 66, 77, 78, 88
Bidloo, Govaert, xii, 14, 15, Fig. 3
Biema, E. van, 52, 56
Bigot, Trophime, 34n, 91, 100
Blankaart, Steven, x, xi, 67, 83, Pl. 17, Pl. 37
Blankert, Albert, 44n
Blasius, Abraham, 23n
Blasius, Gerardus, xi, 23n, 34n, 67, 81, 91, 101, Pl. 35
Block, Jacob, 24, 25, 27, 28
Blok, F. F., 48n
Bocchius, Achilles, 98n
body and soul, 31n, 44, 45, 47, 60, 69, 72, 74, 77, 79, 81, 82
Bogdanus, Martinus, 67, 81
Bokelius [Boeckel], Johannes, 36n, 66, 67, 71
Bol, L. J., 102n
Bologna, University, 16
Bolten, J., 52n
Bolten-Rempt, H., 52n
Bombay, Grant Medical College, ix, Pl. 7
Bontius, Leo [Leone Bonzio], 20n
book, in painting, 46, Pl. 26; see also anatomy-book
Borja, Juan de, xii, 34n, 90, 92, 93, Fig. 12
Bosch, Hieronymus, 27n

Bossuet, J.-B., 44n, 67, 82, 84
botany, 20
Bramer, Leonart, 101n
Bridgewater, 8th earl of, see Egerton, F. H.
Brown, Christopher, 36n
Bucretius, Daniel, 9n
Bulwer, John, 7n
Burger, W. [pseudonym of T. Thoré], 7n
Burgess, R., vii
Burgkmair, Hans, xi, 34n, 98, Pl. 40
Bynum, W. F., vii, 3n

C

Cabbala, 67
Caesar, 26
Calkar, see Kalkar
Calkoen, Mathys, 3n, 6, 7, 8, 23, 25, 27, 28, 30, 55, 56
Cambridge, Fitzwilliam Museum, xii, xiii, 99n
Campagnola, Domenico, ix, xii, 47, Fig. 9, Pl. 11
canal locks, 22
Canappe, Jean, 69
candle, 28, 29, 38n, 39n, 43, 45
"Candlelight Master", 34n, 100
Caravaggio, Michelangelo Merisi da, xii, 34n, 98, 99, 100, Fig. 13
Cardanus, Hieronymus [Girolamo Cardano], 59
carnelian, 90, 93
Carpentier Alting, M. P., 14n, 53–56
Carracci, Annibale, 99n
Casaubon, Isaac, 78
Casserius, Julius, xi, 8, 9, 10, 11, 13, 14, 16, 20n, 42, 76, 77, Fig. 2, Pl. 34
Cetto, Anna Maria, xiv, 6n, 14n, 20n, 40n, 52n, 73n, 81n, 83n, 86n
Chaloner, Sir Thomas, the elder, x, 46, Pl. 26
Charles V, emperor, 69
Charles I, king of England, 42
chemistry, 77
Chilo, 33n, 68, 73, 101
Christ, 46, 69
Christie's, xiii, 101n
Chrysostomus, St. John, 76
Cicero, M. Tullius, 20, 44n, 72, 91
Cicero, Quintus Tullius, 44n, 72
Clarke, E., vii
Cleobulus, 101
Clouck, Andries, 73
Cockx-Indestege, E., 68n
Coiter, Volcher, xii, 13,20, 36, 37, 40, 57, 60, 66, 67, 70, 71, 78, Fig. 5
Colevelt, Jacob, x, 1
Colie, Rosalie, 48n
Collyer [Colyer], Edward, 12n,101n
Colombo, M. R., see Columbus
Colotes, 44n
Columbus, M. Realdus, 13, 17, 20, 57, 60, 61, 62, 72
Commelin, Caspar, 86n, 87
Commelin, Isaac, 86n
Conrat, David, xi, Pl. 36
Consolatio ad Liviam, 91
consolation literature, 90, 91, 92
Coomber, Stella, vii
Copplestone, T., 3n

104

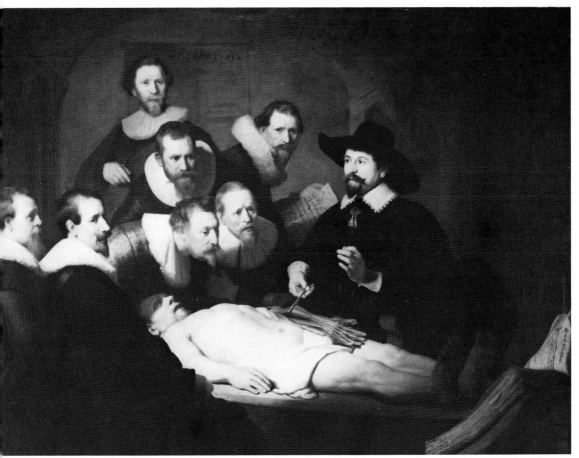

Pl. 2 Rembrandt van Rijn. 'The anatomy (or "anatomy lesson") of Dr. Nicolaes Tulp' (so called), oil painting, 1632, bears signature and date probably painted over autograph signature and date; with alterations by Rembrandt and more than one other hand. The Hague. Mauritshuis.

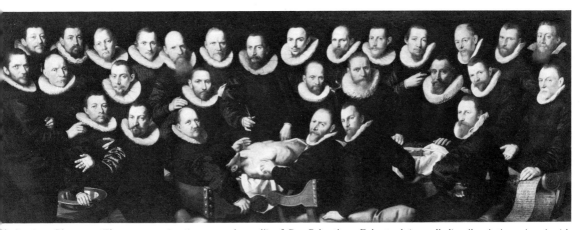

Pl. 3 Aert Pietersz., 'The anatomy (or "anatomy lesson") of Dr. Sebastiaen Egbertsz.' (so called), oil painting, signed with monogram and dated 1603. Amsterdam, Amsterdams Historisch Museum, currently exhibited at the Geschiedkundig Medisch-Pharmaceutisch Museum. Amsterdam.

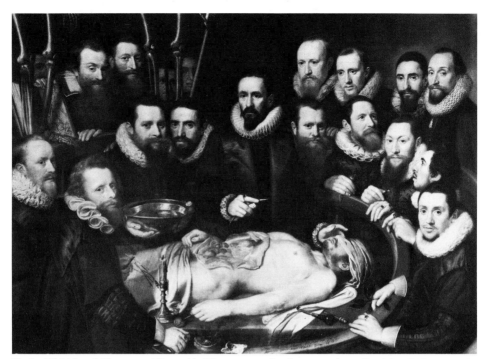

Pl. 4 Michiel and Pieter van Miereveld, 'The anatomy (or "anatomy lesson") of Dr. Willem van der Meer' (so called), oil painting, signed and dated 1617. Delft, Oude en Nieuwe Gasthuis.

Pl. 5 Thomas de Keyser, 'The anatomy (or "anatomy lesson") of Dr. Sebastiaen Egbertsz.' (so called), oil painting, 1619. Amsterdam, Amsterdams Historisch Museum.

Pl. 6 Nicolaes Eliasz. (called Pickenoy), 'The anatomy (or "anatomy lesson") of Dr. Johan Fonteyn' (so called), oil painting, 1625. Central part (only surviving fragment). Amsterdam, Amsterdams Historisch Museum.

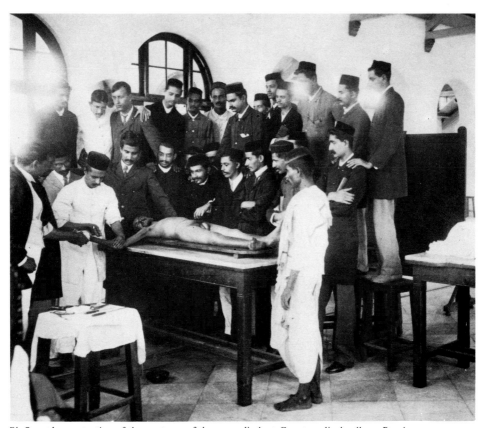

Pl. 7 a demonstration of the anatomy of the upper limb at Grant medical college, Bombay, anonymous photograph, late nineteenth century. London, British Library (India Office Library and Archives). *See p. 3.*

Pl. 8 an anatomy at the Leiden anatomy-theatre, anonymous engraving, 1609, after a drawing by J. C. van 't Woudt (woudanus). *The praelector has a book open in front of him (pp. 5–6). The spectators wear hats (pp. 29–30). Skeletons hold pessimistic inscriptions (p. 96).*

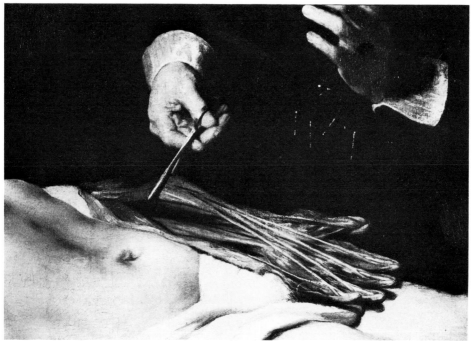

Pl. 9 dissection of the forearm. Detail from Rembrandt's so-called 'Anatomy of Dr. Tulp' (Pl. 2).

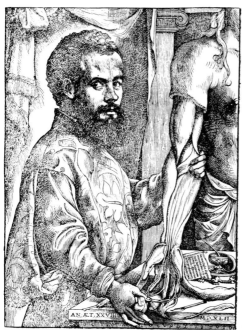

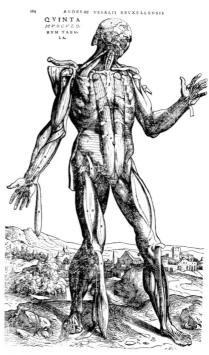

Pl. 10 portrait of Andreas Vesalius, 1542, anonymous woodcut for A. Vesalius, *De humani corporis fabrica,* Basle, 1543, frontispiece. *See pp. 9, 16ff.*

Pl. 11 illustration of the muscles, anonymous woodcut after a design by Johan Steven van Kalkar (?) and Domenico Campagnola (?) after dissections by A. Vesalius for his *De humani corporis fabrica,* Basle, 1543, p. 184. *See pp. 13, 24 (n. 97).*

Pl. 12 Rembrandt, portrait of
Johannes Antonides van der Linden,
etching, 1665. *See pp. 9, 11.*

Pl. 13 Leonardo da Vinci, flexor-
tendons in the wrist and hand, drawing,
c. 1510. Windsor, Royal Library (no.
19009ʳ). *Arrows added on photograph
mark the perforation of one sample
superficial flexor-tendon by one deep
flexor-tendon. See p. 16.*

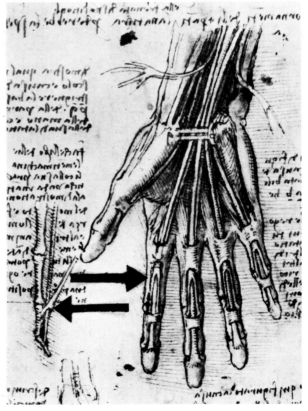

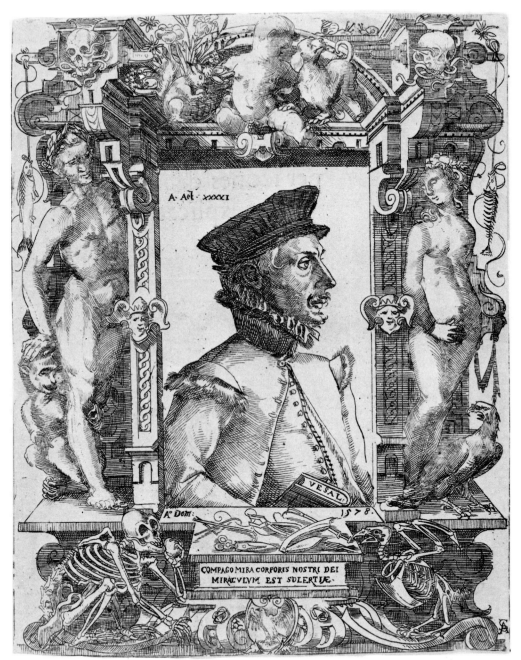

Pl. 14 Abel Stimmer, portrait of Felix Platter, engraving, 1578. *See pp. 19, 36.*

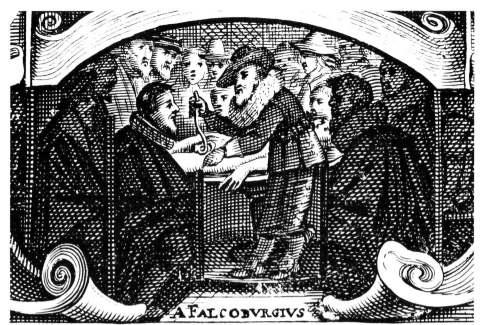

Pl. 15 Adriaen van Valckenburg demonstrating the ileum or ileo-caecal "valve" in the Leiden anatomy-theatre, anonymous engraving for Caspar I and Thomas Bartholin, *Institutiones anatomicae*. Leiden, 1641, title-page, magnified detail. *See pp. 21 (n. 83) and 26.*

Pl. 16 the book held by Hartman Hartmansz. in Rembrandt's so-called 'Anatomy of Dr. Tulp' (Pl. 2), showing the original anatomical figure and heading, with names of the sitters written over them later. *See pp. 1, 24 (n. 97).*

Pl. 17 an anatomical demonstration, anonymous engraving for Steven Blankaart, *Nieuw-hervormde anatomia*, Amsterdam, 1678, title-page. *The spectators consult books (p. 24) and wear hats (p. 30).*

Pl. 18 Nicolaes Eliasz. (called Pickenoy), portrait of Nicolaes Tulp, 1634, oil painting, Amsterdam. Six collection. *See pp. 28–29, 43.*

Pl. 19 Jan van de Velde II, portrait of Jacobus Zaffius, engraving, 1630, after a now mutilated painting by Frans Hals, 1611. *See p. 42.*

Pl. 20 portrait of G. Fabricius Hildanus (Wilhelm Fabry von Hilden), anonymous engraving, 1612, for his *Observationum . . . centuria tertia*. Oppenheim, 1614. *See pp. 42, 97.*

Pl. 21 W. Elder, portrait of Sir Theodore Turquet de Mayerne, engraving after anon., 1655. *See p. 42.*

Pl. 22 Pieter Schenck I, portrait of Frederik Ruysch (1638–1731), mezzotint after Juriaen Pool. *See p. 42.*

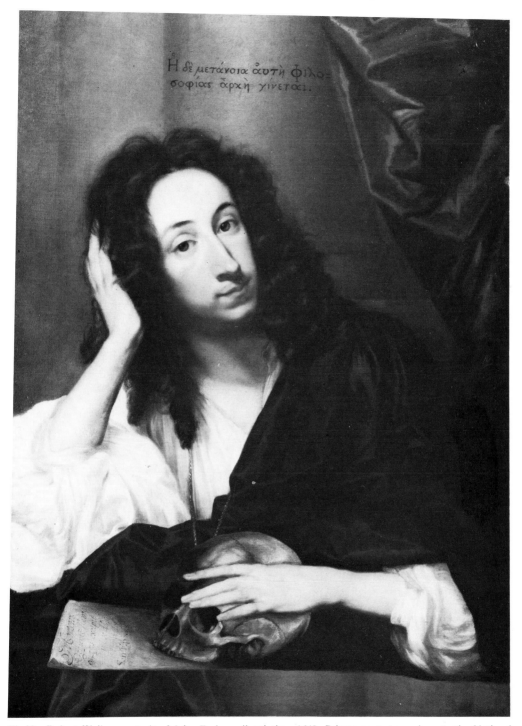

Ἡ δὲ μετάνοια αὐτὴ Φιλο=
σοφίας ἀρχὴ γίνεται.

Pl. 23 Robert Walker, portrait of John Evelyn, oil painting, 1648. Private property on loan to the National Portrait Gallery, London. *See p. 42.*

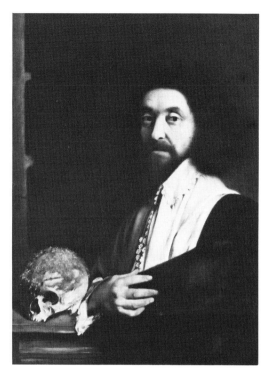

Pl. 24 Isaac Fuller, portrait of (Sir) William Petty, oil painting, 1649/1651, London, National Portrait Gallery. See p. 42.

Pl. 25 Emmanuel de Critz (?), portrait of John Tradescant the younger, oil painting, c. 1652, London, National Portrait Gallery, currently on loan to the Tate Gallery. See pp. 42–43.

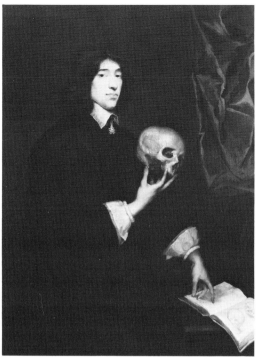

Pl. 26 portrait of Sir Thomas Chaloner I, anonymous Flemish oil painting, dated 1559, London, National Portrait Gallery. See p. 46.

Pl. 27 the Holme triptych, detail of outside of right wing, anonymous English oil painting, dated 1628. London, Victoria and Albert Museum, Department of Furniture and Woodwork. See p. 46.

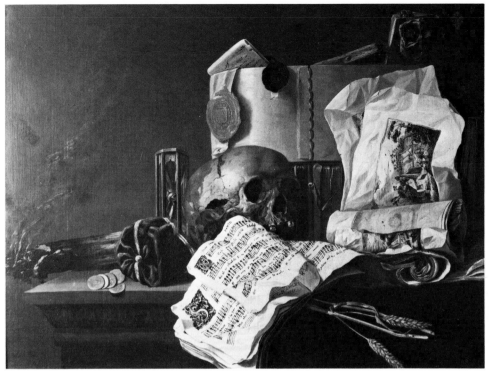

Pl. 28 N. L. Peschier, still-life, oil painting, signed and dated 1659. London, Victoria and Albert Museum, Department of Paintings. *See p. 46.*

Pl. 29 flowers growing from the human skull, anonymous engraving for Thomas Bartholin, *Historiarum anatomicarum rariorum centuria I et II,* the Hague, 1654, title-page. *See pp. 46–47.*

OMNIBVS HÆC CALCANDA VIA EST MORTALIBVS, AT QVI

CALCAT EAM CHRISTO SVBDVCE SALVVS ERIT

STRVCTA ALIBI TITVLIS STANT MAVSOLEA SVPERBIS
VRNA LAI BREVIS EST FAMA PERENNIS ERIT
LAVDE HYPERBOREAS INTERQVE EGESSERAT ORCAS
HIC QVI GLOTTA TVIS ACCOLA GAVDET AQVIS
GYMNASII REDITVS DOMVS HOSPITA PLVMBEA FANI
TECTA SCHOLÆ TANTI STANT MONVMENTA VIRI
EXITVS E VITA PLACIDVS SINE LABE PERACTIS
BIS SEPTEM LVSTRIS PRÆSVLE DIGNVS ERAT.

OBIIT 6to IDVS OCTOBRIS 1632.
J: A: G:

Pl. 30 tomb of Archbishop James Law (1560?–1632), detail. Glasgow, Cathedral. *See p. 47.*

ΓΝΩΘΙ ΣΑΥΤΟΝ

Pl. 31 vignette, anonymous woodcut for Salomon Alberti, *Historia . . . humani corporis*, Wittenberg, 1598, title-page. *See pp. 71, 95.*

NOSCE TEIPSUM.

MEMENTO MORI.

Pl. 32 vignette, anonymous woodcut for Caspar Bartholin I, *Anatomicae institutiones*, Wittenberg, 1611, title-page. *See pp. 74, 97.*

Pl. 33 Crispin de Passe, Jean Riolan II presenting a book (symbolically Riolan's *Anthropographia et osteologia*) to King Louis XIII, engraving for Jean Riolan, *Anthropographia et osteologia,* Paris, 1626, frontispiece. *See p. 76.*

Pl. 34 Francesco Valesio, "Anatomia" (centre) accompanied by "Diligentia" and "Ingenium", engraving after a drawing by Odoardo Fialetti, for Julius Casserius, *Tabulae anatomicae*, Venice, 1627, title-page, detail. *See pp. 76, 101.*

Pl. 35 an anatomist looking at a skeleton in a mirror, anonymous engraving for Gerardus Blasius, *Anatome contracta*, Amsterdam, 1666, additional title-page. *See pp. 81, 101.*

Pl. 36 David Conrat, illustration of the "microcosmic" and "pessimistic" ideas of man, etching for H. S. Schilling, *Tractatus osteologicus*, Dresden, 1668, frontispiece. *See pp. 82, 97.*

ΓΝΩΘΙ ΣΕΑΥΤΟΝ

Pl. 37 a dissection-scene inscribed in Greek "know thyself", with a view of a hospital in the background, anonymous engraving for Steven Blankaart, *Anatomia practica rationalis*, Amsterdam, 1688, additional title-page. *See p. 83.*

Pl. 39 bereavement ring with skull and inscriptions "know thyself" (in Latin) and "dye to live" (in English), anonymous English work in gold and enamel, late sixteenth century. London, Victoria and Albert Museum, Department of Metalwork (no. M 920/1871). *See p. 95.*

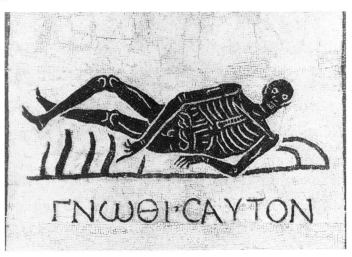

Pl. 38 reclining skeleton with legend in Greek "know thyself", anonymous mosaic for a building on the Via Appia, Rome. Rome, Museo Nazionale Romano. *See p. 93.*

Pl. 40 Laux Furtenagel, portrait of Hans Burgkmair and his wife, oil painting, signed and dated 152[9?]. Vienna, Kunsthistorisches Museum, Gemäldegalerie. *See p. 98.*

STVLTA, quid ad speculum fastus assumis inanes. *Hic cernis, quod eris, quodque es, quid credere cessas?*
 Atque tibi forma, quæ peritura, places? *Qua loquor, hæc forsan iam dabit hora fidem.*

Pl. 41 allegory with cartouche inscribed in Latin "know thyself", anonymous engraving after a drawing by Jacob Jordaens, mid-seventeenth century. Oxford, Ashmolean Museum. *See pp. 99–100.*

Pl. 42 Nicolas Tournier (?),
allegory, oil painting, *c.* 1625,
Oxford, Ashmolean Museum.
See p. 100.

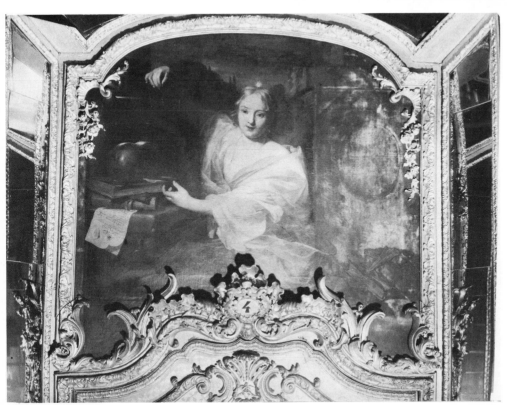

Pl. 43 Niccolò Renieri (Regnier), allegory, oil painting, signed and dated 1626. Turin, Palazzo Reale, Galleria del Daniele. *See p. 100.*

Pl. 44 *vanitas* still-life with skull looking in mirror, anonymous Dutch oil painting, third quarter of the seventeenth century. *See p. 101.*

Pl. 45 Simon Luttichuys (1610–1661), *vanitas* still-life with skull looking in mirror, oil painting, signed. Amsterdam, property of Bernard Houthakker. *See p. 102.*